04

WORLD PRESS PHOTO

Thames & Hudson

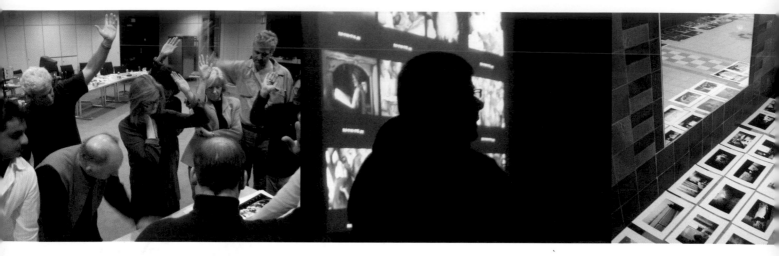

It took the jury of the 47th World Press Photo Contest two weeks of intensive deliberation to arrive at the results published in this book. They had to judge 63,093 entries submitted by 4,176 photographers from 124 countries.

World Press Photo

World Press Photo is an independent non-profit organization, founded in the Netherlands in 1955. Its main aim is to support and promote internationally the work of professional press photographers. Over the years, World Press Photo has evolved into an independent platform for photojournalism and the free exchange of information. The organization operates under the patronage of H.R.H. Prince Bernhard of the Netherlands.

In order to realize its objectives, World Press Photo organizes the world's largest and most prestigious annual press photography contest. The prizewinning photographs are assembled into a traveling exhibition, which is visited by over a million people in 40 countries every year. This yearbook presenting all prizewinning entries is published annually in seven languages. Reflecting the best in the photojournalism of a particular year, the book is both a catalogue for the exhibition and an interesting document in its own right.

Besides managing the extensive exhibition program, the organization closely monitors developments in photojournalism. Educational projects play an increasingly important role in World Press Photo's activities. Seminars open to individual photographers, photo agencies and picture editors are organized in developing countries. The annual Joop Swart Masterclass, held in the Netherlands, is aimed at talented photographers at the start of their careers. They receive practical instruction and professional advice from leaders in the profession.

World Press Photo is sponsored worldwide by Canon and TNT.

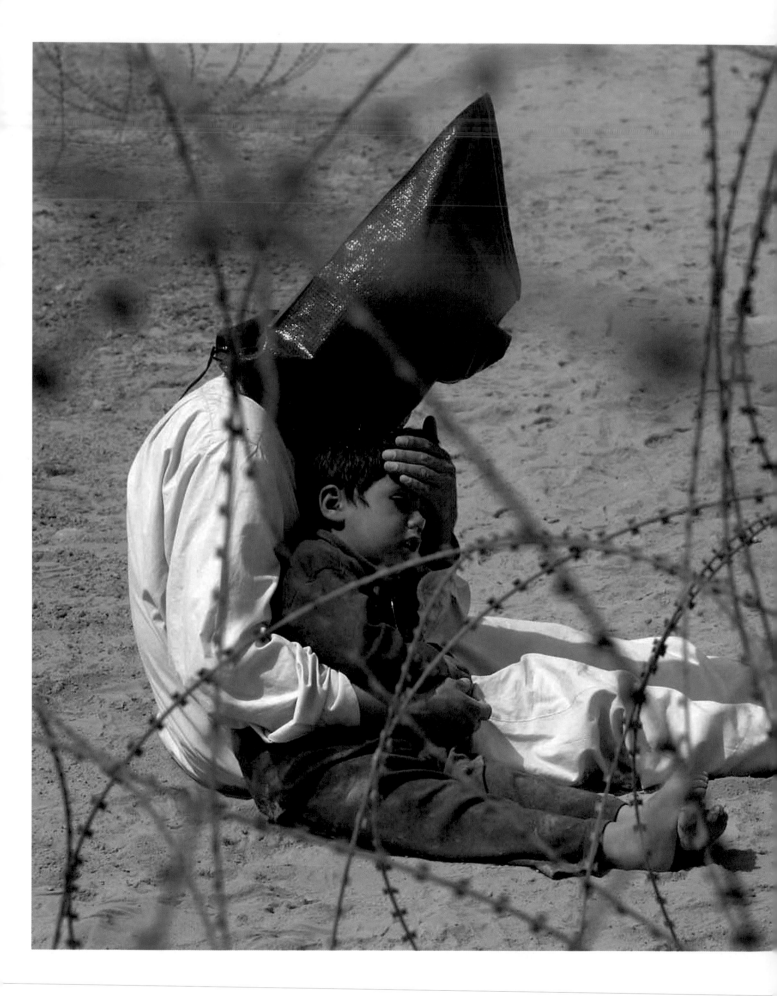

Jean-Marc Bouju
France, The Associated Press
1st prize People in the News Singles

An Iraqi man comforts his four-year-old son at a holding center for prisoners of war, in the base camp of the US Army 101st Airborne Division near An Najaf, southern Iraq, on March 31. The boy had become terrified when, according to orders, his father was hooded and handcuffed. A US soldier later severed the plastic handcuffs so that the man could comfort his child. Hoods were placed over detainees' heads because they were quicker to apply than blindfolds. The military said the bags were used to disorientate prisoners and to protect their identities. It is not known what happened to the man or his son.

Jean-Marc Bouju was born in 1961 in Les Sables d'Olonne, France. Since 2001, he has lived in Los Angeles where he works as a photographer for The Associated Press. Bouju studied photography as a graduate student at the University of Texas in Austin, gaining practical experience by working on the college newspaper *The Daily Texan*. In 1993, he began his career with The AP in Nicaragua, and has since photographed major news events in Central America, Africa, Europe and Asia. In 1994, Bouju moved to Africa where he photographed Rwanda's civil war, genocide and refugee crisis. Coverage of Rwanda earned Bouju and colleagues the 1995 Pulitzer for feature photography. He later photographed conflicts in Liberia, Sierra Leone, Ethiopia and Eritrea, and followed Rwandan-backed rebels on a seven-month trek across then-Zaire as they overthrew Mobutu Sese Seko. Bouju's photos of the US embassy bombings in East Africa by Osama bin Laden's followers won him and colleagues a Pulitzer Prize for news photography in 1999. During the conflict in Iraq in 2003, he was an embedded photographer with the US Army. Bouju and his wife Karin Davies have a daughter, Lauren.

Jean-Marc Bouju

Jean-Marc Bouju, winner of the World Press Photo of the Year 2003, responded to questions about his work.

How did you become involved in photojournalism?
I was trying to find a way out of teaching French to students who only wanted to fulfill a language requirement. I was teaching at the University of Texas in Austin, and I was intrigued by the student photographers running around campus, and by their photos published in *The Daily Texan*. I thought photography would be a great way to combine my interests in travel and history with work. On a summer vacation, I shot eight rolls of black-and-white film in India. I showed them to a professor who enrolled me as the lone student in his graduate photography program. Even though I was a grad student, I attended the basic photography classes. I spent all the rest of my time working at the student newspaper. My grades suffered, but I won two national student prizes for images I shot on a hitchhiking trip through Central America during a Christmas break. That portfolio convinced The Associated Press to hire me as a photographer in Nicaragua in 1993.

What has guided your development as a photographer?
I've always loved art, and enjoy drawing and painting. When I'm taking photographs, I try to combine visual interest with reporting. I think of myself as a journalist whose medium is photography. Working for a wire service has been a big influence on my work. The deadlines are constant, and I have to move photos every day. I seldom have the luxury of waiting for just the right light, or just the right moment. I have to make the best of the news as it breaks, and move something fast.

In Iraq you were embedded with the US Army's 101st Airborne Division, 3rd Brigade. Did you feel compromised or restricted?
It was very different from what I'd been used to. Previously, I'd worked on my own or with a writer, sorting out my own accommodation and transportation, and chasing news as it broke or developing features. But when you're embedded, you're just like a soldier. You have no transportation of your own, no way to go anywhere independently. And if the troops aren't doing anything or going anywhere, then you're not either. We were stuck in the desert when Baghdad was falling, and that was very frustrating. The military didn't block me from photographing anything, but being embedded meant that I often wasn't where the big news was happening. By living and traveling with the soldiers, I gained a deeper understanding of how the gigantic military machine works. Did it make me soft towards them? No. When you're living so close to people you get to know them, and even like them, but that doesn't prevent you from keeping your eyes open. I suppose that works both ways – the presence of journalists may have made the military more accountable.

How did the winning image come about?
When we were camped in the desert, I heard that the brigade had received some prisoners who were going to be flown to another camp for interrogation. I was driven to where they were being held. There were about 30 prisoners, plus a small boy, who caught my eye. The unit that was transporting the prisoners wasn't the unit that had captured them, so the soldiers didn't know if the prisoners were combatants. They did say that the boy was with his father when he was captured, and they didn't want to leave the child alone in the desert. The soldiers took the prisoners from a truck inside a ring of razor wire, and, following orders, put hoods and handcuffs on the prisoners, including the boy's father. The child was terrified and started to scream. One of the American soldiers then cut off the man's plastic handcuffs, so he could embrace and calm his son. I could hear the man, who was frightened himself, murmuring to his son in Arabic. The soldier's compassion and the father's love were heartwarming. The army couldn't tell me the prisoners' names, and I don't know what happened to them because I had to leave with my ride. I tried to find out, but with troops scattered and on the move in the desert, and communication limited, I could not.

What were you thinking about when you took the photo?
I couldn't help but imagine my own little girl, Lauren, who was the same age, 4, and the same size, in the same situation. I thought of that a lot before, during and after taking the photo. The image shows no guns, no soldiers, no blood, but for me it shows a truth of war – that it affects not just the soldiers who fight it and the politicians who order it.

What does winning the World Press Photo of the Year mean for you?
It means a lot. It's a big deal – almost everyone I know in the business enters the World Press Photo contest. It's the prize I've always wanted to win.

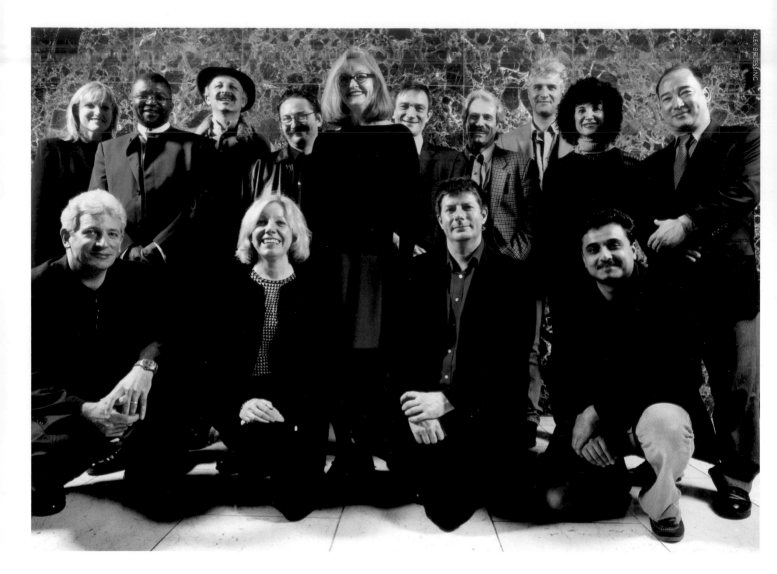

THIS YEAR'S JURY. FRONT ROW,
FROM LEFT TO RIGHT:
Steve Crisp, UK
Ruth Eichhorn, Germany
Stephen Mayes, UK (secretary)
Swapan Parekh, India
BACK ROW, FROM LEFT TO RIGHT:
Susan Olle, Australia
Herbert Mabuza, South Africa
Reza, Iran
Dani Yako, Argentina
Elisabeth Biondi, Germany (chair)
Mark Grosset, France
Aleksander Zemlyanichenko, Russia
Gary Knight, UK
Elena Ceratti, Italy
James K. Colton, USA

Foreword

We live in chaotic times, and the images of World Press Photo 2004 reflect the drama of events of the past year. We saw heartbreaking pictures from the conflict in Liberia and the earthquake in Bam; and moving pictures of an Aids-infected village in China, and of the forgotten Hmong guerrillas in Laos. But of all the images seen by the jury, it was the pictures of the war in Iraq that dominated and provoked the most discussion.

Ten years ago, when I was a member of the jury, the beginning of the conflict in the former Yugoslavia equally demanded our attention. Yet, in the end, the World Press Photo of the Year we chose was not from Bosnia, but an image of the Israeli-Palestinian conflict. That conflict is still with us and so are the pictures. Far from enjoying a more peaceful world, all of us who follow the news and consider its consequences are aware that we live in a tense and complicated time. September 11, 2001 changed our lives. War and its consequences touch all of us.

According to the World Press Photo guidelines, the photo of the year must be of "great journalistic importance" and an "outstanding level of visual perception and creativity". In other words, the picture is selected for the news value of its content and for the individual stylistic approach that captures that content. In my opinion, journalistic pictures are successful when they bring a specific situation to our attention. They can touch us with their use of iconography, by clearly describing the facts, or by their use of aesthetics to communicate to us in a quieter way. For example, we have given an award to images from the Liberian war that shock and touch us by the cruelty they expose. Their journalistic value cannot be contested. At the aesthetic end of the scale, we gave an award to a single image of the Liberian massacre. It is a close-up of bodies in a mass grave equally touching and provocative because of its quiet and awful beauty.

At the beginning of its deliberations, this jury thought the World Press Photo of Year could be of any event, as long as we all agreed that it best fulfilled the qualifications. But the longer we looked at pictures, the clearer it became to all of us that the photograph would come from the Iraq war or the post-war period there. As we continued looking, Jean-Marc Bouju's picture of a hooded Iraqi prisoner of war comforting his son imprinted itself on our minds. War is cruel, and we saw many excellent pictures that showed this cruelty. Yet love can survive war, and war can also bring out compassion in those whose lives it has turned upside down, civilians and soldiers alike. Jean-Marc Bouju was touched, as were we, by what he was a witness to – a father, powerless and disoriented, embracing his son.

This picture indicates one truth of war: it shows how war affects life in a terrible way regardless of why it is initiated. It is a powerful picture, a re-affirmation of the universality of emotions, the love of a father for his son and the instinctive desire to protect him. Photojournalists have the power to show both the horrors of war and the compassion of humanity during war. We chose a picture of compassion.

ELISABETH BIONDI
Chair of the Jury
New York City, February 2004

Contemporary Issues

Stephanie Sinclair
USA, Corbis for Marie Claire
1st Prize Singles

Marzia, aged 15, has her burns
cleaned at the Herat Public Hospital
in Afghanistan. Terrified at the
prospect of her husband's wrath
after she short-circuited the
television he had been saving for, she
set fire to herself. Although no
statistics are kept on female self-
immolation, staff at the hospital
estimate that they treated between
300 and 400 women with self-
inflicted burns between November
2001 and February 2003. The suicide
attempts make use of the kerosene
used for cookers. Medical officers say
that there were almost no similar
cases under the Taliban regime, and
some attribute the increase to a
growing frustration as Western
culture infiltrates Afghanistan, yet
the position of women in society
remains much the same.

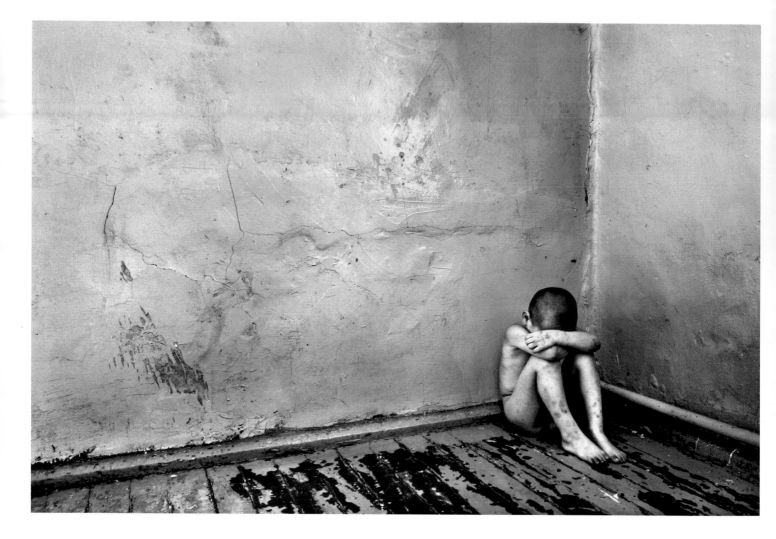

Jacob Ehrbahn
Denmark, Politiken/Jyllands-Posten
2nd Prize Singles

A Mongolian street boy shelters in a
corner of the Address Identification
Center in Ulan Bator, a state center
run by the police department to
identify runaways and return them
to their homes or orphanages. The
breakdown of communist rule in
Mongolia following the collapse of
the Soviet Union in the early 1990s
led to the first generation of street
children. Police estimate that there
are over a thousand street children in
Ulan Bator. Most of them cannot stay
with their families due to problems
related to alcohol, violence or abuse
and because they cannot adapt to
regimented life in orphanages, end
up running away. This means that it
is often the same children that the
police bring to the center again and
again.

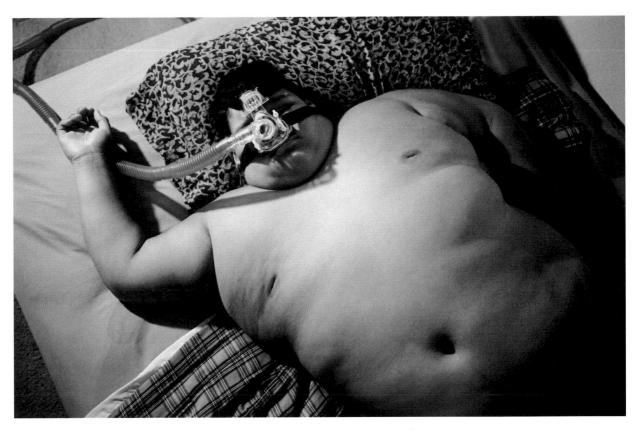

Felicia Webb
UK, Independent Photographers Group
3rd Prize Singles

Jonathan Rojo, aged 14, sleeps attached to a BIPAP machine that forces air into his nostrils to counter the effects of obstructive sleep apnea. The condition is caused by excess fat constricting the throat, resulting in a chronic lack of oxygen. Jonathan weighs 118 kilograms. His sister Yomara is nine and weighs 70 kilograms. The World Health Organization has called obesity 'a global epidemic', and it is set to become the number one killer in the United States. Two-thirds of Americans are overweight or obese, and the numbers are on the increase. Houston, where Jonathan and his sister live, has been named the fattest city in the United States for the last three years running, with 37 per cent of children overweight, and 22 per cent obese. Across the country, obesity claims around 325,000 lives each year – more than the combined deaths from alcohol, drugs, shootings and road accidents, and second only to smoking fatalities.

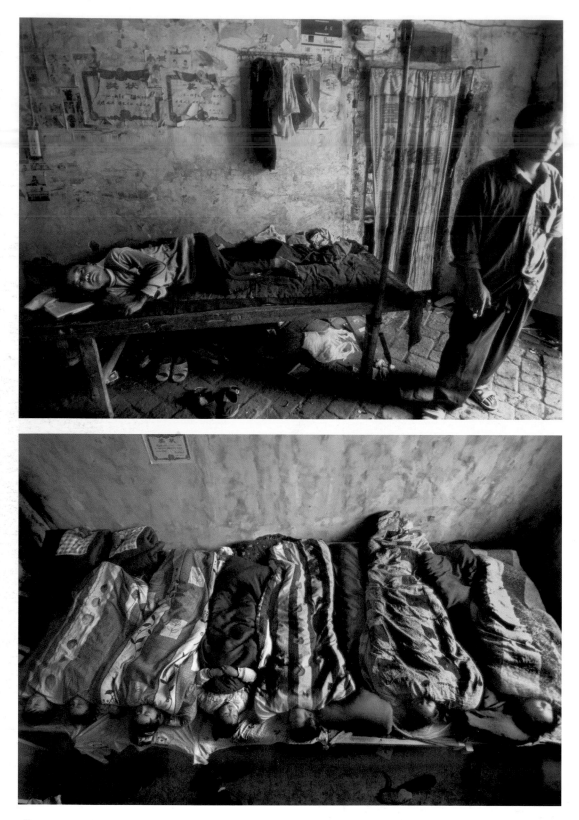

Lu Guang
People's Republic of China, Gamma
1st Prize Stories

In the mid-1990s, poor peasants in Henan province in eastern China sold their blood for 50 yuan a pint, enough to buy two bags of fertilizer. As a result of unsafe procedures, large numbers were infected with the HIV virus. In some villages up to 40 per cent of the inhabitants are seropositive, but for a long time have been isolated from help because the existence of Aids in China was not officially acknowledged.

This page, top: Families such as this one have sold almost everything valuable in their home to help meet expenses. Below: Children in the orphanage 'Home of Care and Love' curl up against each other to sleep. Facing page: A woman carrying her severely ill grandson implores the sky to prevent the devil of pain returning. She had already lost her son and only other grandson to Aids. (story continues)

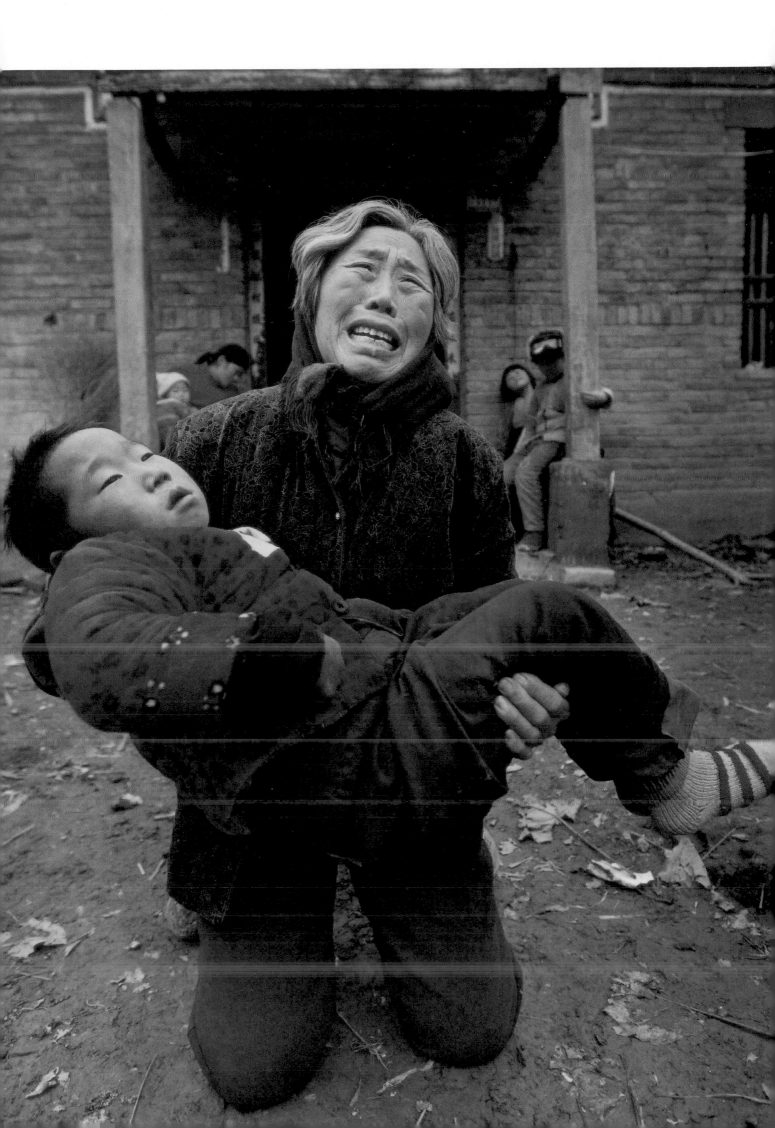

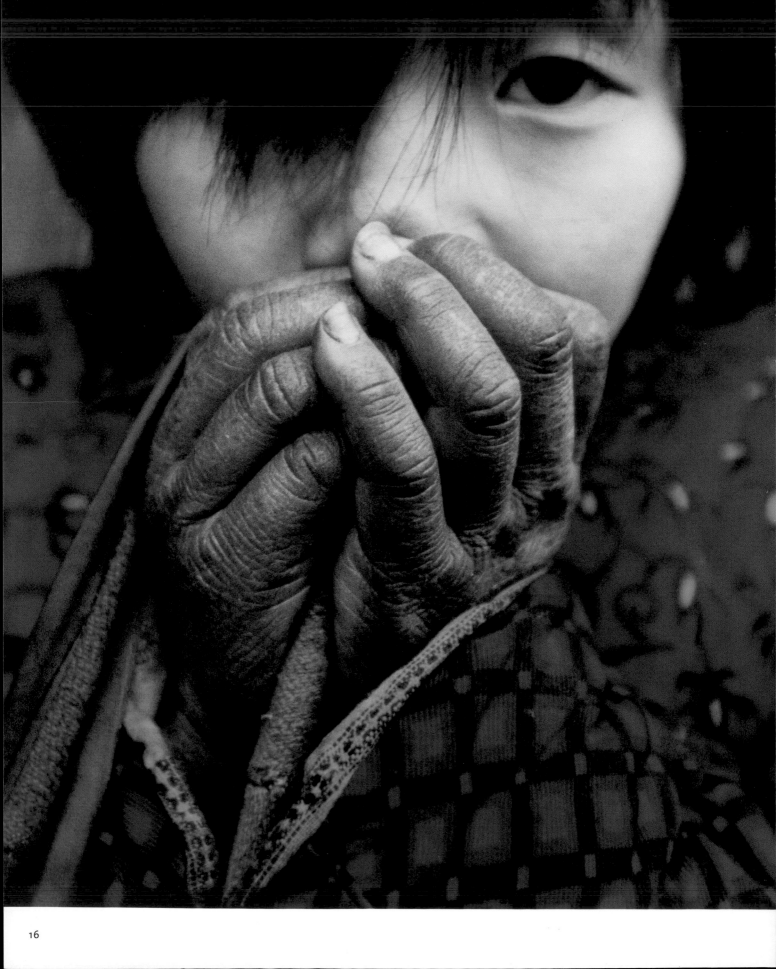

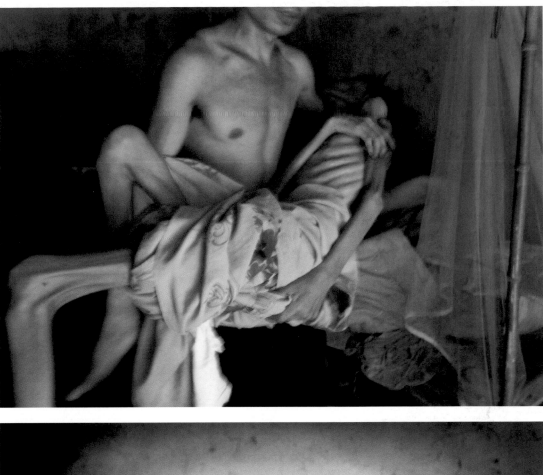

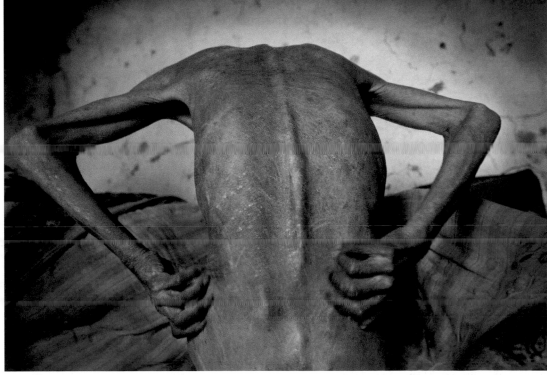

(continued) Even today, many villagers are uncertain whether they are infected and cannot afford a test, which costs 80 yuan. Organized help from local health authorities is getting underway, but many people do not have the money to go to hospital and are cared for by family and friends. Facing page: A young girl warms her hands in winter. Her father is infected with HIV and still has his elderly parents and five children to care for. This page, top: Qi Guihua, here held by her husband, fell ill when she returned to the village from Beijing to celebrate the Spring Festival. She died two hours after this photograph was taken. Below: Zhou Mao sold his blood three times in order to raise the money to send his five children to school for one semester. He has been ill for three years, and his children have now left school to take care of him.

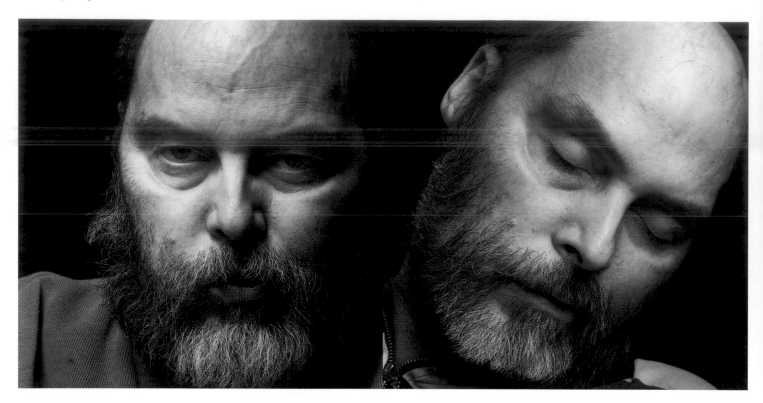

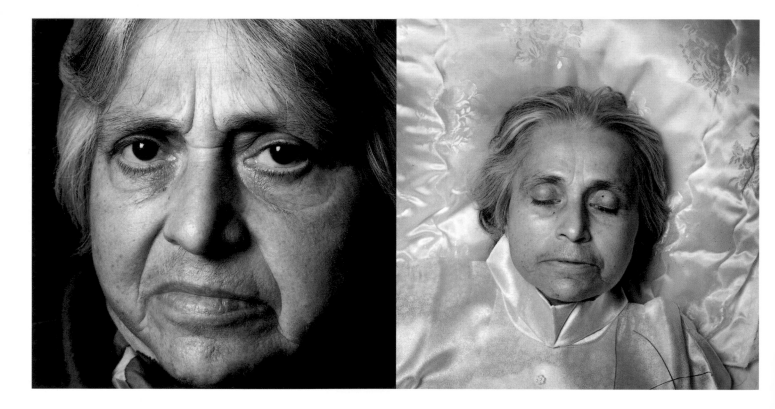

Walter Schels
Germany, for Der Spiegel
2nd Prize Stories

The practice of palliative hospice care in Germany goes back only to the 1980s. The Ricam hospice in Berlin has 15 single rooms – more than a third of the total number of hospice beds available in the city. There was a growth in the palliative-care movement in response to patients suffering from Aids-related illnesses, but the advent of drugs cocktails that help control Aids has meant that, increasingly, hospice places are occupied by people with diseases such as cancer. Facing page, top: Michael Föge, aged 50, a political activist, died of a brain tumor in the Ricam hospice. Below: Gerda Strech, aged 69, was looked after by her daughter, who is a nurse, but was admitted to the hospice when her daughter burnt herself out. This page, top: Irmgard Schmidt, aged 82, the widow of a ship's radio officer, nursed her husband through Alzheimer's before herself falling ill. Below: Michael Lauermann, aged 56, was a workaholic company manager before being diagnosed with a brain tumor.

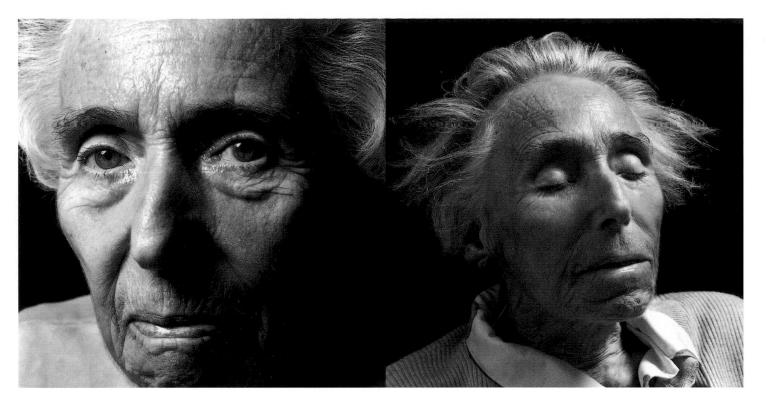

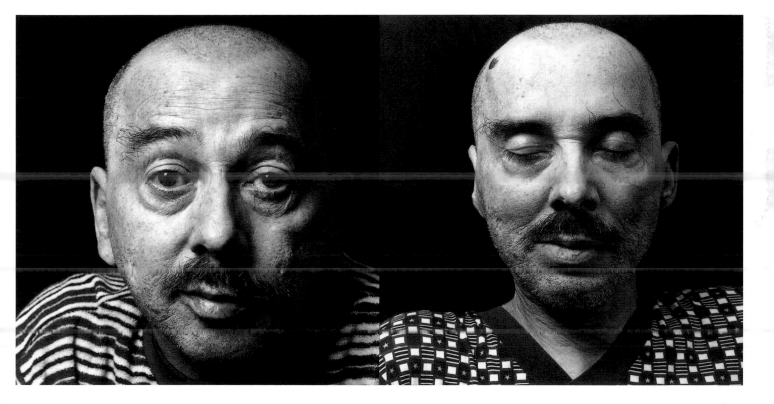

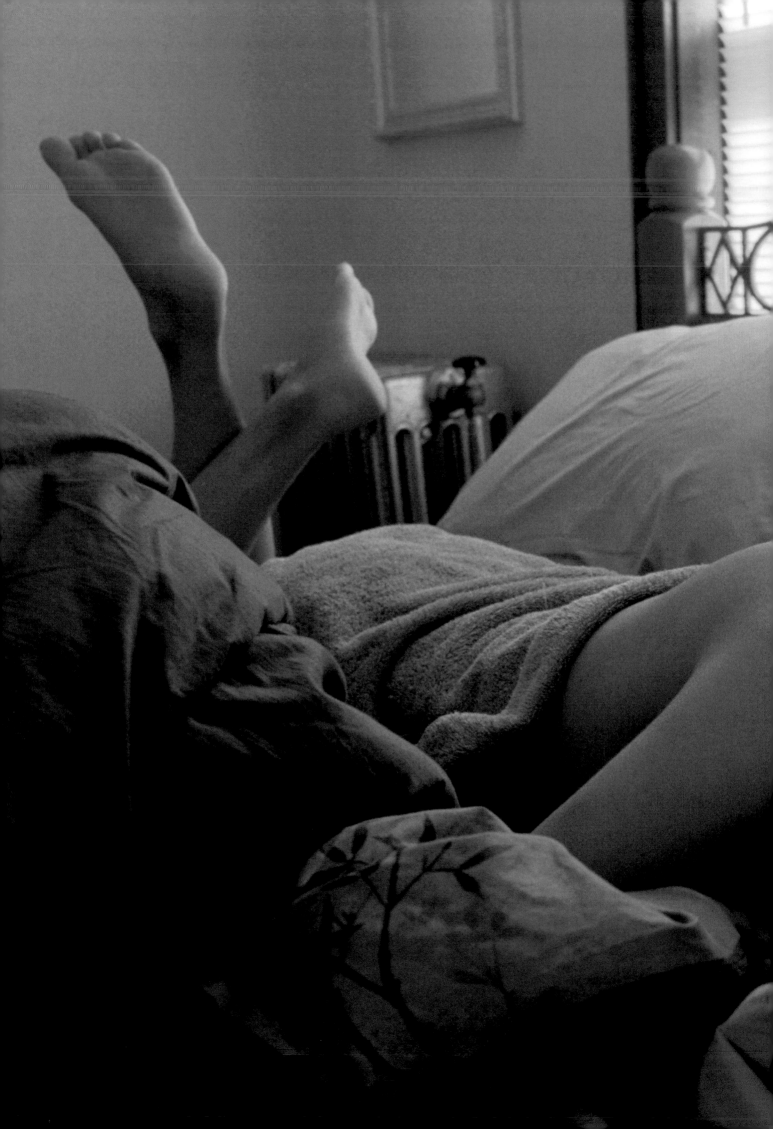

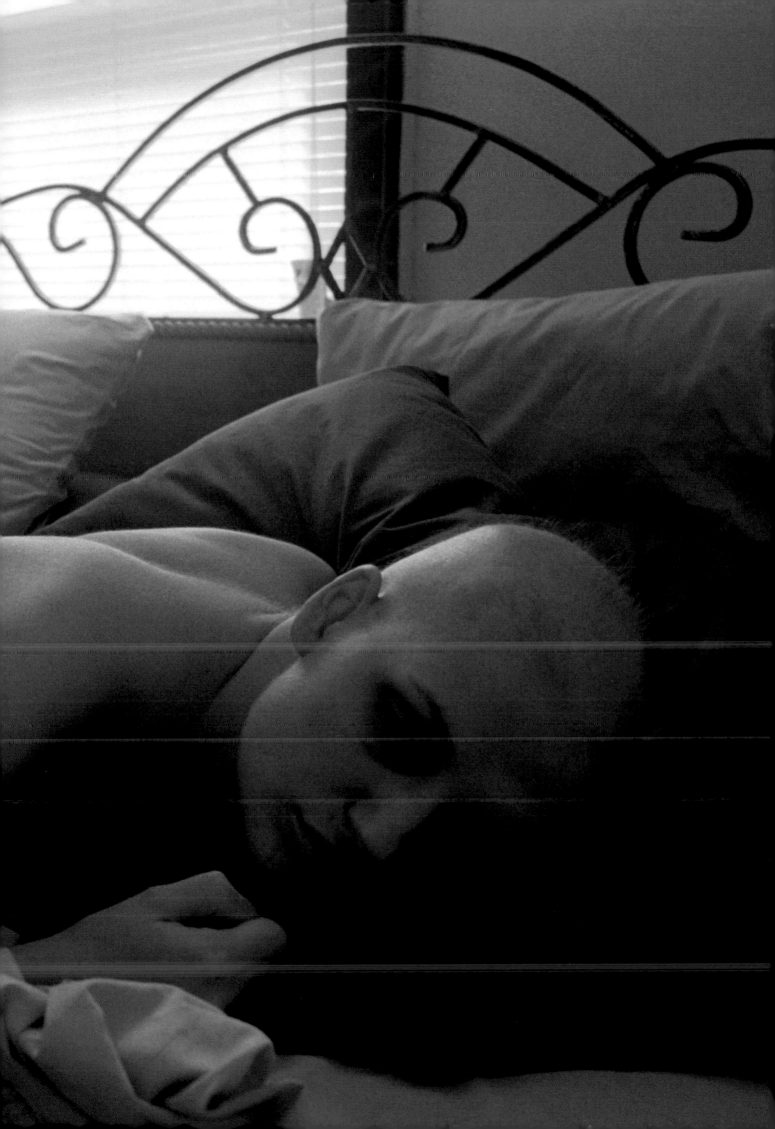

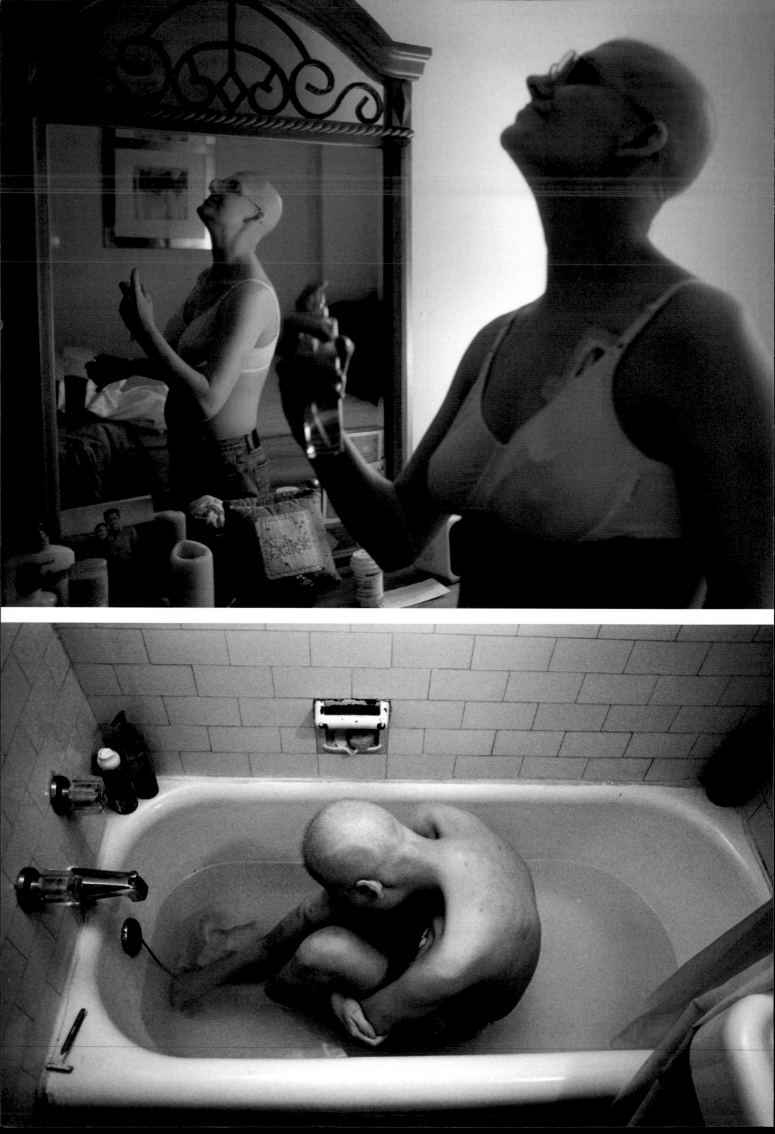

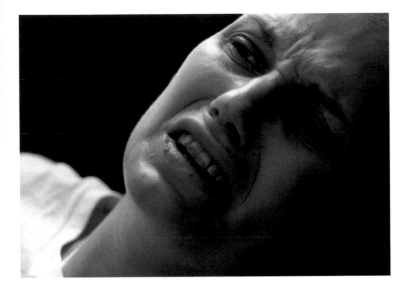
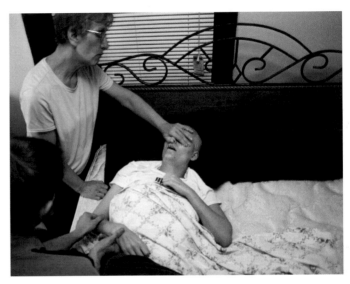

Tippi Thole
USA
3rd Prize Stories

Pamela Sullentrup was diagnosed with acute myeloid leukemia in January 2000, when she was aged 20. For three years she underwent several rounds of chemotherapy as well as radiation therapy and bone marrow transplantation, but the cancer did not stay in remission. In January 2003 doctors recommended that she enter hospice care within the context of her own home. Previous page: Pamela elected to undergo hospice care at home because she wanted to be in her own bed, surrounded by those who loved her, when she died. Facing page, top: She struggled to maintain a normal life as the cancer advanced, delighting in daily rituals that allowed her to feel feminine and beautiful. Below: Though surrounded by family members, Pamela often felt alone in her battle, especially at night when she suffered from medication-induced nightmares. This page, left: Pamela wakes up in severe pain. Her bones hurt and she can barely move. Right: Pamela's mother closes her eyes, after she passed away on February 5, 2003.

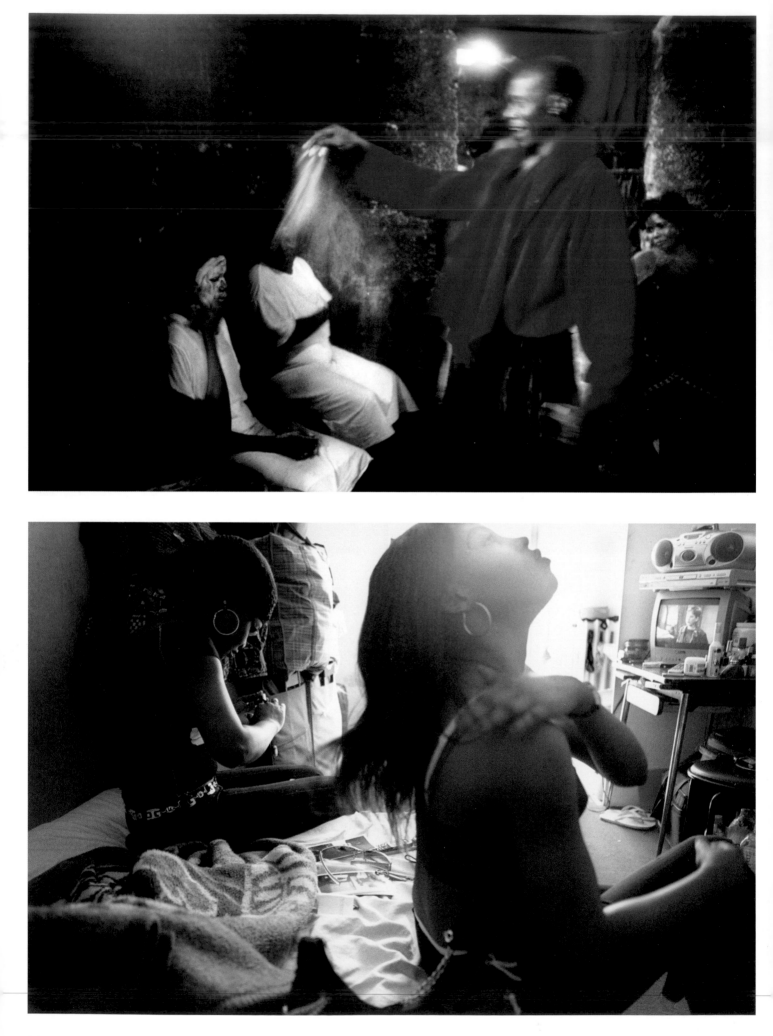

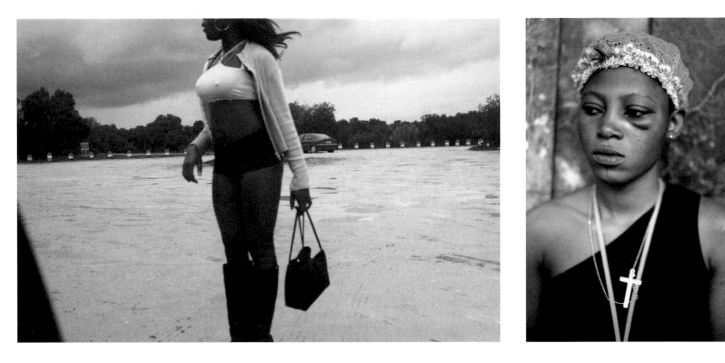

Lorena Ros
Spain, Fotopress La Caixa for Elle
Honorable Mention

Thousands of Nigerian women are transported to Europe every year and forced to work in the sex industry. Having entered countries illegally, they are pushed to the periphery of society and have little access to social care. They remain in financial debt to their traffickers, and are also controlled by juju, a voodoo ritual whereby an oath of loyalty is pledged between a god, the trafficker and the woman. Facing page, top: A juju ritual is performed on Betty in Benin City in Nigeria. The white powder marks her out for the god Okun to take her soul. He will keep her soul until she has earned enough to pay her debt to her trafficker. Failure to pay the debt, which can amount to US$ 50,000, is a death sentence. Below: Jessica and Otta get ready to go to work in the hotel room they share with other Nigerian women in Paris. This page, left: Mary does a day shift in Madrid. Right: A client hit Jessica in the eye the previous night, but her illegal residence status in Paris means she cannot report abuse.

Spot News

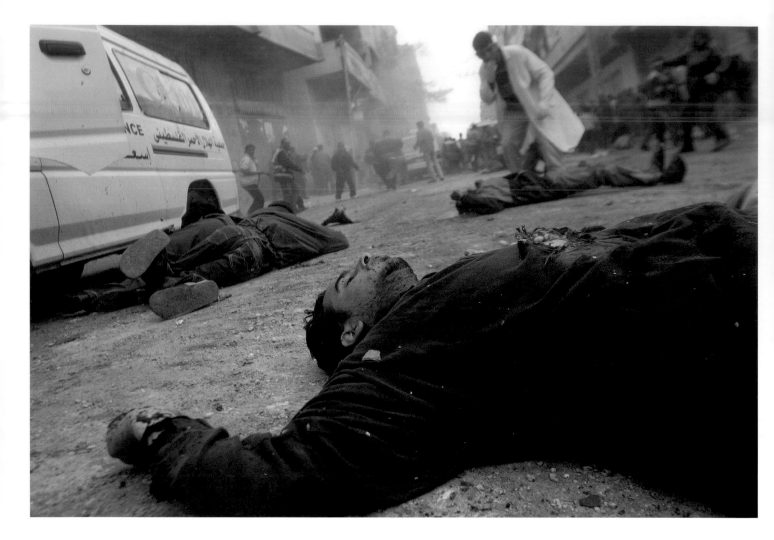

Ahmed Jadallah
Palestinian Territories,
Reuters News Pictures
1st Prize Singles

Unidentified bodies lie on a street in Jabalya, the largest refugee camp in the Gaza Strip. Israeli tanks spearheaded a major raid on the camp in the night of March 5, after a suicide bomber had killed 15 people on a bus in Haifa in Israel the day before. At least 11 Palestinians were killed in the Jabalya attack and more than 140 were injured. The photographer was himself wounded by shrapnel, taking this photo after he had collapsed with a severed leg artery.

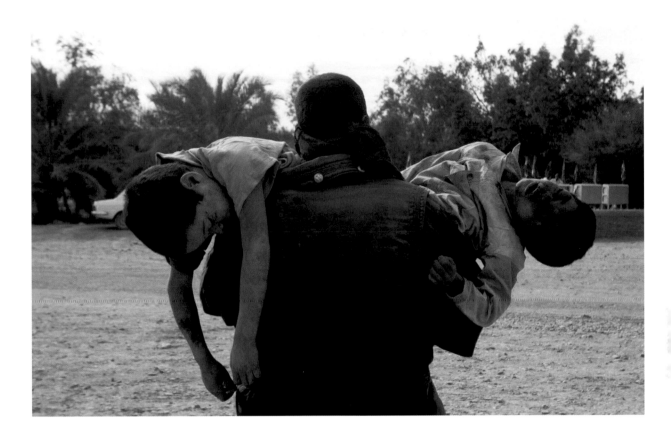

Atta Kenare
Islamic Republic of Iran, Agence
France-Presse
2nd Prize Singles

A father carries his two sons to be
buried after the earthquake that
leveled the ancient city of Bam in Iran
in the early hours of December 26.
The initial tremor lasted just 20
seconds, yet killed over 40,000
people, in some cases wiping out
entire families. The heavy death toll
was attributed to the fact that
traditional mud-brick houses in Bam
collapsed quickly, while people were
sleeping. The dust created by the
falling houses meant that there was
little chance of air pockets forming
under the rubble, which might also
have saved lives.

Kuni Takahashi
Japan, Boston Herald/Reflex News
3rd Prize Singles

Soldiers loyal to the Liberian
government fire on rebel militia in a
battle for control over a bridge giving
access to the center of Monrovia, in
July. Fighting in the long-ongoing civil
war had intensified that month, as
rebels struggled for dominance of the
capital. Several hundred people were
killed in street fighting and mortar
attacks.

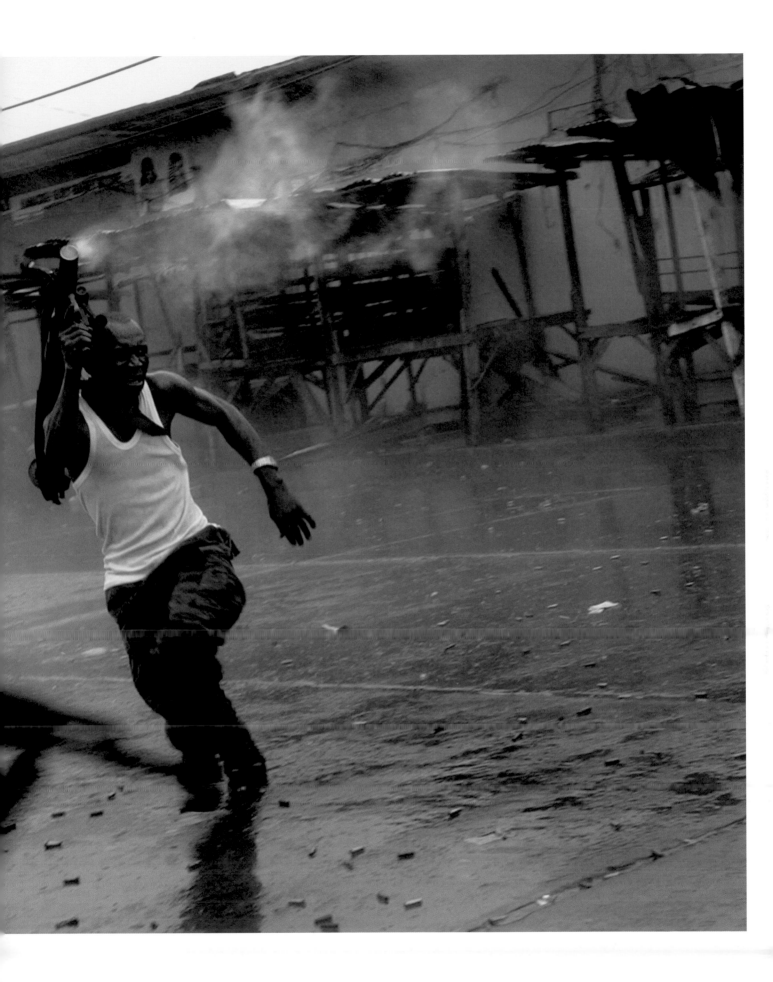

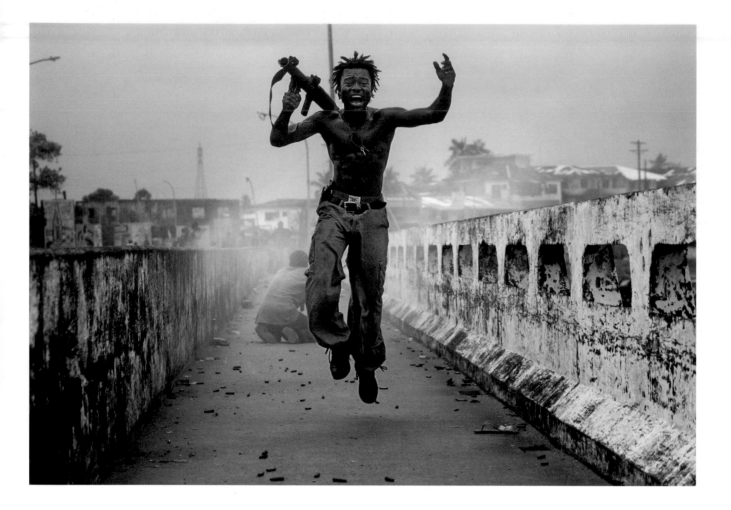

Chris Hondros
USA, Getty Images
Honorable Mention Singles

A Liberian militiaman loyal to the
government exults after firing a
rocket-propelled grenade at rebel
forces at a key strategic bridge in
the capital Monrovia on July 20.
Government forces succeeded in
driving back the rebels in fierce
fighting around the edge of the city
center.

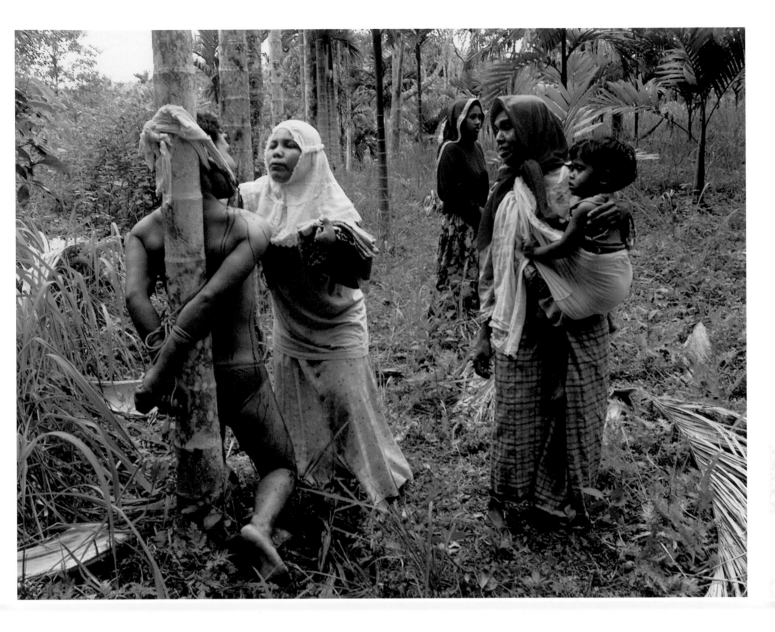

Tarmizy Harva
Indonesia, Reuters News Pictures
Honorable Mention Singles

A woman mourns a relative killed in civil conflict in the Indonesian province of Aceh, in June. Government forces have been battling the separatist Free Aceh Movement (Gerakan Aceh Merdeka, or GAM) for control of the oil and gas-rich area since 1976. An agreement signed in December 2002, offering autonomy in return for rebel disarmament, collapsed a few months later when it became clear that neither side was fulfilling its obligations. In May the army launched a major offensive against GAM rebels. Both sides claimed that the other was targeting civilians.

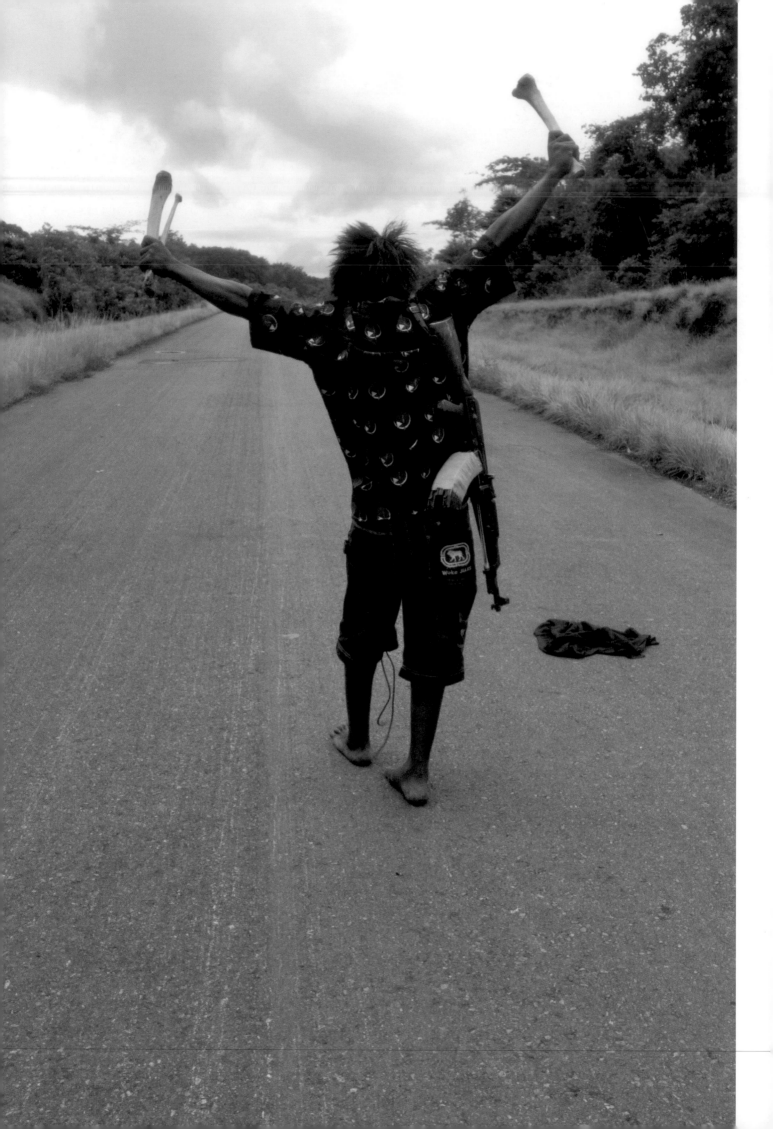

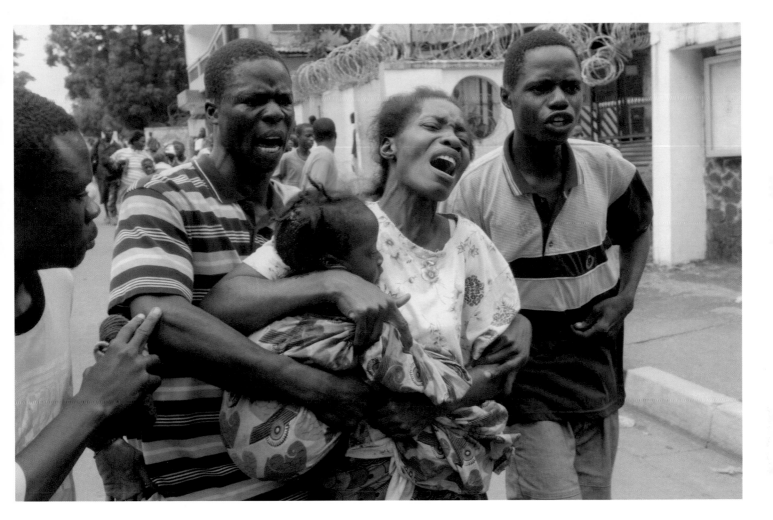

Noël Quidu
France, Gamma for Newsweek
1st Prize Stories

Liberia has been wracked by on-off civil war since the 1980s. Following an uprising against the government led by Charles Taylor in 1989, the next decade saw occasional cease-fires – but each time fighting resumed after a matter of months. Increasing rebel activity in the north of the country followed Taylor's election victory in 1997. By March 2003, rebels had advanced to within 10 kilometers of the capital Monrovia, and by July fighting had intensified and government and rebel militia were battling for control of the city. Facing page: A fighter loyal to the government brandishes human bones in celebration of taking the strategic position of Klay Junction in June. This page: Many people sought refuge near the US embassy in Monrovia, but rebel rockets struck the building on July 21, causing both injury and loss of life. (story continues)

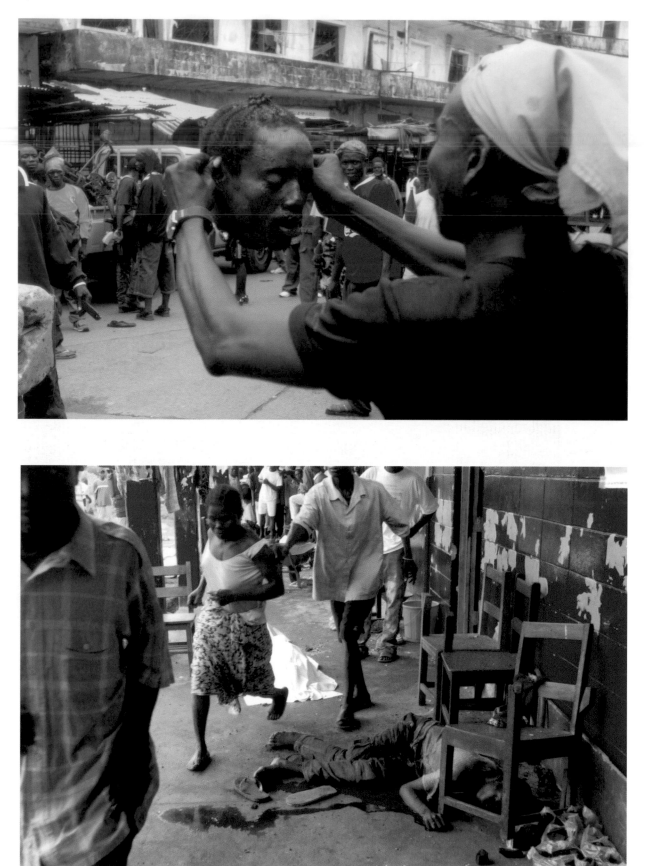

(continued). After intervention of UN and US forces in August, rebels signed a peace accord and President Charles Taylor, in the meantime indicted on war-crimes charges, left the country. Facing page, top: A loyalist fighter displays the decapitated head of a rebel killed during fighting on July 21. Below: A school in Monrovia used as a refugee camp is hit by rebel shelling. This page: A child soldier at government militia headquarters waits for the signal to return to combat.

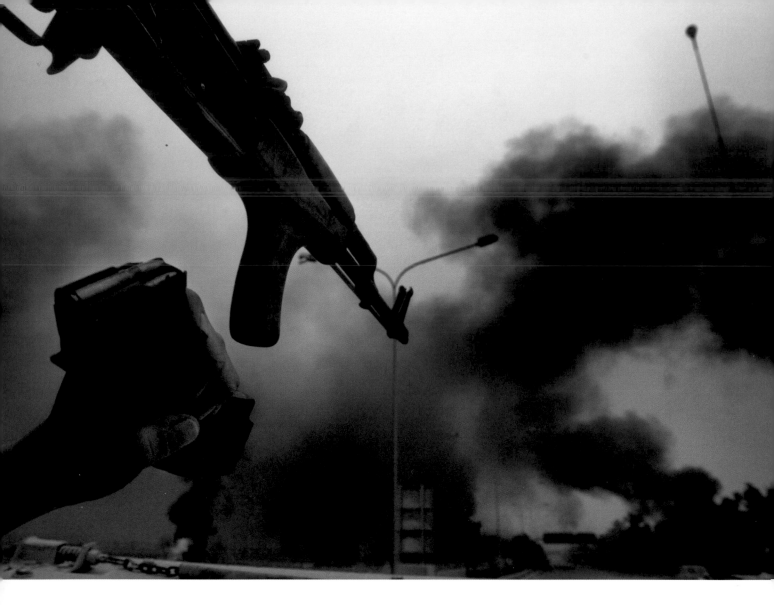

David Leeson
USA, The Dallas Morning News
2nd Prize Stories

On March 17 the British ambassador to the United Nations announced that the diplomatic process regarding the situation in Iraq had ended, and US President George W. Bush gave Iraqi leader Saddam Hussein 48 hours to leave the country or face war. On March 20 the first American missiles hit Baghdad, and a few days later US and British ground troops advanced into Iraq from bases in Kuwait. By early April, the Americans had reached central Baghdad.

Facing page, clockwise from top left: A US soldier shouts for troops to take cover before detonation of explosives on an Iraqi anti-tank weapon in northern Baghdad. An Iraqi boy looks on as men remove the body of a man killed by soldiers in Baghdad. A Bradley Fighting Vehicle passes a burning truck filled with rocket-propelled grenades. Iraqis wounded in a Baghdad air attack ask soldiers not to shoot them.

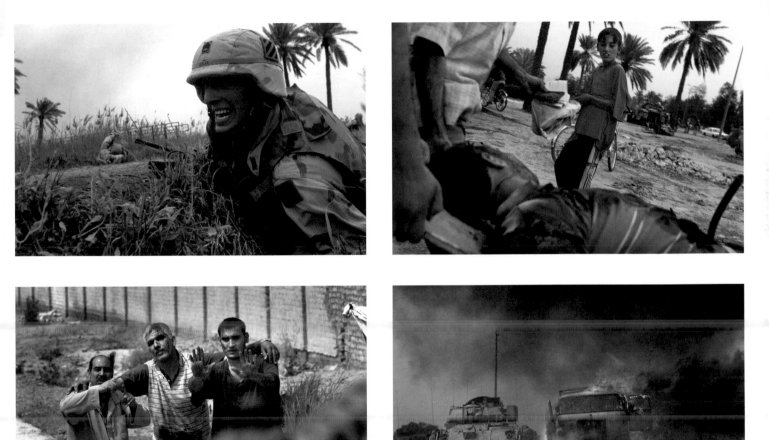

Ilkka Uimonen
Finland,
Magnum Photos for Newsweek
3rd Prize Stories

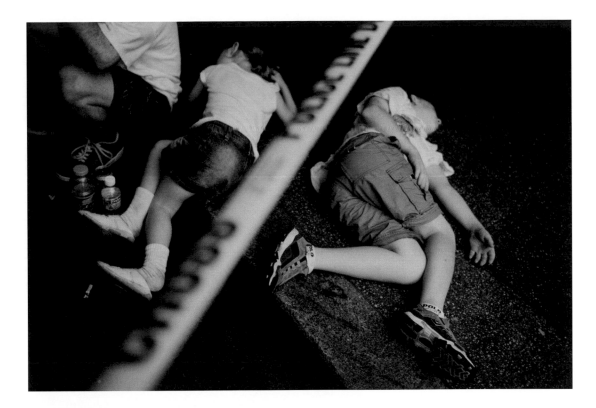

On August 14, during the evening rush hour, the northeastern United States and parts of Canada were hit by a massive electricity failure. In New York, as in other major cities, thousands of people were trapped in metros and lifts, and chaos ensued as traffic lights went out. Many chose to walk home, others were stranded overnight yet the overall mood remained calm. The blackout, thought to have been caused by an overload due to hot weather, lasted nearly 18 hours. Facing page, and this page top: Passengers while away time at Grand Central station. Below: The lights go out on 42nd Street.

Daily Life

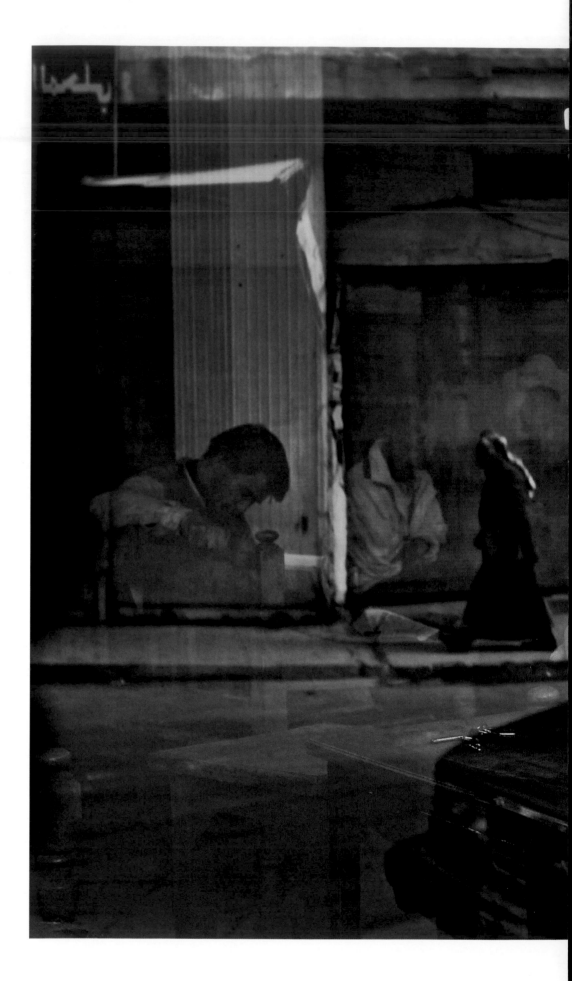

Bruno Stevens
Belgium, Cosmos for Stern/The New
York Times Magazine
1st Prize Singles

Men pass the time at the Al Zahawi
café, in Rashid Street in the old part
of Baghdad, some weeks before the
US-led attacks on the city. Cafés like
Al Zahawi, which is named after a
famous local poet and musician, are
an integral part of Baghdad life. Men
gather after prayers to drink tea or
Arabic coffee, converse and play
dominoes or backgammon.

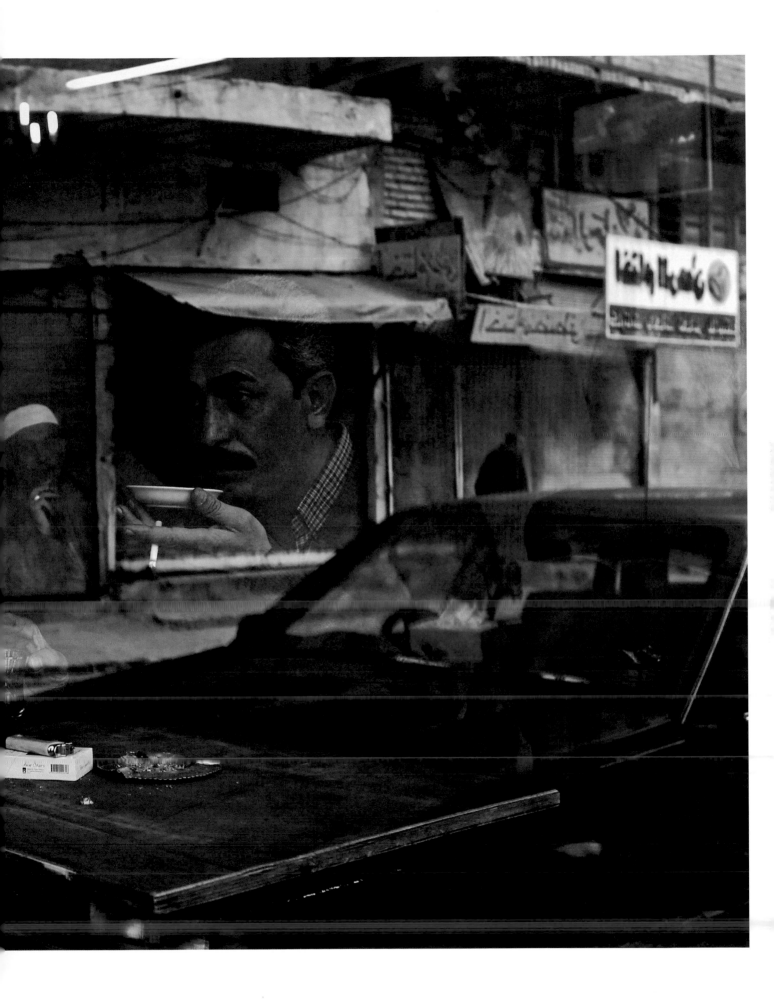

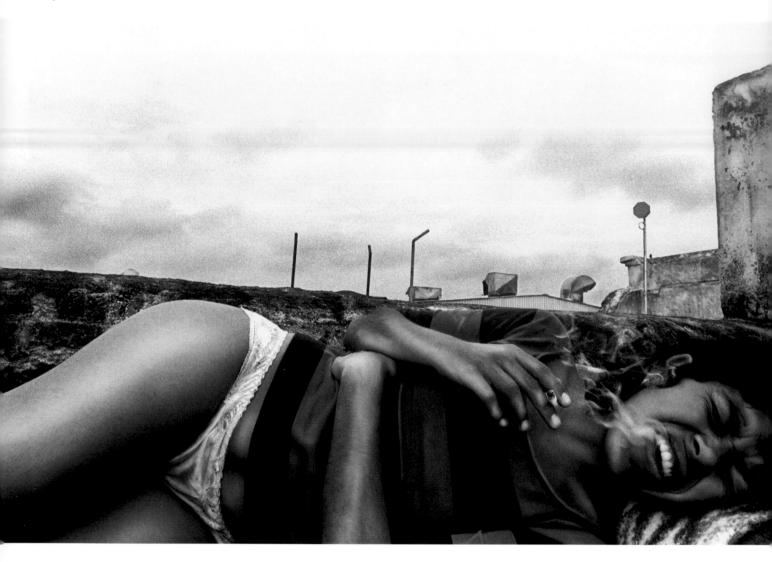

Jorge López Viera
Cuba
2nd Prize Singles

Alma, aged 23, smokes an early-morning marijuana cigarette on a rooftop in Mexicaltzingo, an old quarter of Guadalajara in Mexico. The neighborhood is home to many people living on the margins of city life, including prostitutes and street children. Marijuana is readily available, and the youth experiment with other substances in the face of the narrow options offered by poverty in an urban environment.

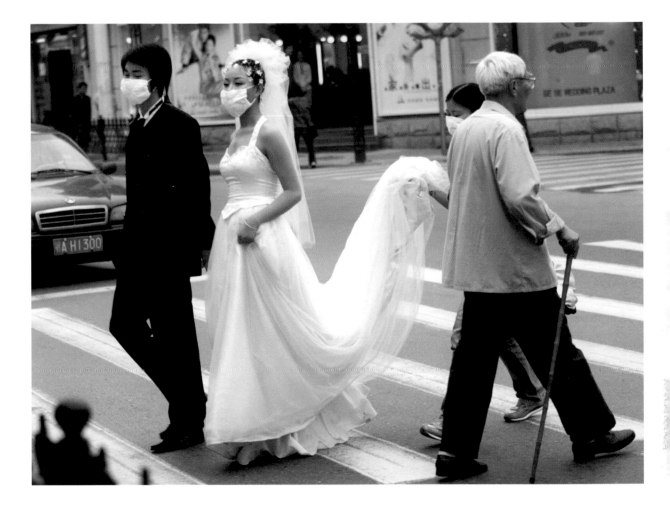

Qiu Yan
People's Republic of China,
Wuhan Evening News
3rd Prize Singles

Chinese newly weds wear masks as a protection against SARS (severe acute respiratory syndrome) as they cross a street in Wuhan, the capital of Hubei province in China on May 6. The deadly virus, for which there was no cure, infects the lungs and is spread easily by person-to-person contact. It first made its appearance in Guandong province in November 2002 and spread rapidly around the country. Initial government reluctance to admit the extent of the epidemic lifted in April, when the official tally of infections in Beijing was boosted tenfold. By May more than 4,800 cases had been reported in at least 26 countries, with over 300 fatalities. As it was so easily transmittable, SARS caused widespread public concern, resulting in impositions of quarantine, and plummeting tourist and airline figures.

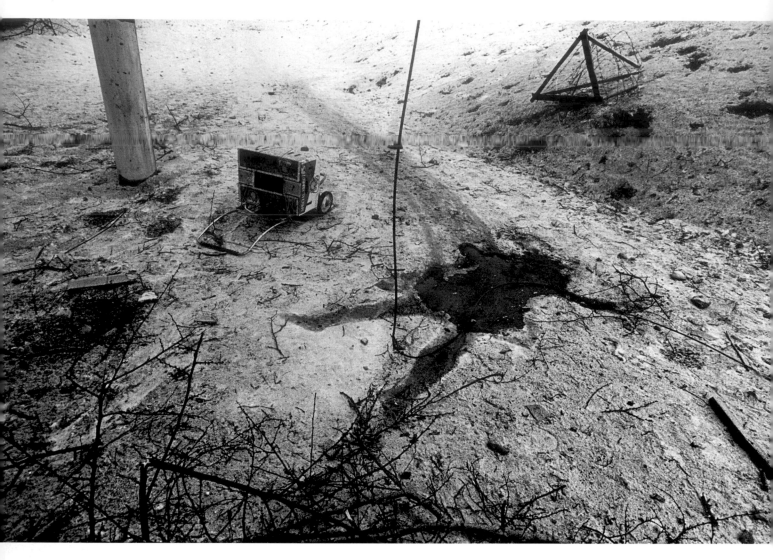

Stanley Greene
USA, Agence Vu
1st Prize Stories

When the Soviet Union collapsed in 1991, Chechnya proclaimed itself independent of Russia. In December 1994 Russian troops entered Chechnya to quash the independence movement. It is estimated that up to 100,000 people, many of them civilians, died in the ensuing 20-month war. Under Russian President Boris Yeltsin, a formal peace treaty was signed in July 1997, though the issue of independence wasn't settled. In 1999, under the new prime minister

Vladimir Putin, Russian forces re-deployed in Chechnya. Open conflict, as well as suicide bombings in Chechnya and in Moscow, continued into 2003. This page: A body has been hastily dragged back indoors after an explosion in Grozny in January 1995. Food and water supplies stopped within days of the Russian attack. Men and women searched for sustenance among the exploding shells. Facing page, top: A corpse lies in the snow in Minutka Square, Grozny in January 1995. The severity

of the Russian bombardment made it dangerous to venture out to retrieve the dead. Middle: On the road to Samashki, a village razed by the Russians in April 1995, with 100 reported deaths. Below: Anya fought against the Russians until the war ended in August 1996. Her leg was badly wounded and she now cannot walk without assistance. Following pages: Staring from a window in Grozny in April 2001, Zelina grieves the loss of her child in the conflict.

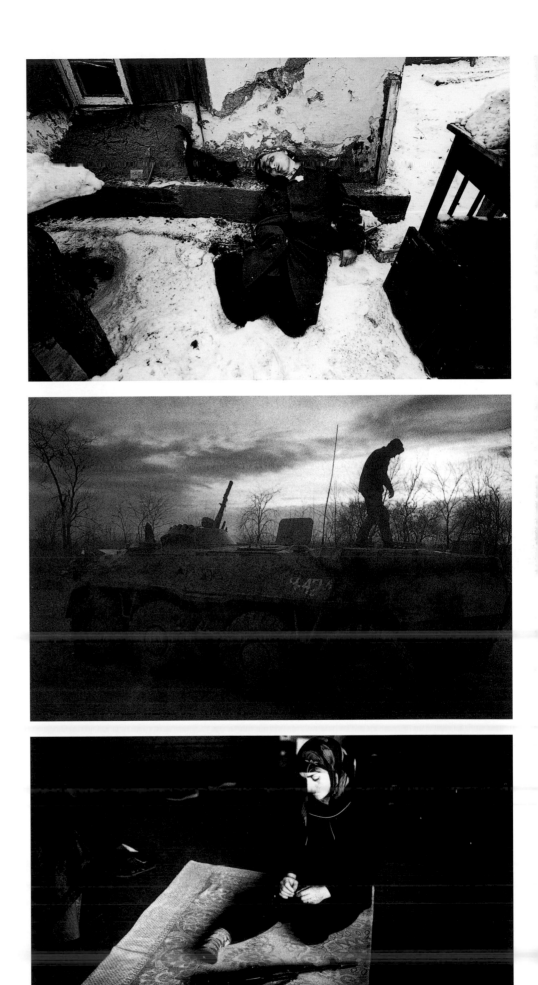

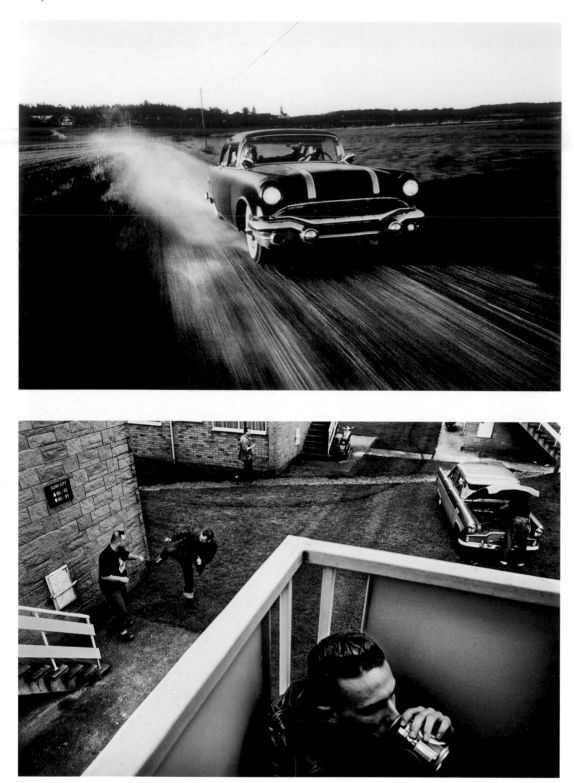

Erik Refner
Denmark, Berlingske Tidende/Rapho
2nd Prize Stories

Devotees of 1950s rock-and-roll retro gather in the English village of Hemsby for a 'Hemsby Rock 'n' Roll Weekender'. The festivals take place twice a year, in May and October, and can lay claim to being the biggest rock-and-roll lifestyle events in Europe, attracting thousands of fans from all over the world. Hemsby is chosen as a location as the village has changed little in the past 50 years. The 'Weekenders' last five days and nights and include live rockabilly music and other events that rekindle the spirit of the 1950s. This page, top: A 1950s Pontiac roars into town. Facing page, top: Two girls sit in the back of their car at a car show near Hemsby beach. Below: An Elvis clone waits in a Hemsby launderette.

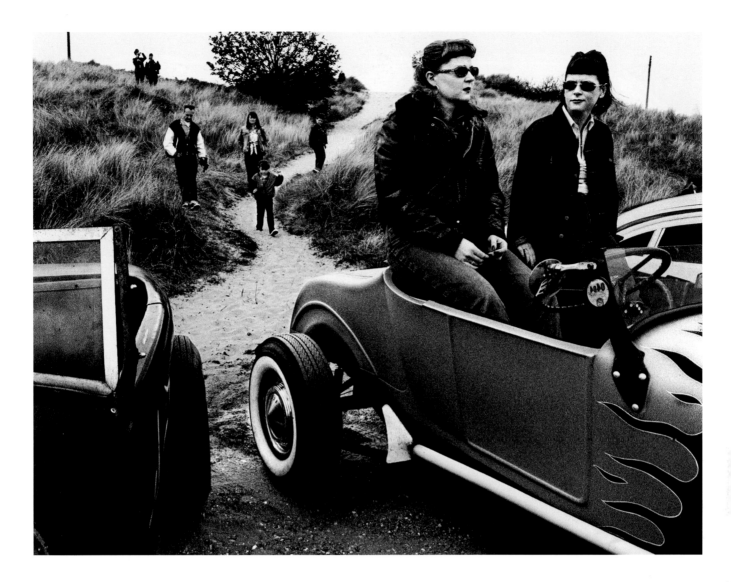

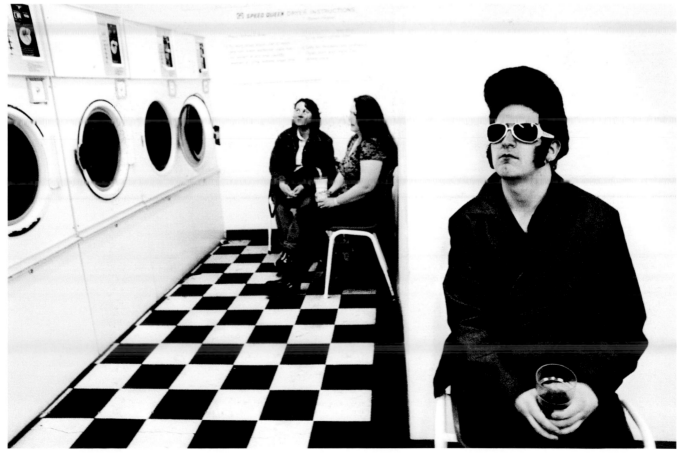

49

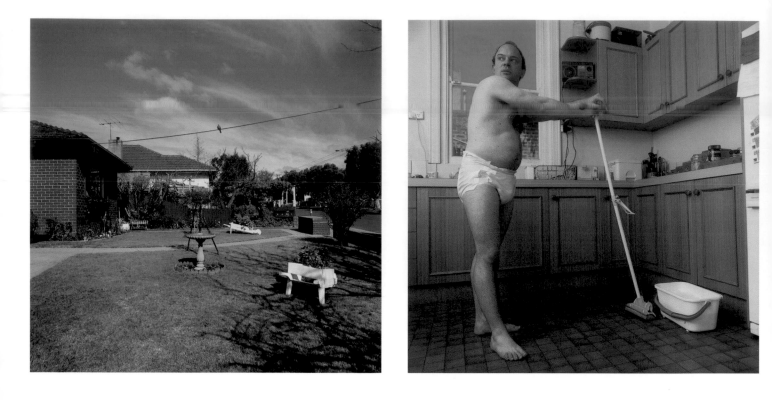

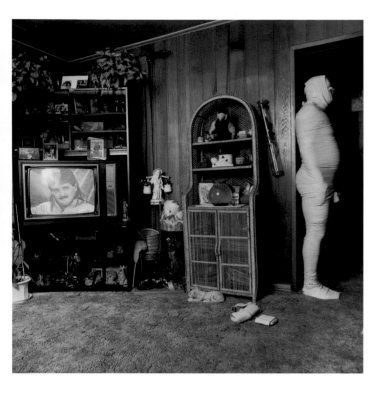

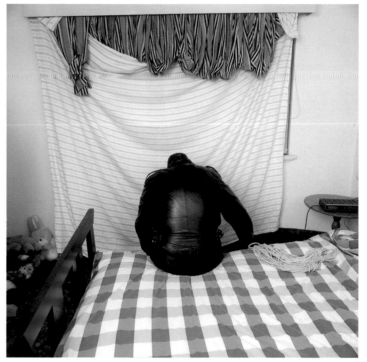

Sandy Nicholson
Australia, Redux Pictures
3rd Prize Stories

The people, activities and obsessions represented here are not part of an overt, inner-city transgressive sexual scene, but rather of a more private suburban realm, in Melbourne, Australia. Facing page, right: Jon, 30, wears diapers because he likes to feel urine against his skin. This page, left: Bob, 40, still meets his one-time partner Tiam for bondage and discipline. They learned of mummification from a magazine dedicated to the subject. Right: Ian, 38, lives in a furnished garage behind his parents' house. He is an unemployed toolsetter with a fetish for uniforms, enjoying both dominant and submissive fantasies with other male uniform fetishists.

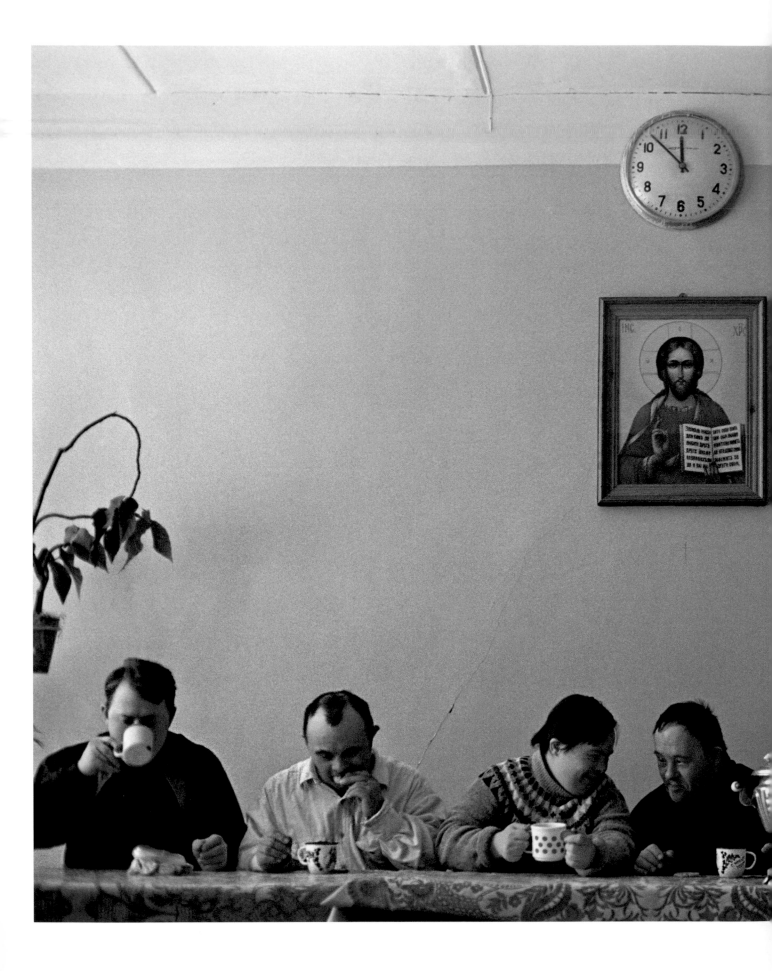

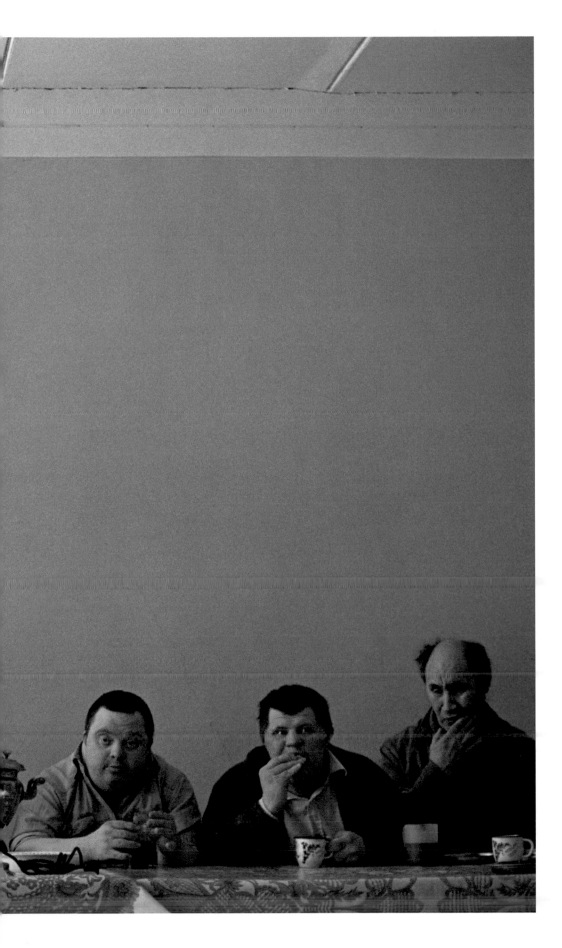

Sergey Maximishin
Russia, Izvestia
1st Prize Singles

Amateur actors of 'The Naïve Theater Company' take a break over tea at the St Petersburg Psycho-neurological Institution no. 7. Six out of seven troupe members have Down's Syndrome. The amateur company was formed as part of a program initiated by the city authorities that includes theater work and visits to the Hermitage museum. First productions were short pieces based on Japanese Kabuki theater and knockabout clowning, but the actors have progressed to a two-act play. The actors perform once a month in various facilities and institutions around St Petersburg, but aim to take their new play before a more general audience.

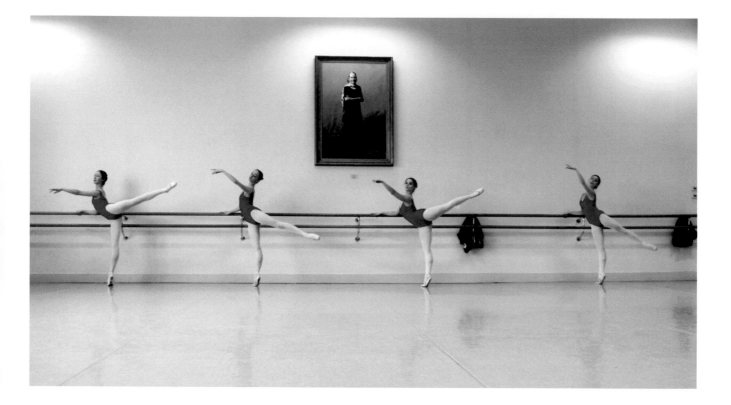

Tim Clayton
Australia, The Sydney Morning Herald
2nd Prize Singles

Ballerinas of the Australian Ballet
School exercise at the barre. The
school shares premises in Melbourne
with the Australian Ballet Company,
so aspiring dancers can witness first-
hand the work of professionals as
they prepare for a production.

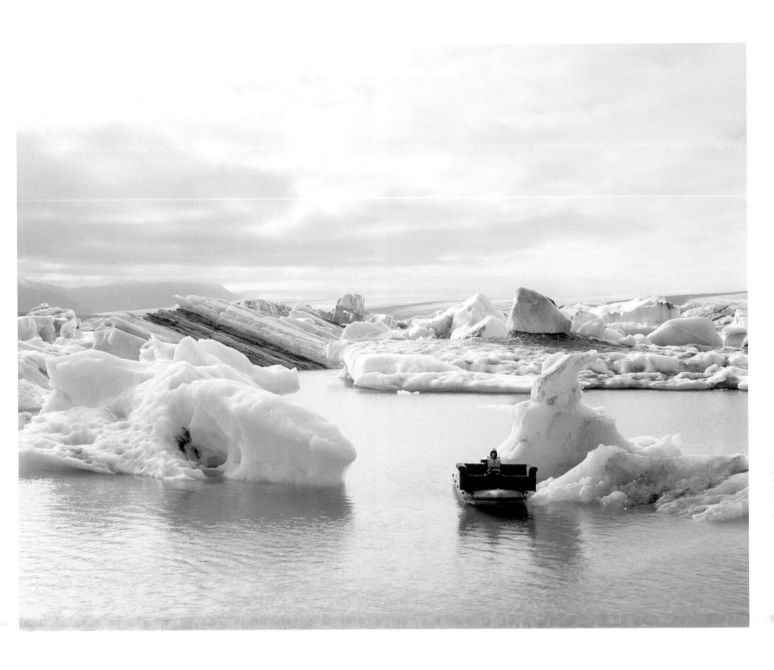

Horst Wackerbarth
Germany, for Geo
3rd Prize Singles

The red couch occupied by tour-leader
Klara Sigurdadottir, on an ice floe in
Jökulsárlón, Iceland, is the centerpiece
and common denominator in a series
of photographs that aims to include
locations on all five continents and
people from all races, creeds and
classes.

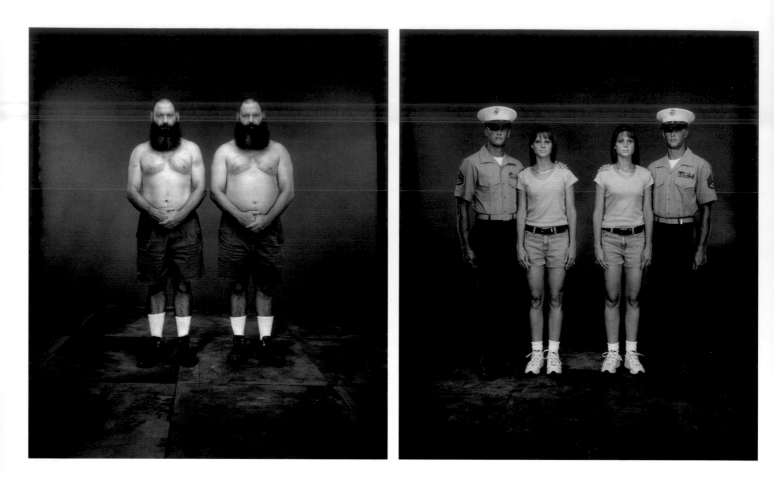

Mary Ellen Mark
USA
1st Prize Stories

The Twins Days Festival in Twinsburg, Ohio is an annual gathering of several thousand sets of twins, in a small town just south of Cleveland. Each year, on the first weekend in August, twins from all over the world gather to socialize and enjoy entertainment including parades, concerts, contests and talent shows. This page, left: Don and Dave Wolf, 44 years old, Dave older by six minutes. Right: Roy and Amanda Tesmer and Rhianna and Troy Tesmer; Amanda and Rhianna, 24 years old, Rhianna older by five minutes; Roy and Troy, 29 years old, Troy older by one minute. Facing page: Caylee and Mylee Simmermon, 10 years old, Mylee older by two minutes. (story continues)

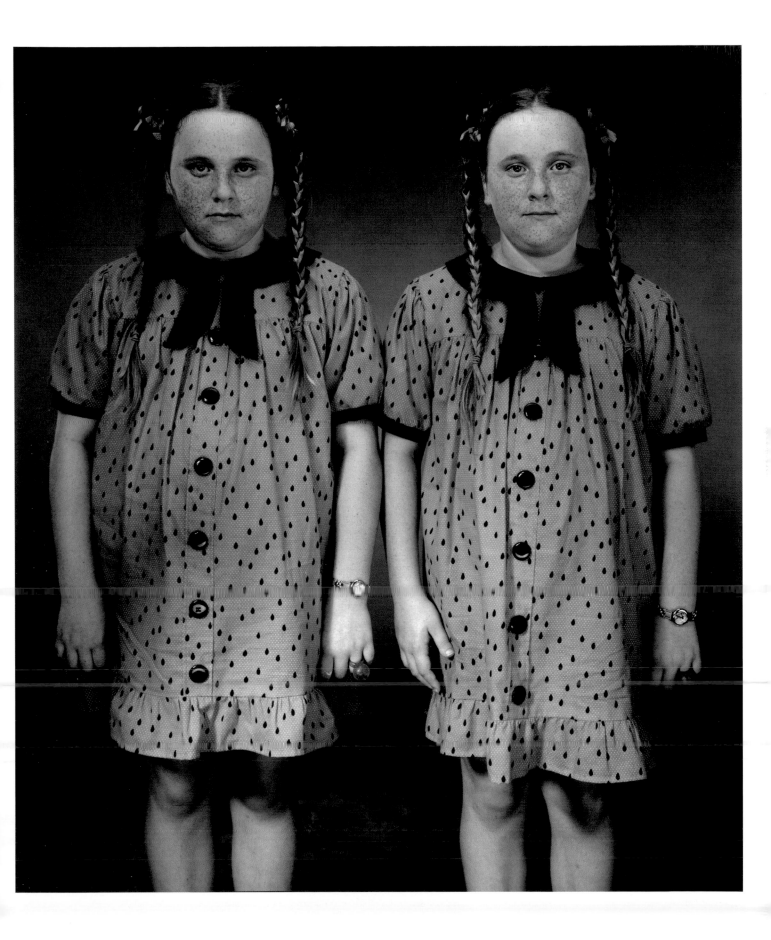

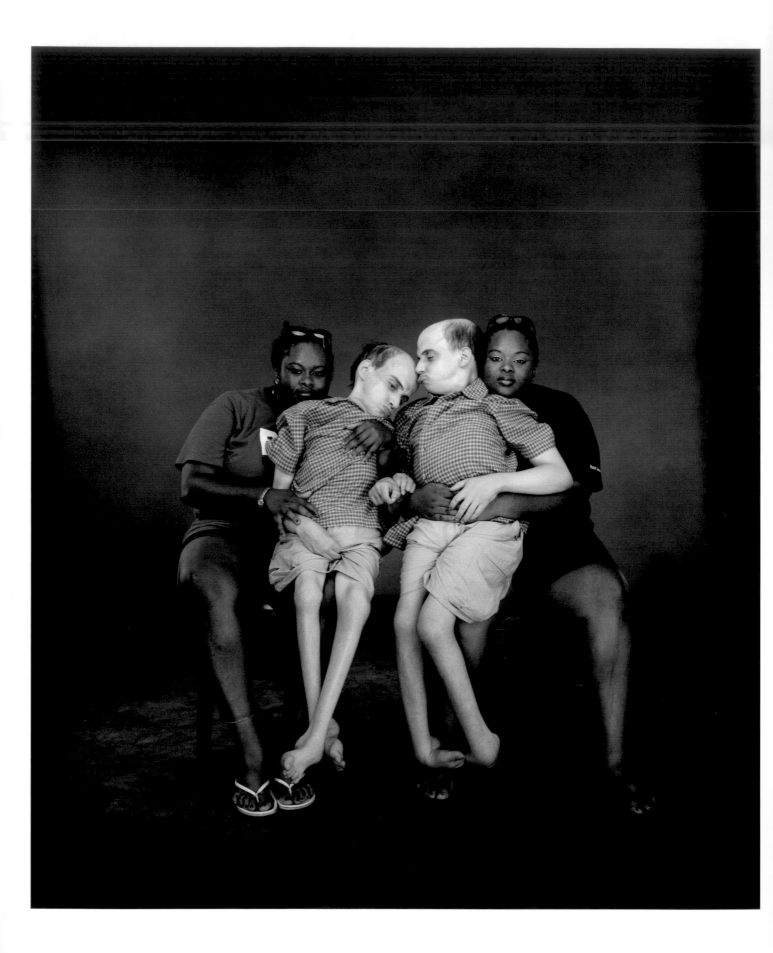

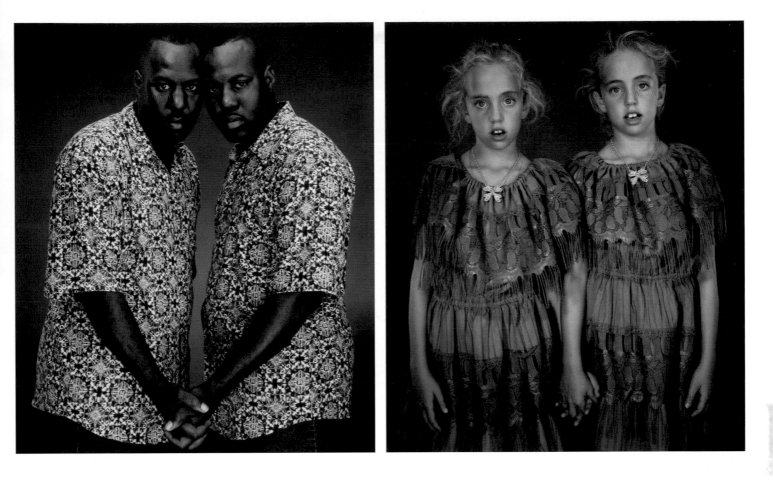

(continued) The first Twins Days Festival was held in 1976, with an attendance of just 37 sets of twins. In 1980, the governor of Ohio designated the first weekend in August as Twins Day throughout the state. Facing page: Bruce and Brian Kuzak, 40 years old, Brian older by eight minutes, with their nurses Teresa and Tillie Merriweather, 20 years old, Tillie older by one minute. This page, left: Shane and Shawn Riggins, 29 years old, Shane older by three minutes. Right: Heather and Kelsey Dietrick, 7 years old, Kelsey older by 66 minutes.

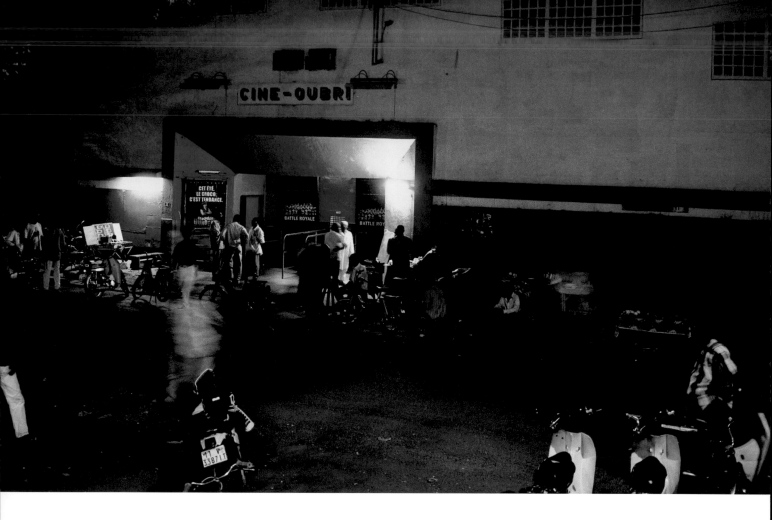

Stephan Zaubitzer
France
2nd Prize Stories

Open-air cinemas in Ouagadougou, capital of Burkina, are a heritage of a once-flourishing film culture. The ten cinemas, all built to the same model but in different parts of the city, are venues for FESPAC, a pan-African festival of arts and film. But the advent of 'Videodromes', halls equipped with DVD players and televisions screening American action movies, are posing a threat to the open-air cinemas. The cinemas are not economically viable, and are too expensive for the Burkina state to maintain, so the World Bank is pressurizing for their privatization. This page: Customers gather outside Ciné-Oubri, in central Ouagadougou, which is the main venue during FESPAC and can seat several hundred people. Facing page, top: A screening gets underway at Ciné-Oubri. Below, left: Etienne, the cashier at Ciné-Oubri, mans the box office. Right: Two boys take an illicit peek through a crack in the door of a suburban cinema.

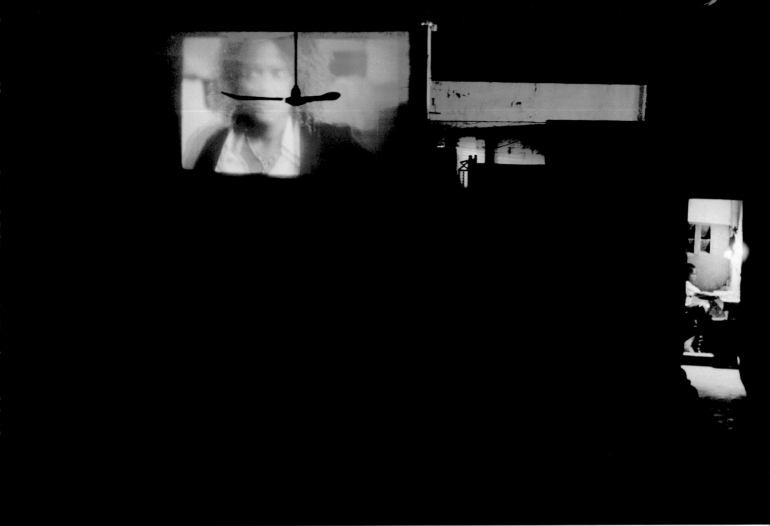

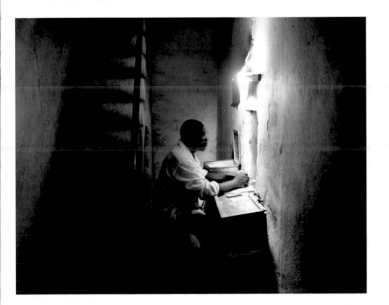

Raúl Belinchón
Spain
3rd Prize Stories

Metro stations in London, Paris,
Madrid and Lisbon.

Nature

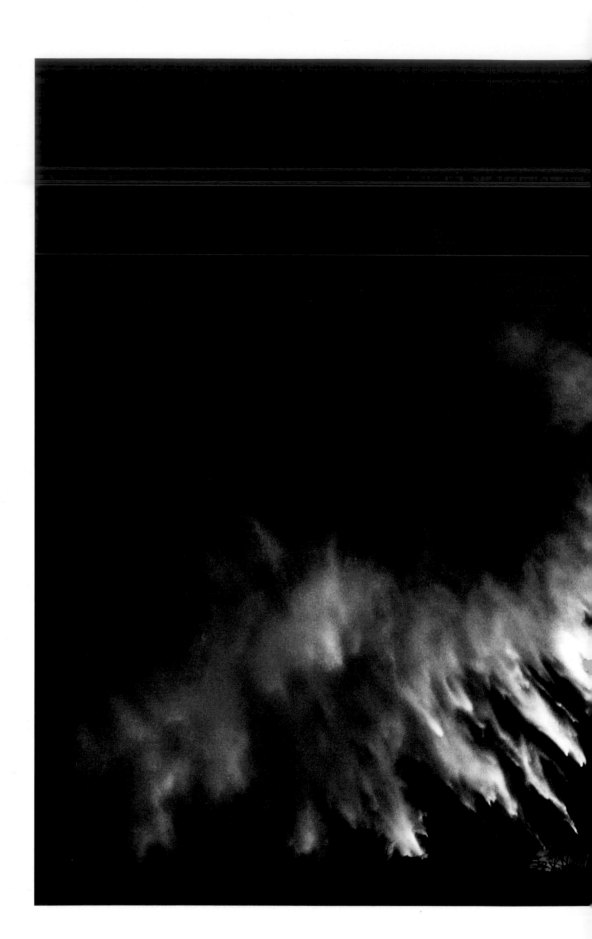

Mark Zaleski
USA, The Press-Enterprise
1st Prize Singles

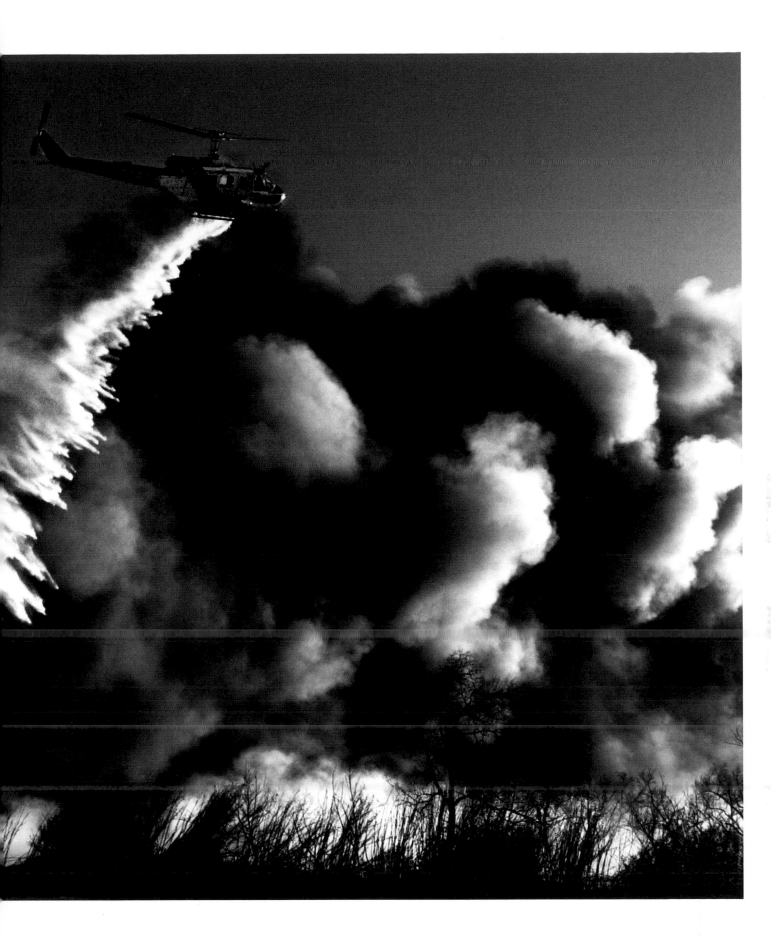

A California Department of Forestry helicopter drops water on a raging brushfire near Goose Creek Golf Club in Riverside County, Southern California in January. Over 1,000 acres were burned. A number of homes were threatened, but none was destroyed and no lives were lost. Dry conditions and high winds in the state led to major wildfires later in the year, when thousands of acres were scorched, homes were destroyed, and President Bush declared parts of Southern California a disaster area.

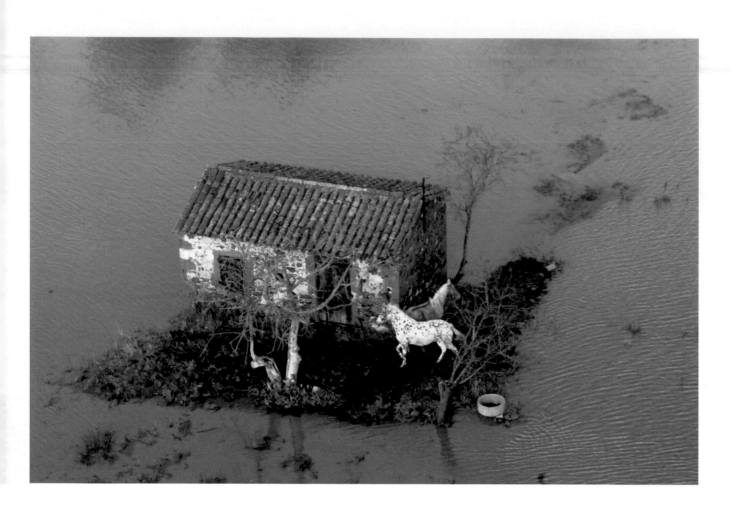

Gérard Julien
France, Agence France-Presse
2nd Prize Singles

Two horses take refugee on higher
ground around a farm cottage, after
heavy flooding near the town of
Agde in southern France in
December. More than 27,000 people
were evacuated in the region after a
week of torrential rains, and floods
that claimed at least six lives. The
hardest hit regions were those of the
Gard, around the city of Nîmes, and
the Hérault around Montpellier.

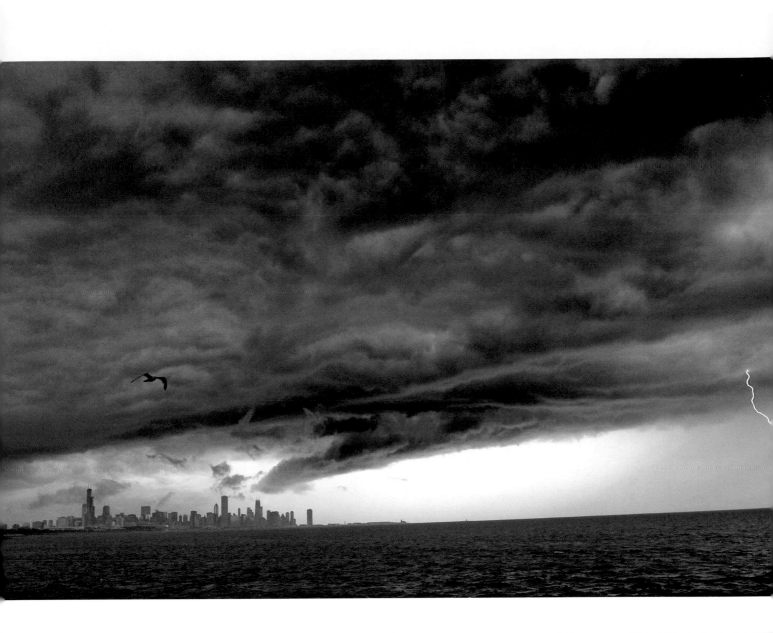

Jon Lowenstein
USA, Aurora Photos
3rd Prize Singles

Clouds gather over Lake Michigan
and the city of Chicago before a
summer thunderstorm.

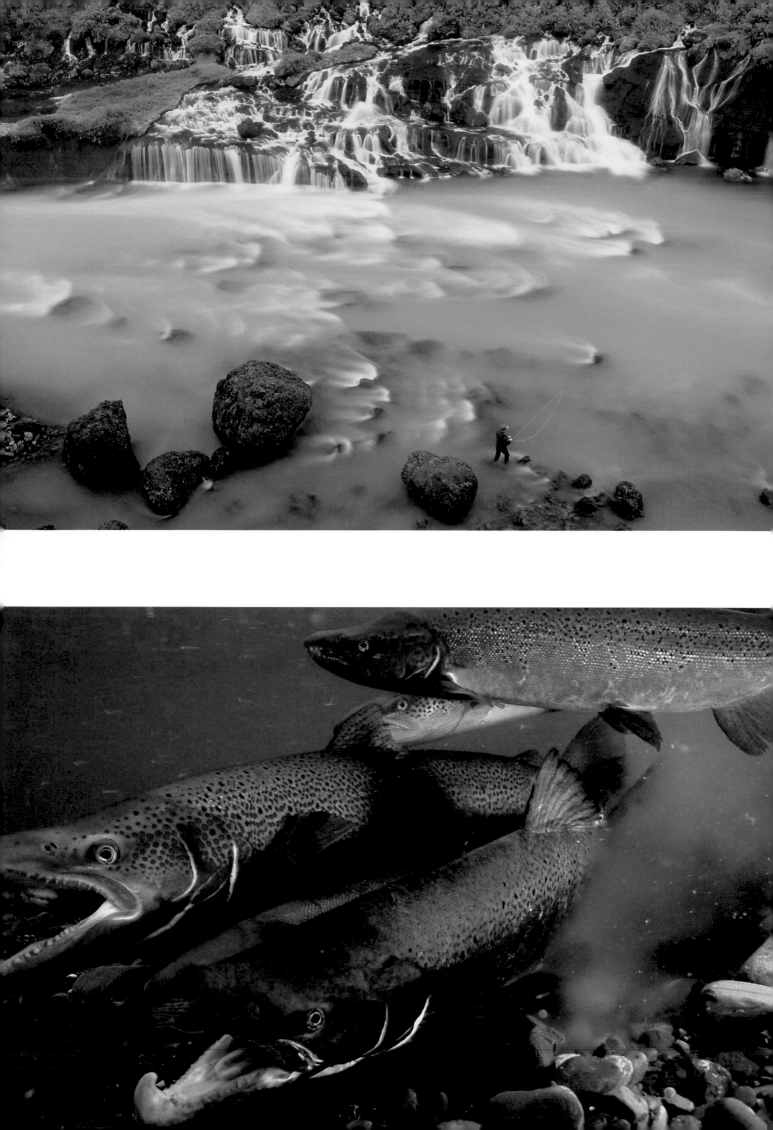

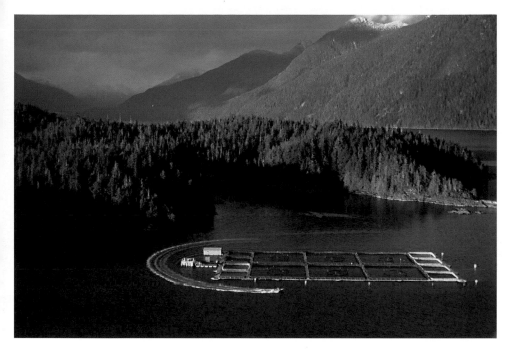

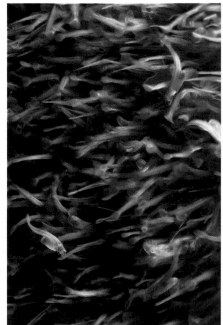

Paul Nicklen
Canada, for National Geographic Magazine
1st Prize Stories

As wild Atlantic salmon populations falter, salmon farming is on the increase globally, with over 274 million farmed fish present in the world's waters. Pound for pound, more pesticides and antibiotics are used in this than in any other livestock industry, having an impact on both human health and the environment. The waste from a large farm can be equivalent to a town of 50,000 people dumping sewage directly into the sea. Diseases and sea lice transfer quickly between fish packed tightly in pens, and many farmed salmon escape into the wild, spreading infection. It is estimated that over 500,000 farmed salmon escape each year in Norway alone. They breed in the wild, ultimately lowering the gene pool of wild salmon. In the US, Atlantic salmon is listed as critically endangered. Facing page, top: A fisherman tries his luck on the Hvita River in Iceland. The country boasts some of the cleanest and healthiest salmon rivers in the world. Below: During spawning, a female releases eggs into her redd (nest) while the male simultaneously fertilizes them. This page, left: Over a million salmon live in this fish farm in British Columbia. Right: Thousands of freshly hatched alevins (salmon fry) form a ball with their tails outwards for safety. Following pages: Martin Fadian, a 72-year-old fisherman from Ireland, pulls up his draft net with only one fish to show for two days' work.

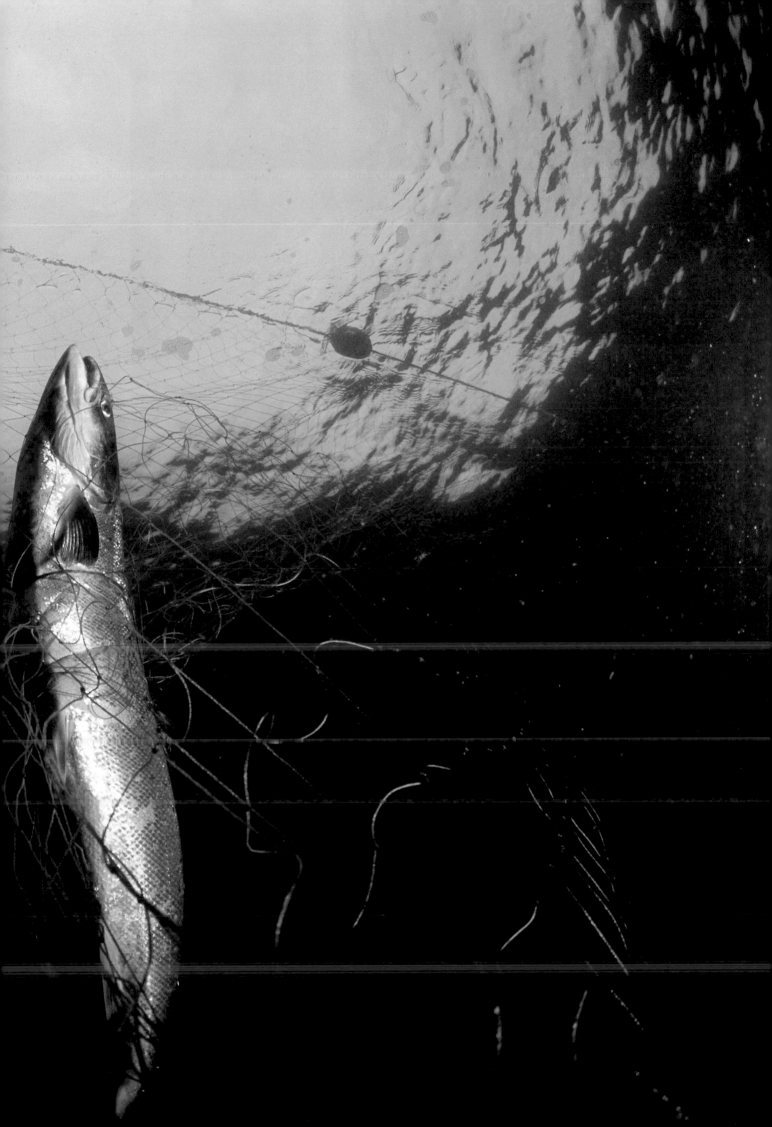

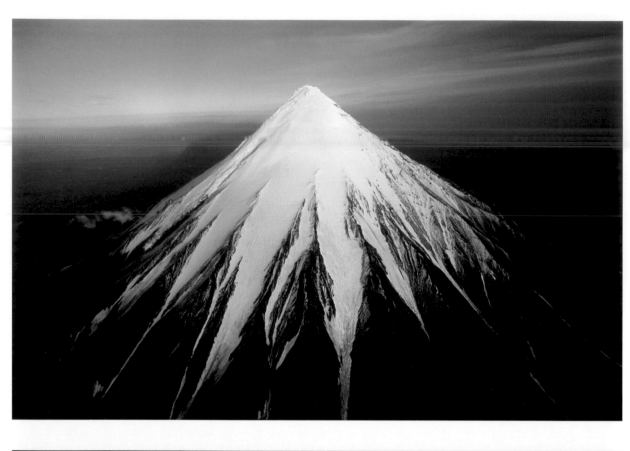

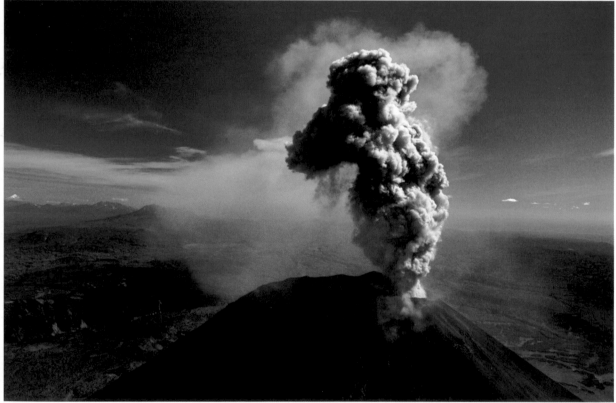

Olivier Grunewald
France, for Figaro Magazine/Grands
Reportages
2nd Prize Stories

The Kamchatka peninsula in eastern Russia presents a landscape of geysers, boiling lakes and active volcanoes. Facing page, top: The symmetrical Mount Kronotskiy is perhaps the most beautiful of the 200 volcanoes on the peninsula. Below: Since Mount Karimsky's last eruption in 1996, it has regularly spouted plumes of ash up to five kilometers high. It is one of the most active volcanoes in the area. This page, top: Mount Tolbachik's 1975 eruption lasted a year and a half, sending fountains of lava over two kilometers into the air, and emitting clouds of ash and toxic substances that asphyxiated and bleached surrounding forests. Below: Rising sulfuric gases explode in bubbles on the surface of the Uzon caldera, a volcano in its death throes.

Tanya Lake
Australia
3rd Prize Stories

The beaches and waterways around
Sydney provide a playground for the
city's residents. This page: A woman
takes an early-morning dip on
Newport Beach. Facing page, top:
The town lights up in the evening at
Marouba Beach. Middle: A dolphin
documentary airs on television, as
the sun sets over the sea. Below: A
girl somersaults under a wave at
Newport Beach.

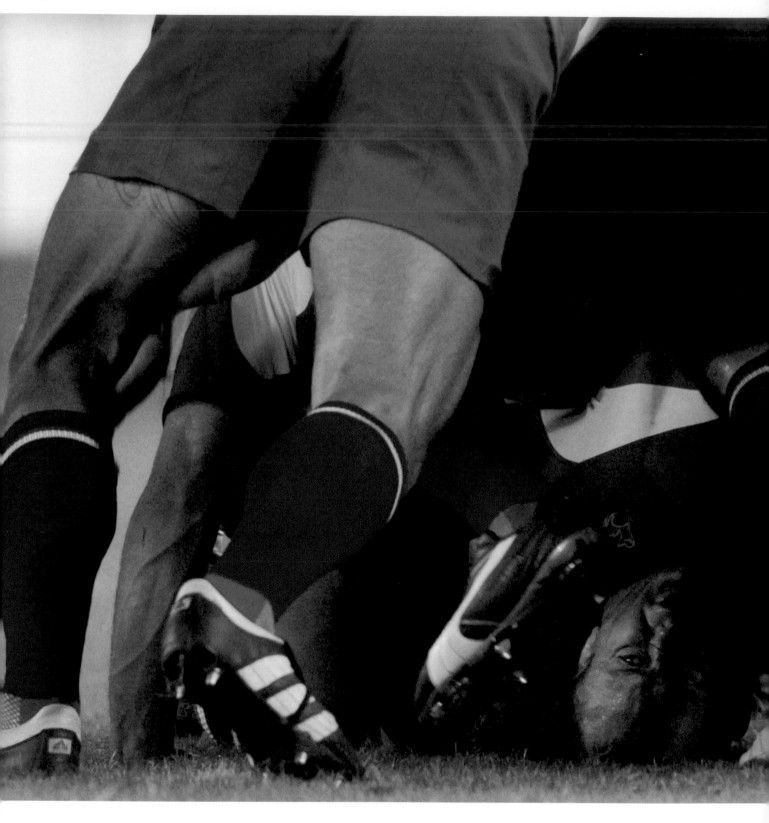

Tim Clayton
Australia,
The Sydney Morning Herald
1st Prize Singles

The head of French captain Yannick Bru peers out of the scrum during the third-place play-off match against New Zealand during the Rugby World Cup in Sydney, Australia in November. New Zealand won the match 40-13.

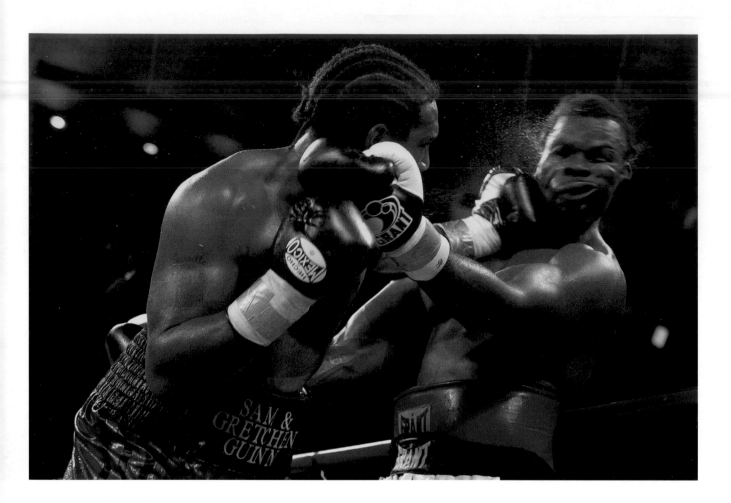

Al Bello
USA, Getty Images
2nd Prize Singles

Undefeated newcomer Dominick
Guinn knocks out former
heavyweight contender Michael
Grant in the seventh round of a fight
in Atlantic City, USA in June.

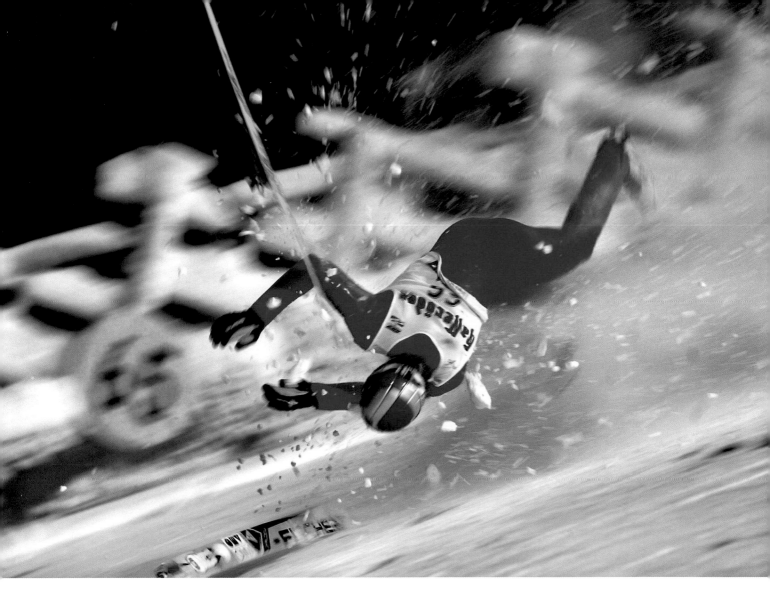

Alexander Hassenstein
Germany, Bongarts Sportfoto
3rd Prize Singles

Thomas Morgenstern takes a dive
at the Ski-jumping World Cup in
Kuusamo, Finland in December. The
17 year old Austrian sports star
escaped with relatively minor
injuries.

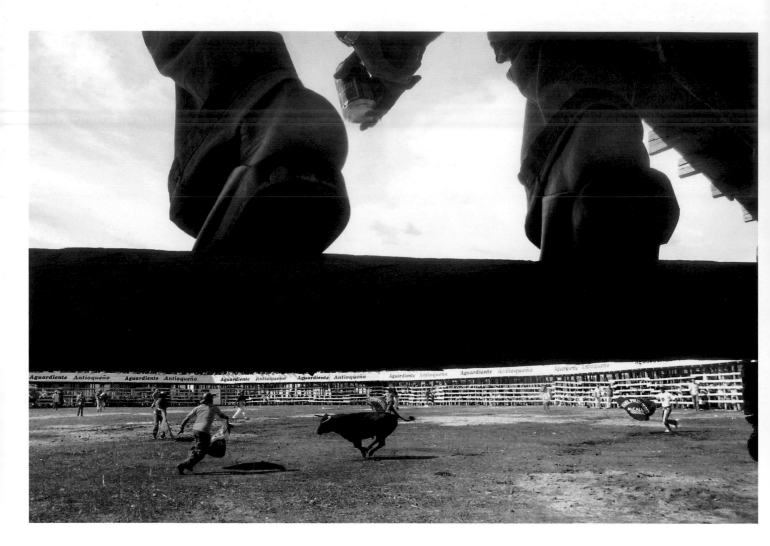

Henry Agudelo & Jaime Pérez
Colombia, El Colombiano
1st Prize Stories

La corraleja, a version of traditional Spanish bullfighting, is extremely popular along the Atlantic coast of Columbia. The tradition goes back some 200 years. Bullfighting fiestas go on for up to seven days, with animals that can weigh over 500 kilograms. Contests last from late afternoon through to the early evening, and are divided into sessions of five to 30 minutes. Teams of three to five men, either on foot or mounted on horseback, attempt to exhaust the bulls, using *banderillas* (spiked sticks) bearing the team colors. Each team represents a region, village, or part of a town, and the members are local sports heroes. Some team members specialize in acrobatics, which adds to the spectacle. The session ends when the bulls are exhausted, which is decided by a referee who also tots up the number of *banderillas* remaining in the bull to allot each team a score. Bulls are then allowed out of the ring, to return to fight the following day. At the end of the fiesta, cumulative team scores are tallied, and the winners go home with prize money that can amount to between US$ 1,000 and US$ 2,000. A trophy is also awarded to the owner of the bull that has proved most difficult to beat.

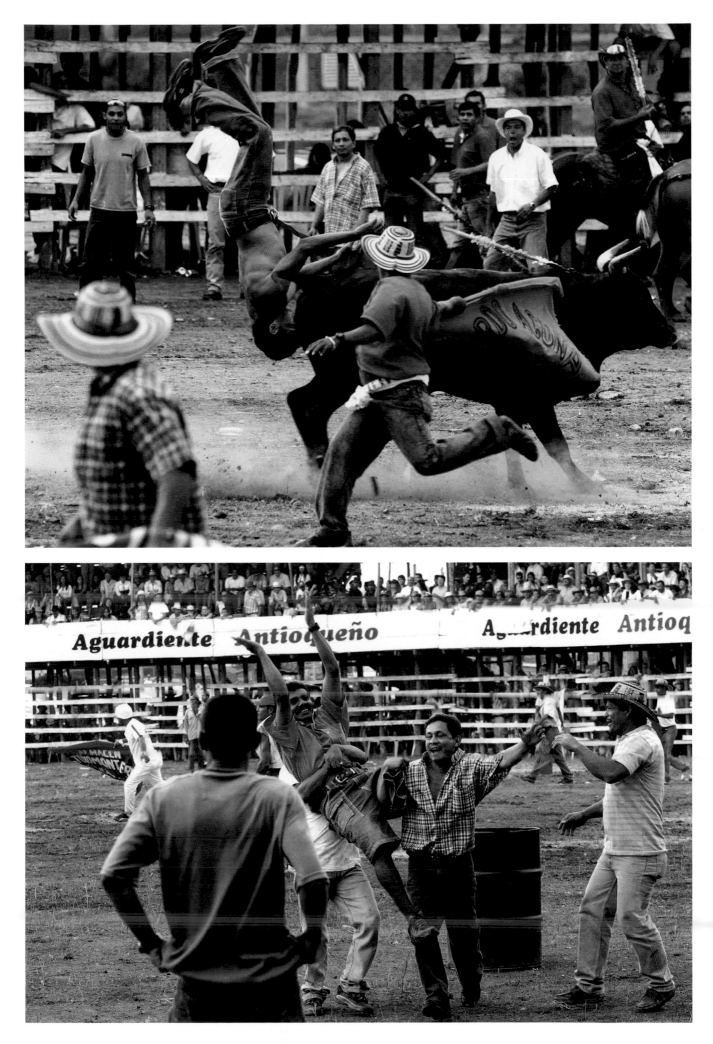

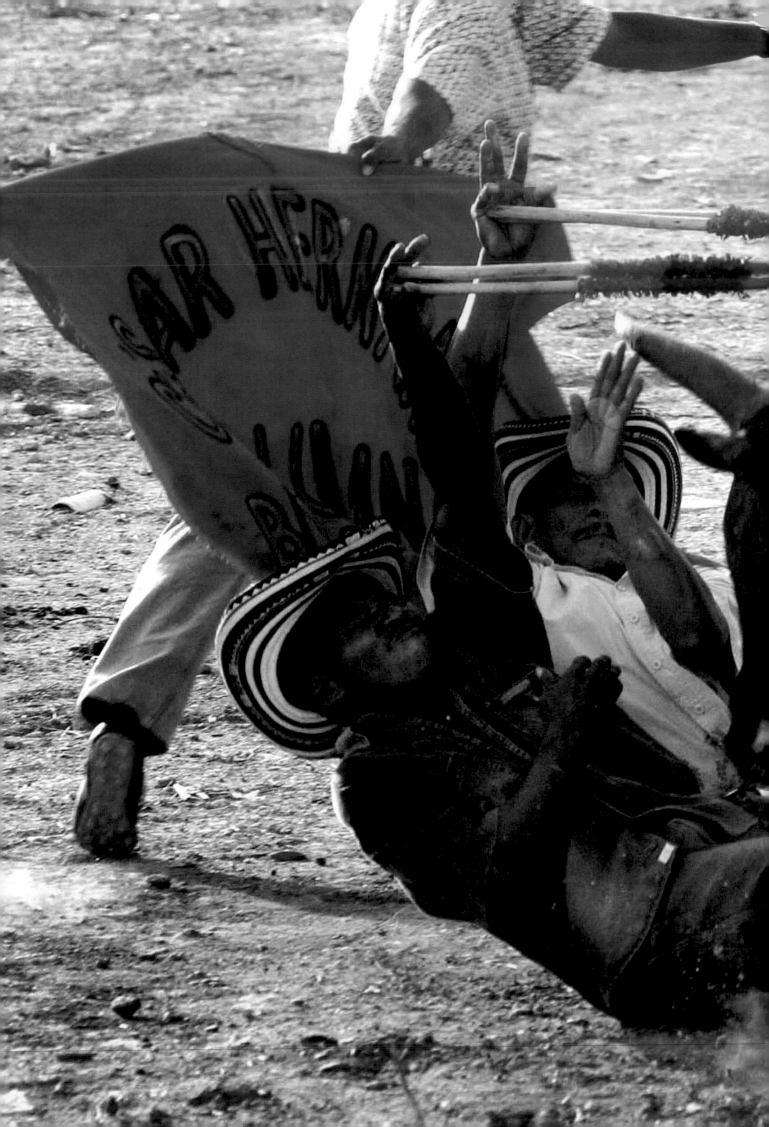

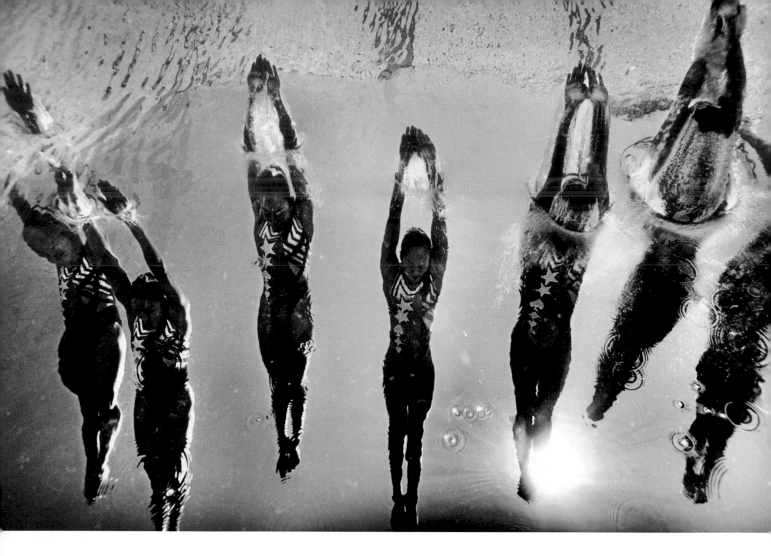

Adam Pretty
Australia, Getty Images
2nd Prize Stories

This page: The Japanese team trains
before the team technical routine for
synchronized swimming during the
World Swimming Championships in
Barcelona in July. Facing page, top:
Mark Philippoussis of Australia
celebrates after defeating Juan Carlos
Ferrero of Spain in the Davis Cup final
in Melbourne in November. Middle:
The Men's Bondi Beach surfboat A-
crew smash through the spray after
hitting a wave as they row out to sea,
in Sydney. Below: South Australia
men's pursuit team in action during
the National Track Championships in
Sydney in May.

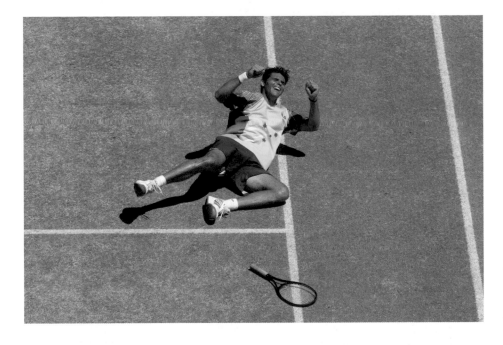

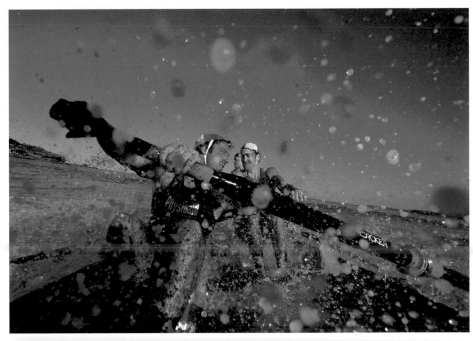

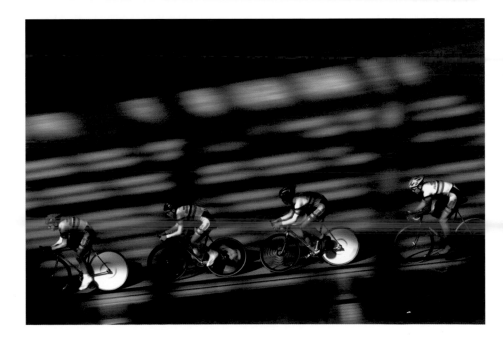

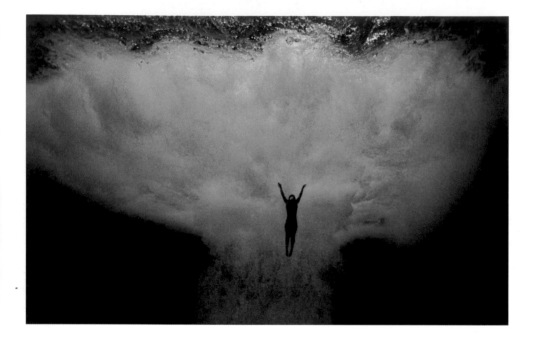

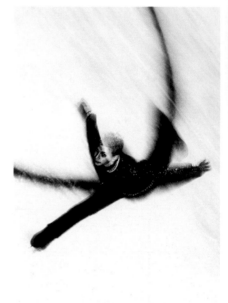

Craig Golding
Australia,
The Sydney Morning Herald
3rd Prize Stories

This page, left: Australian diver Loudy Tourkey practices at the Sydney Aquatic Centre. Right: Nicholas Fernandez trains for the New South Wales Ice-skating Championships at the Penrith Ice Palace. Facing page, top: Competitors head towards the finish line during the Sydney Morning Herald half-marathon, in May. Below: At Australia's National Lifesaving Championships, competitors in the men's double ski race make their way through the breakers.

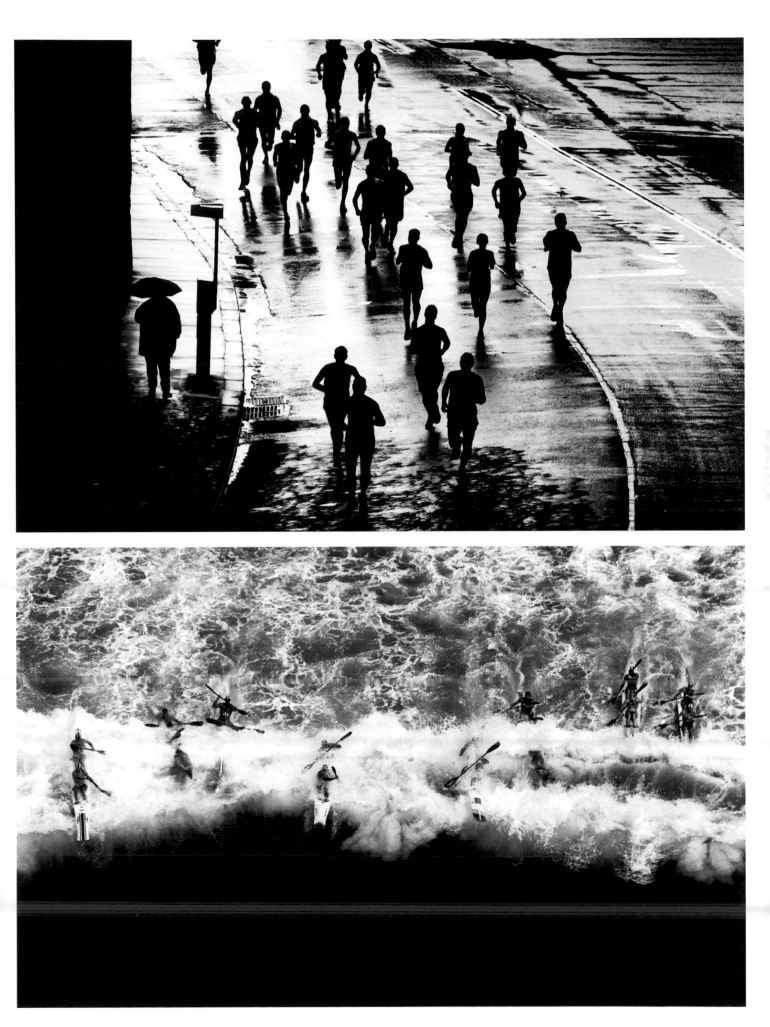

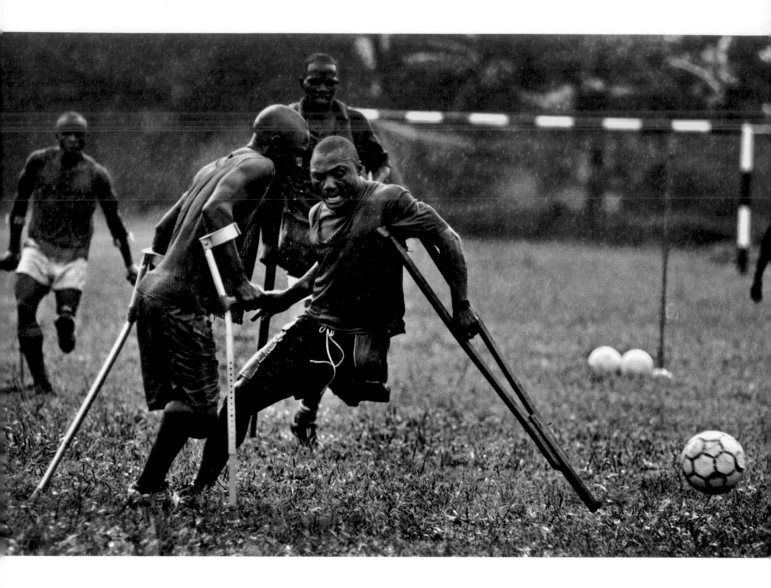

Adam Nadel
USA, Polaris Images for
The Christian Science Monitor
1st Prize Singles

Captain of the Sierra Leone national amputee soccer team, M'byo Conteh, practices with fellow teammates in Freetown, during a training camp prior to a tour of the United Kingdom in August. The club was founded in 2001 by men who had lost their limbs in Sierra Leone's decade-long civil war. Players come from the country's lowest socio-economic level and have little opportunity for employment. Part of the aim of the tour was to draw attention to the plight of amputees in Sierra Leone. The Sierra Leoneans failed to defeat the UK's national amputee team.

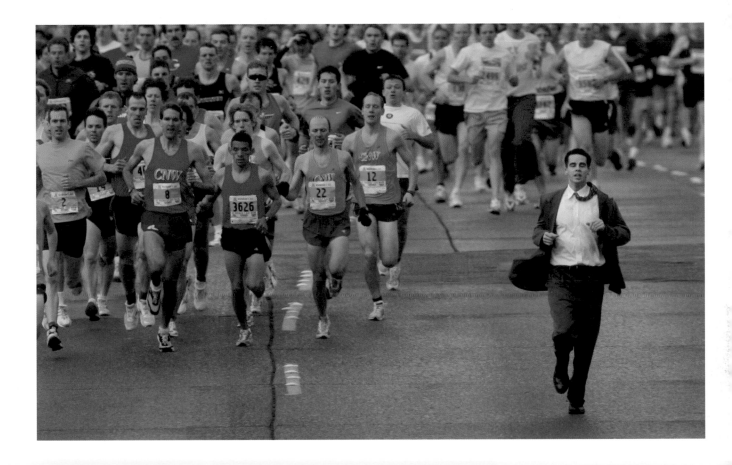

Tom Reese
USA, The Seattle Times
2nd Prize Singles

A business-suited runner joins the start of the 19th annual St Patrick's Day Dash in Seattle. Over 10,500 runners and walkers participated in the 5.6-kilometer event, which was won by a Canadian, Mark Bomba, in 16 minutes 52 seconds. First woman home was fellow Canadian Leah Pells.

Vladimir Vyatkin
Russia, Ria-Novosti
3rd Prize Singles

Russian sportswomen go through
their routine at the synchronized
swimming school of the Moscow
State Institute of Physical Culture.
Russia is a leader in international
competitions in the field. Initially a
male sport, synchronized swimming
is now practiced largely by women,
and was first admitted to the
Olympic Games as a full-medal sport
in 1984.

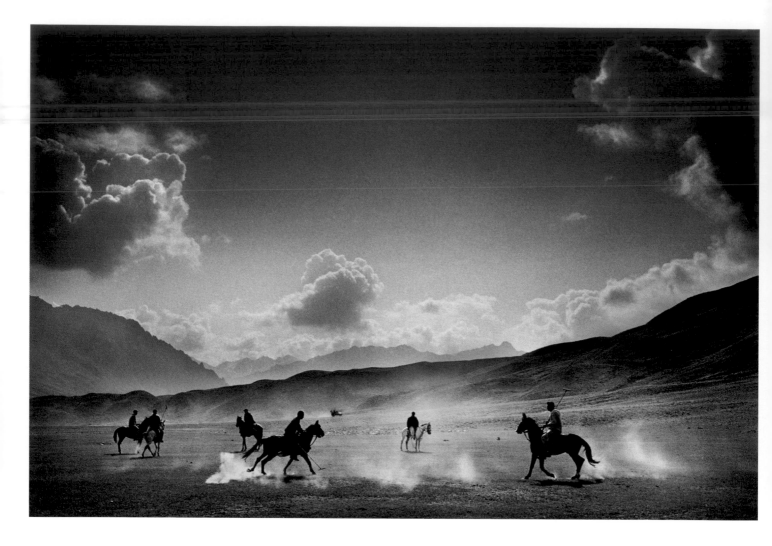

Jakob Carlsen
Denmark
1st Prize Stories

Every year a polo tournament high on the Shandur Pass in the Pakistani Himalayas attracts thousands of spectators. The pass is some 3,900 meters above sea level and a nine-hour jeep ride from the nearest town. The opposing teams come from two villages on either side of the pass. This page: Players ride out on to the plain at the top of the pass for morning practice. Facing page: A horse that has died of a heart attack caused by exertion at such a high altitude is dragged off the field by spectators. It had been out of breath earlier in the match, but was forced back into the game by its rider. (story continues)

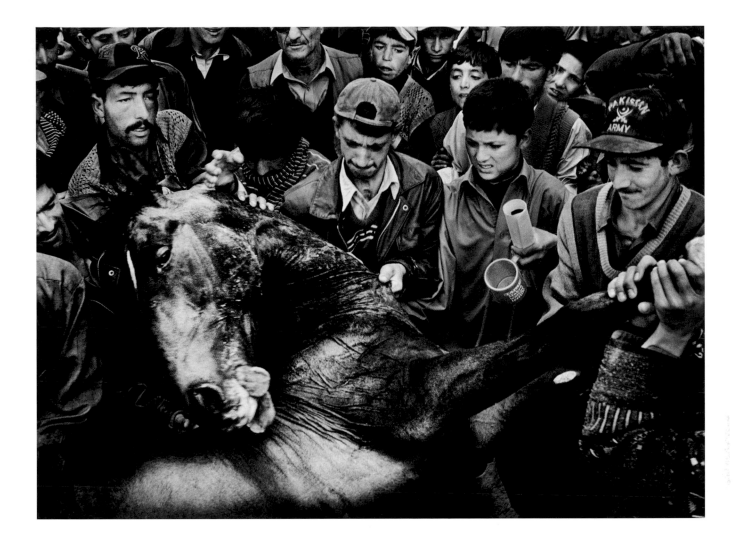

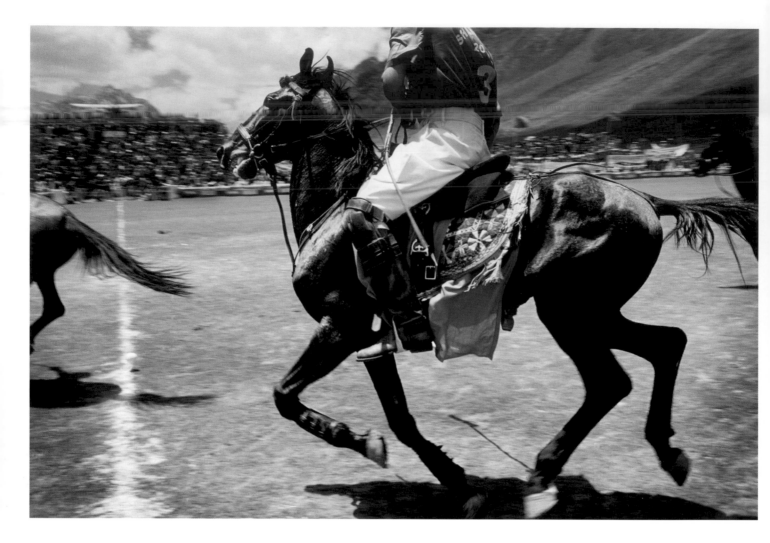

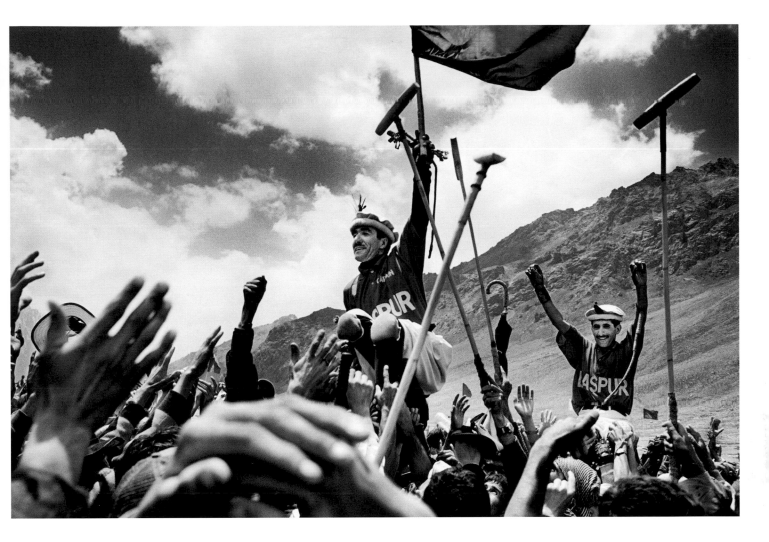

(continued) Four matches are played
over three days, with the crowds of
spectators who come for the event
transforming the plateau into a busy
tent village. It is a great honor to win
the tournament, and victorious
players are held in high regard. This
page: Members of the winning team
are lauded by the crowd.

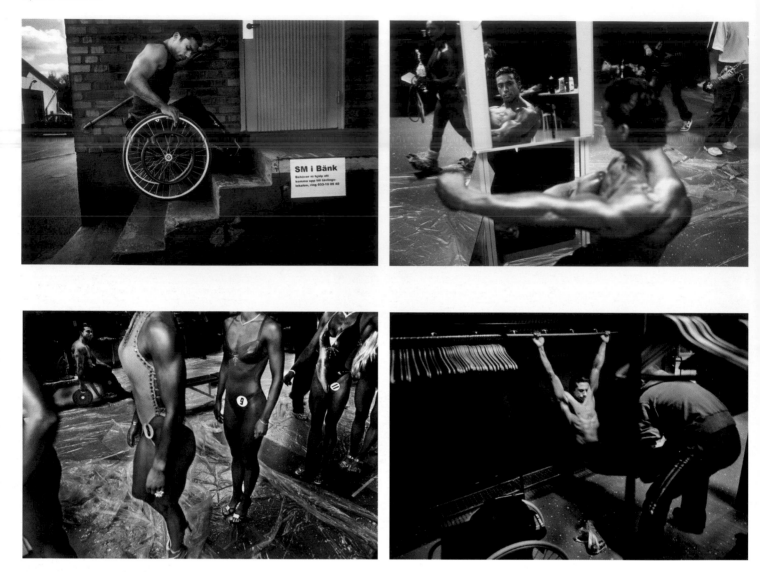

Jonas Lindkvist
Sweden, Dagens Nyheter
2nd Prize Stories

Antoni Khadroui has won medals in both weightlifting and bodybuilding in Sweden and internationally. He suffered an accident that paralyzed his lower body while in the Algerian army. Later, having moved to Europe, he took up weightlifting to take his mind off the violence of the war in Algeria. He won a silver medal in the first major contest he entered, and has since taken numerous trophies, competing in categories not only specifically for people with disabilities, but also against able-bodied contestants. He has met some resistance from sports authorities in his insistence on breaking down barriers regarding disability within sport. This page, clockwise from top left: Khadroui struggles up the stairs to get into the Swedish weightlifting championship in Borås. He practices poses before going on stage for a bodybuilding championship. Khadroui warms up before the Swedish bodybuilding championship in Västerås. He waits to go on stage in Västerås. Facing page: Onstage in Västerås.

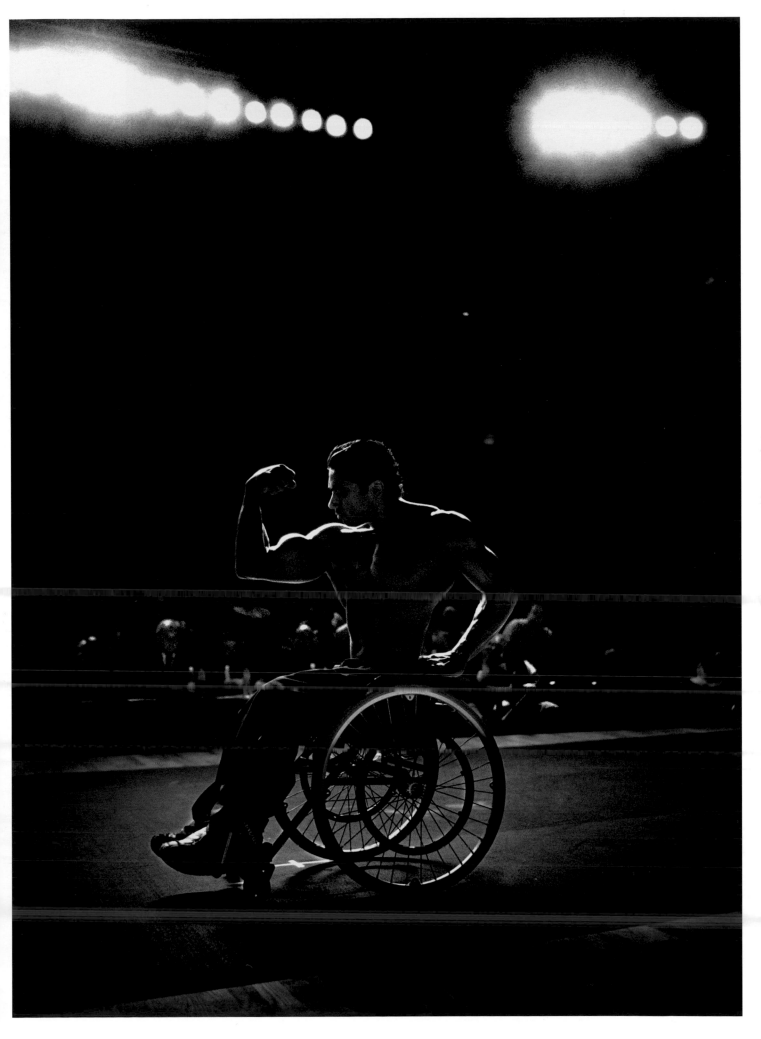

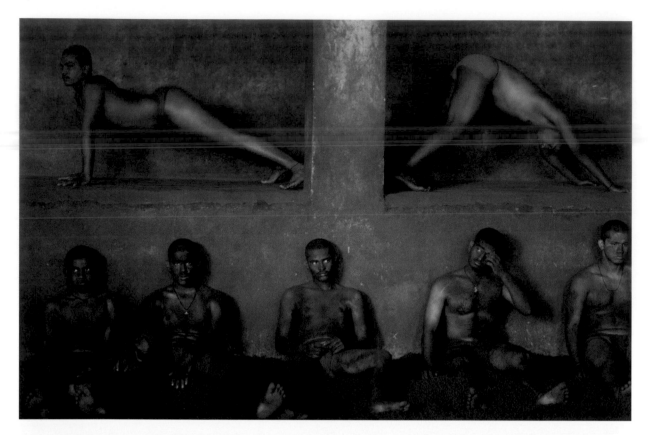

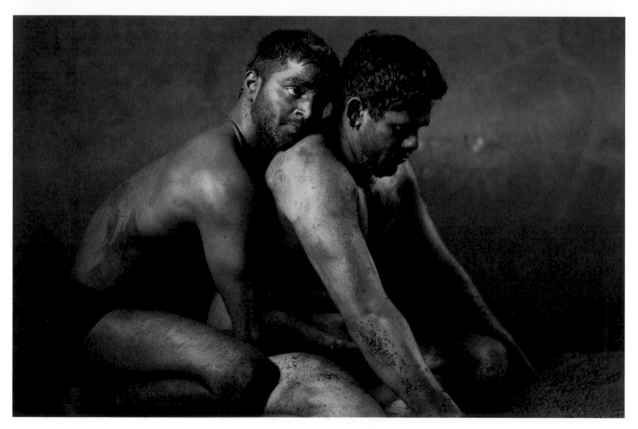

Jan Sibík
Czech Republic, Reflex Magazine
3rd Prize Stories

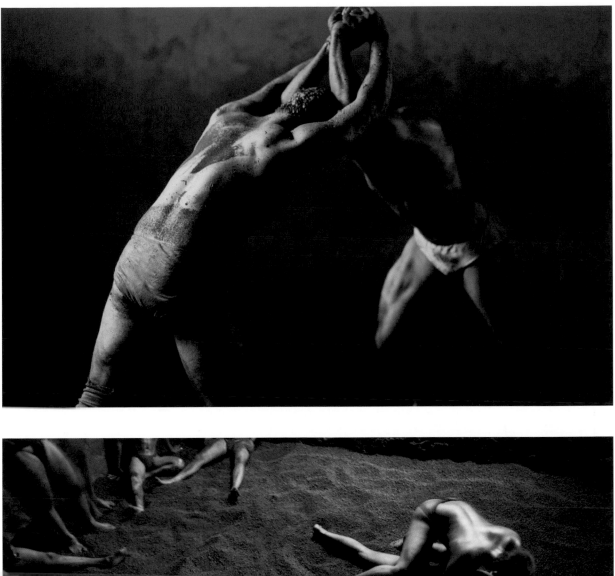

Kusti, a form of traditional Indian wrestling, takes place in an arena covered with red clay dust. After exercising, wrestlers rub their bodies with the dust to dry perspiration and prevent the body from cooling too quickly and causing illness. The earth is also thought to have curative properties. The town of Kolhapur is the center of kusti in India, attracting young men from all over the country. Wrestlers train twice a day and live, eat and sleep together in a small room near the arena. Facing page, top: Fighters rest along the edge of the arena, known as the *akhada*. Gymnastic and aerobic exercises form part of the training. This page, top: Wrestlers practice grips during afternoon training. Below: Two trainees engage in a match.

Portraits

Nick Danziger
UK, Contact Press Images/NB Pictures
for The Times Saturday Magazine
1st Prize Singles

US president George W. Bush and
British premier Tony Blair make eye
contact in one of the few moments
they did not have aides at their sides,
in Hillsborough Castle, Northern
Ireland, on April 8, a day before
American troops entered Baghdad.
The coalition that conducted the air
and land attack on Iraq the previous
month comprised almost entirely
British and American forces. Britain's
support for the American-led
operation had caused a rift with other
European Union countries, most
notably Germany and France.

Mike Moore
UK, Daily Mirror
2nd Prize Singles

Italian soccer referee Pierluigi Collina, who officiated at the 2002 World Cup final between Germany and Brazil, and had already four times been voted 'Referee of the Year' by FIFA international football association, announced that he would be stepping down in 2005. He will be 45, the mandatory retirement age for referees. He expressed his reluctance to go, but noted that people in his profession had to be bound by the rules. Collina is popular off the pitch, too, and has appeared in advertising, on the fashion catwalk and in several television shows.

Charles Ommanney
USA, Contact Press Images for
Newsweek
3rd Prize Singles

Former first lady Barbara Bush poses
at Walkers Point, the Bush's home in
Kennebunkport, Maine, while
President George Bush senior peers in
through the window to inquire why
lunch is late.

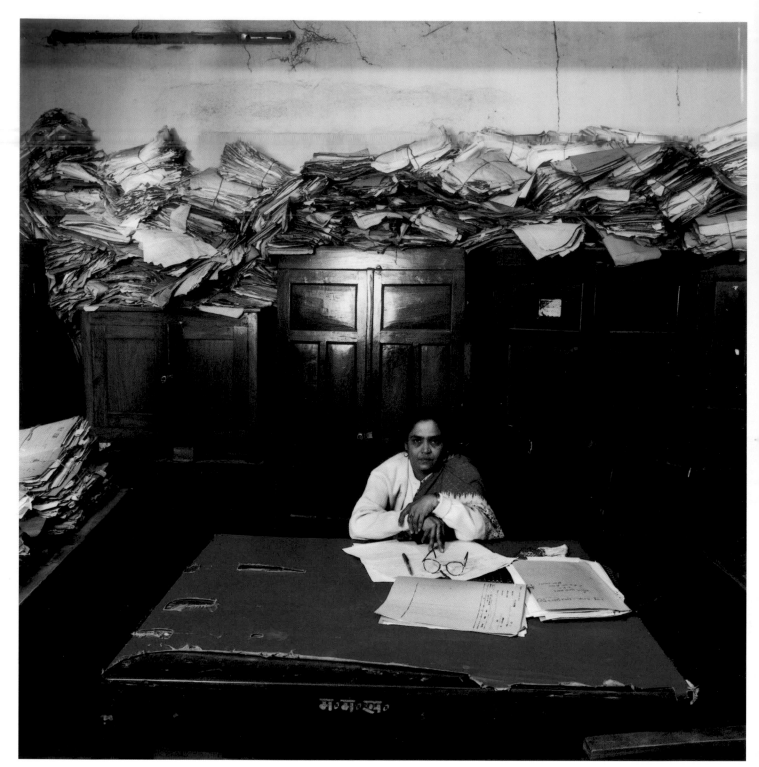

Jan Banning
The Netherlands, Laif Photos for
M Magazine/NRC Handelsblad
1st Prize Stories

India's weighty bureaucracy is an inheritance from British colonial times. Some 6,500 civil servants are employed at state level in Patna, the capital of Bihar. This page: Sushma Prasad, assistant clerk to the cabinet secretary. Facing page: Arbind Kumar, head assistant, supply section of food supplies in Kishanganj district. (story continues)

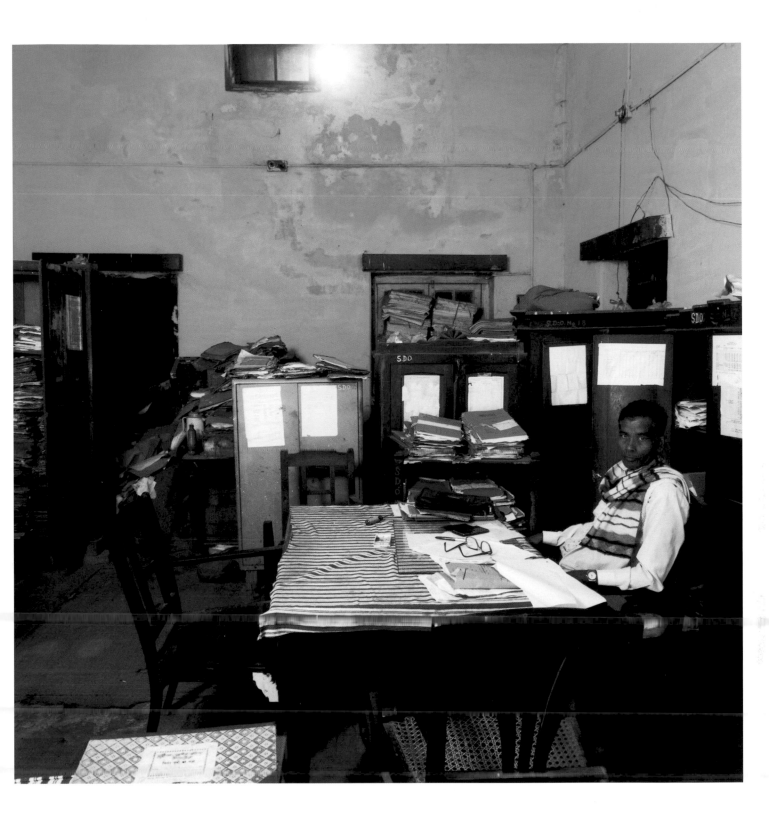

(continued) An estimated 45 per cent of bureaucratic positions in Patna are currently vacant due to economic restrictions. Facing page: Anjani Kumar Verma, personal assistant to the chief secretary. This page: Rp Yadav, sub-inspector of police in Maner Block, Patna district.

Lene Esthave
Denmark
2nd Prize Stories

Participants in the Men's World Powerlifting Championships in Vejle, Denmark. The competition was divided into 11 weight classes, with the lightest contestant weighing 50 kilograms and the heaviest 214 kilograms. Players are ranked according to 'total lift' – the sum of a number of lifts in different positions. Overall champion, according to a formula that relates body weight to individual lifts, was Olech Jaroslaw of Poland. This page, left: Jean-Luc Collart of Belgium, who was placed twelfth in the -125kg class, with a total lift of 840kg. Right: Andrey Tarasenko of Russia, placed second in the -90kg class, with a total lift of 955kg. Next Page, left: Daisuke Midote of Japan, third in the +125kg class, with a total lift of 1,032.5kg. Right: Frederic Gander, France, placed fourth in the −82.5kg class, with a total lift of 800kg.

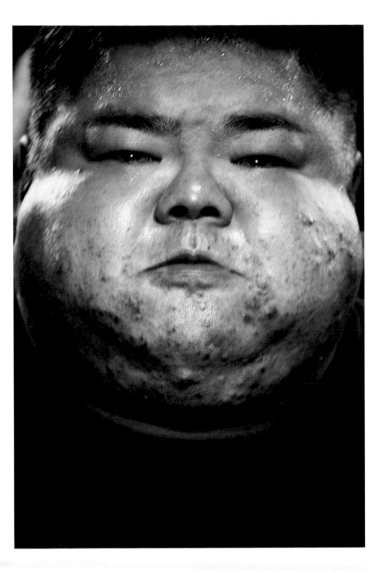
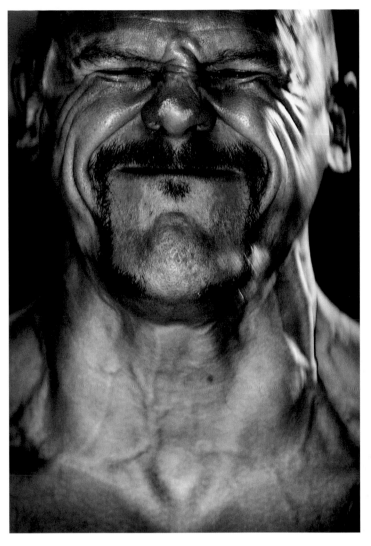

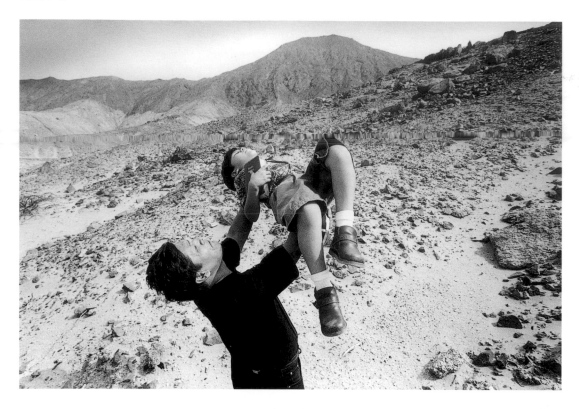

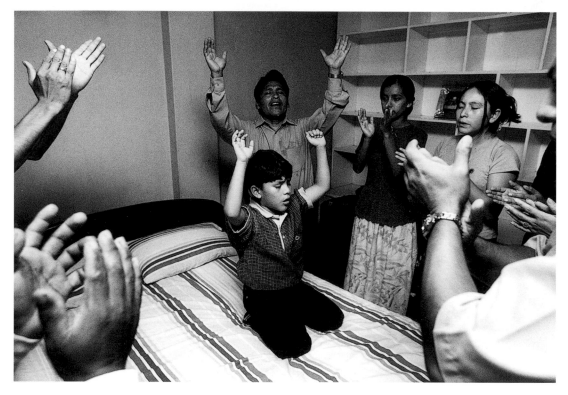

Seamus Murphy
Ireland, Redux Pictures for Algemeen
Dagblad
3rd Prize Stories

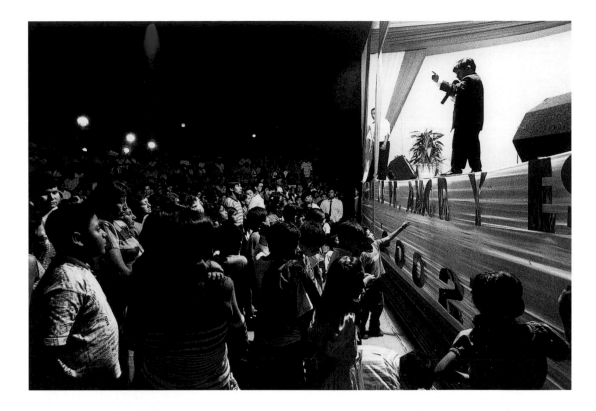

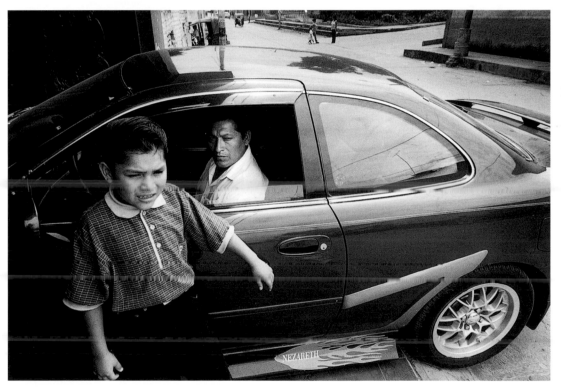

Nezareth Castillo, aged eight, of Trujillo in Peru is an evangelical preacher who can command audiences of thousands. His father Andres says God told him that he would produce a son powerful with words and in knowledge. Nezareth wasn't born until Andres was 40, considered late to become a parent in Peru. At the time, the family lived in a shack behind the market place, but Nezareth's success has bought them a new house and car. Facing page, top: Before each preaching tour, Andres takes Nezareth to the desert outside Trujillo and holds him up to the heavens. Below: Nezareth and members of an evangelical group pray the evening before a mission in Chepén, north of Trujillo. This page, top: Nezereth preaches in Chepén, a two-hour drive from home. Below: Nezareth stands in front of the family home in Trujillo, beside his father in a new Japanese car.

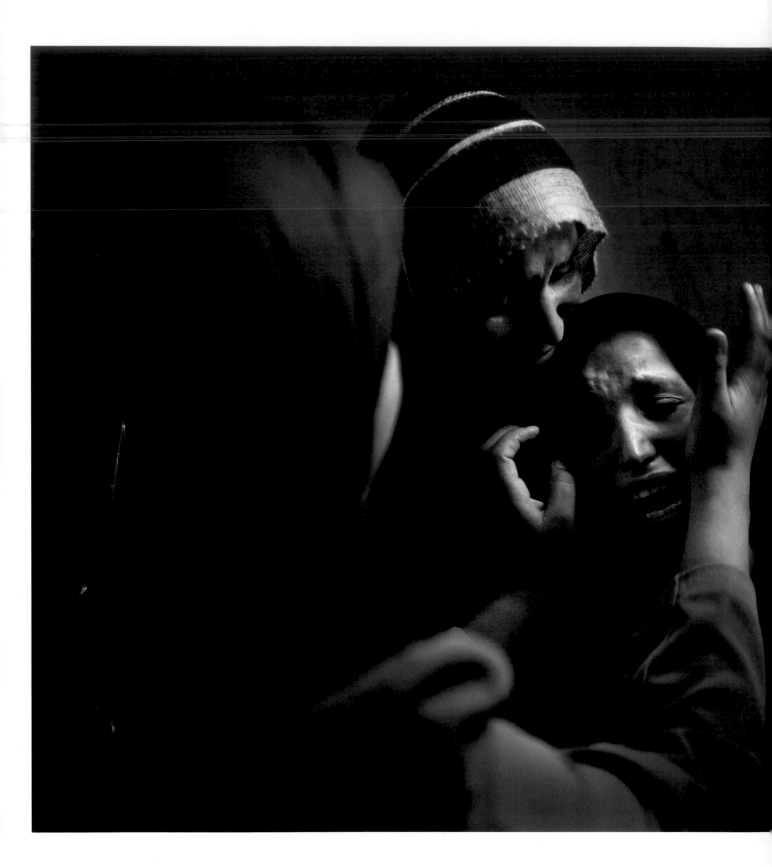

Jerry Lampen
The Netherlands,
Reuters News Pictures
1st Prize Singles

Manal Al Simiri, the wife of Palestinian Osama Al Simiri is comforted by relatives as her husband's body Is taken from their home in Der Al Balah, near the Kfar Darom Jewish settlement in the central Gaza Strip. He was one of three Palestinian men, all belonging to the same family, killed by Israeli soldiers as they fled in a car following a lengthy pursuit on foot. Israeli military officials said the soldiers had given chase after seeing a group of Palestinian militants approach a road used by soldiers and settlers.

113

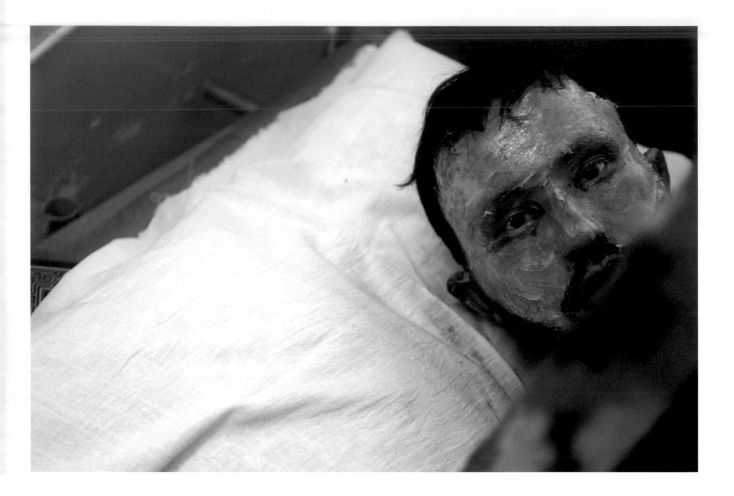

Moises Saman
Spain, New York Newsday
2nd Prize Singles

An Iraqi man suffering from severe
burns recuperates in the Al-Yarmuk
Teaching Hospital in Baghdad, two
days after the onset of US bombing of
the city in March. Immediately after
the first attacks, the Iraqi Ministry of
Information took all foreign journalists
present in Baghdad on a tour of
several hospitals in the city in order to
demonstrate casualties, claiming that
only civilian targets had been hit. The
ministry set the toll at over 200
injured. Reports of a shortage of
supplies and medical staff followed.

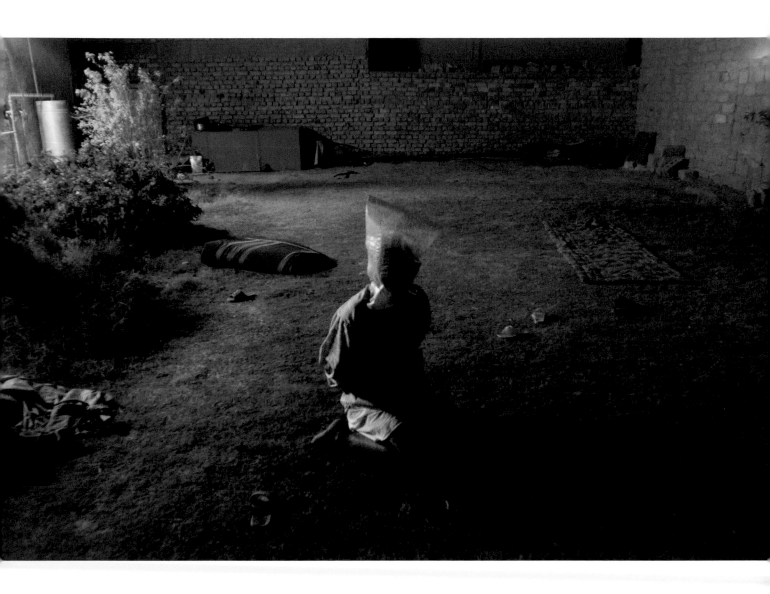

Stefan Zaklin
USA for EPA
3rd Prize Singles

An Iraqi man detained by US soldiers kneels in his yard in Tikrit in October before being taken away for questioning. American forces had conducted a pre-dawn raid that targeted men suspected of planning and carrying out attacks on coalition forces. Although the army had moved quickly on Baghdad earlier in the year, encountering scant resistance, by October soldiers were finding it increasingly difficult to keep order, and dozens had been killed in bombings carried out by insurgents. By the end of the year more US soldiers had died as a result of guerilla activity than in the initial phase of the conflict, and the US-backed Interim Governing Council (IGC) unveiled plans for an accelerated transfer to Iraqi control.

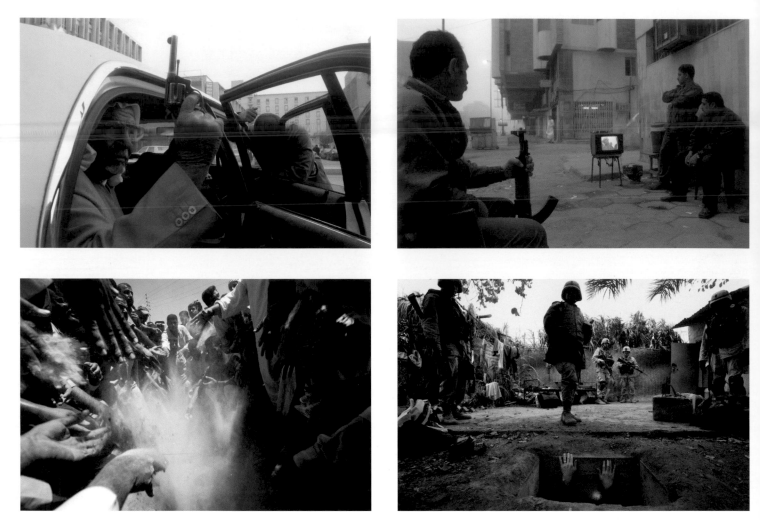

Yuri Kozyrev
Russia, Time magazine
1st Prize Stories

A long-ongoing standoff with Iraq came to a head when a coalition of British and American forces attacked the country in March. The initial offensive comprised a pre-dawn bombing raid on Baghdad on March 20. This was followed by an advance of ground troops across the south of the country, and an extensive 'shock and awe' bombing campaign on the capital and other strategic cities. The Americans said they targeted sites identified as having military significance, or as possibly sheltering the Iraqi leader Saddam Hussein. By April 9, US forces had reached central Baghdad. Saddam Hussein's grip on the city was broken, but he and leading members

of the ruling Baath Party had disappeared – the Iraqi leader would not be captured until December 14. The Americans abolished the Baath party and established an Interim Governing Council (IGC), which received cautious backing from the UN Security Council. This page, clockwise from top left: A local sheikh arrives in Baghdad on March 28 to receive instructions on how to carry out guerilla war in the provinces. Members of the ruling Baath Party watch TV during a sandstorm in downtown Baghdad on March 25. A journalist climbs out of the hole where Saddam Hussein was discovered hiding out, in the village of Ad Dawr. Citizens of Owja

and Saddam's hometown Tikrit bury the bodies of the toppled Iraqi leader's sons Uday and Qusay and of Qusay's son Mustafa, who were killed in a gun battle in the city of Mosul in July. Facing page, top: The ruins of a house destroyed by an US-led rocket attack in northern Baghdad. Below: A cemetery worker carries a reusable casket to the storage house, after the funeral of a woman killed in a rocket blast in the south of Baghdad. Following pages: Ali Ismail, aged 12, is tended by a distant relative in the Al-Kindy hospital in Baghdad, unaware that the rocket blast which mutilated him killed both his parents, his brother, and 11 other relatives.

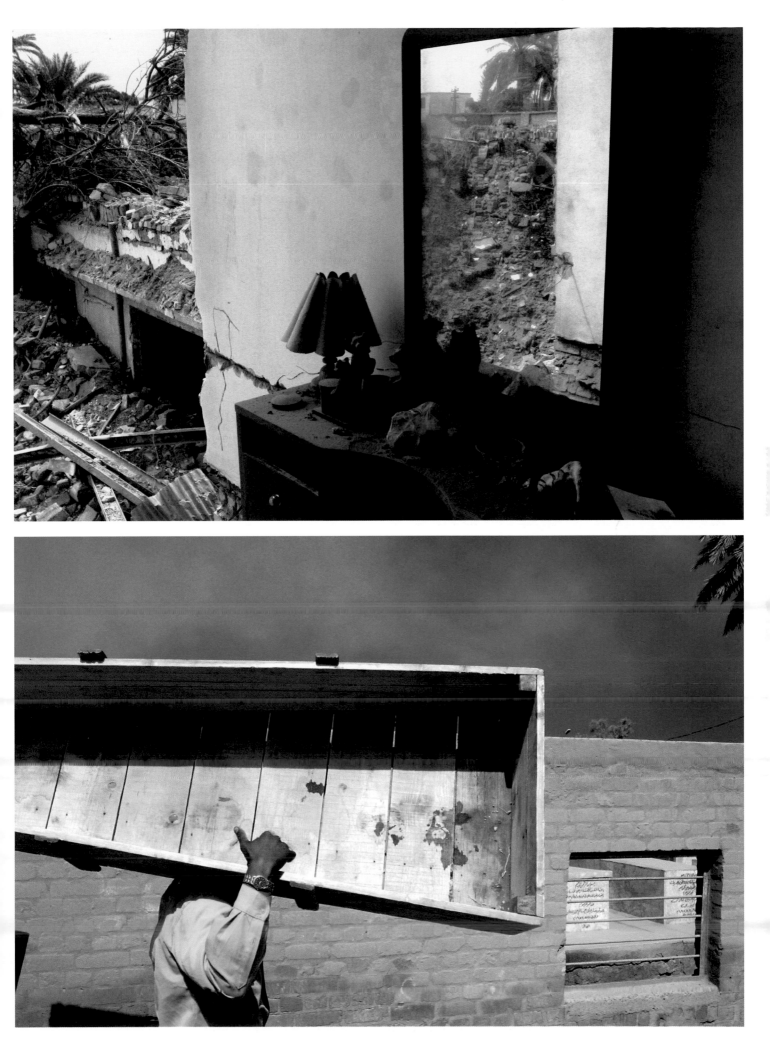

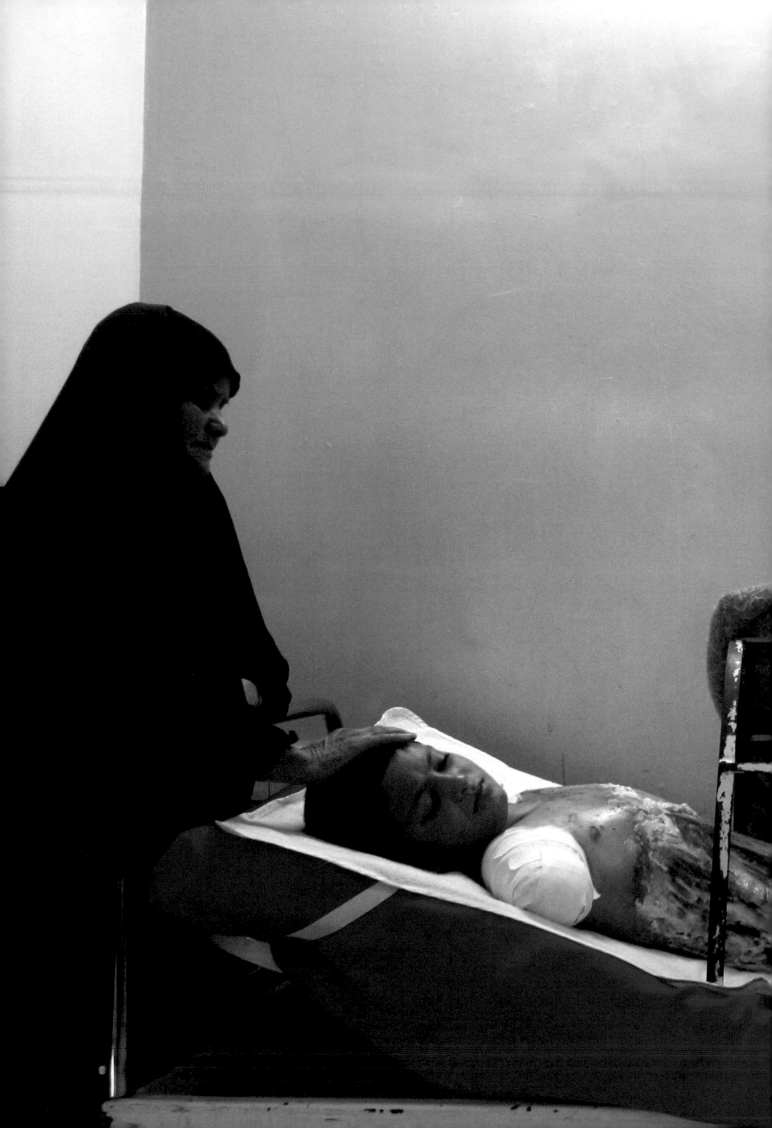

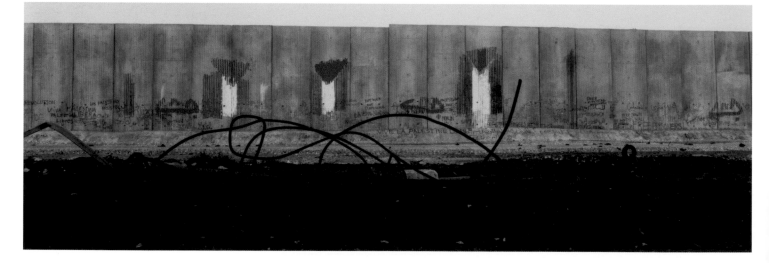

Kai Wiedenhöfer
Germany, Lookat Photos for NZZ/
Newsweek/Greenpeace Magazine
2nd Prize Stories

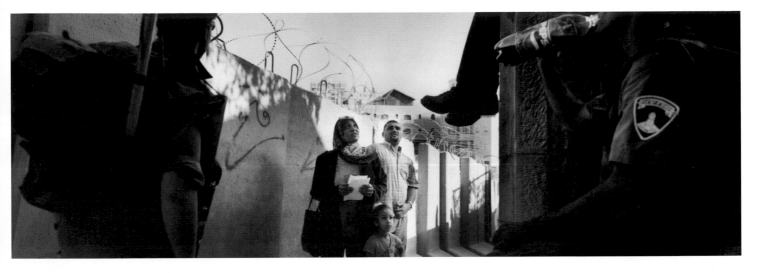

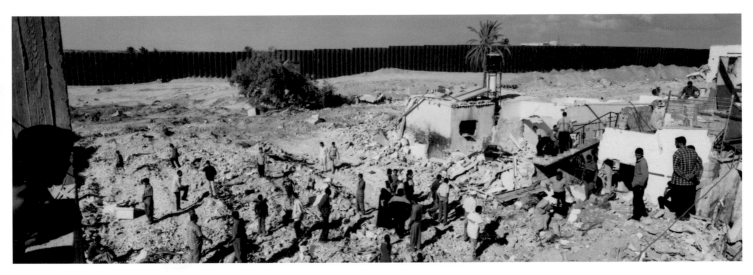

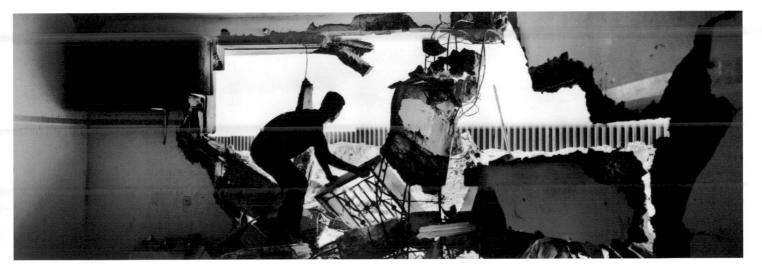

In 2002 Israel began to construct a 700-kilometer-long security barrier in the West Bank saying that it was designed to stop suicide bombers. Palestinians complained that the barrier was illegal and that its route cut off hundreds of farmers and traders from their land and means of economic survival. Facing page top:

The eight-meter-high section around the Palestinian town of Qalqilya (pop. 40,000) was conceived as a 'sniper wall' to prevent gun attacks against Israeli motorists, and has one checkpoint. Middle: Part of the wall still under construction in the Sauwahri neighborhood of Jerusalem. Below: Peace activists

have painted graffiti on the wall that surrounds Qalqilya. This page, top: A Palestinian family on their way to hospital attempt to pass through a checkpoint in the Jerusalem district of Abu Dis, where a provisional 2.5-meter-high wall has been erected. Middle: Thousands were made homeless when dwellings in the

Palestinian refugee camp of Ibda, in the town of Rafah on the Egyptian border, were demolished to make way for a six-meter-high wall, intended by the Israelis to create a free-fire zone and prevent arms smuggling. Below: A man salvages belongings from a demolished house in Ibda.

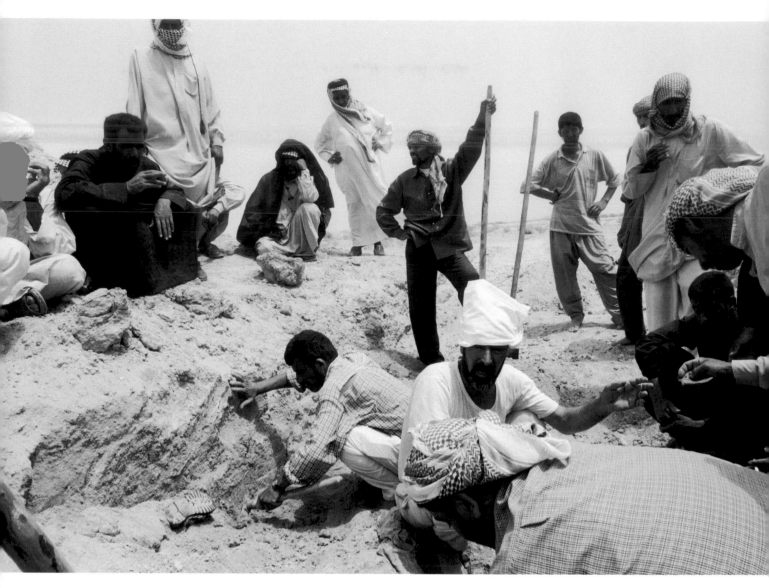

Dario Mitidieri
Italy, Katz Pictures
3rd Prize Stories

According to human rights groups, an estimated 300,000 people disappeared in Iraq during Saddam Hussein's rule. Some went missing in the 1980s, when Saddam ordered the detention and execution of thousands of communists, Shiite Muslims and rival members of his Baath Party. Most disappeared in the aftermath of the 1991 Gulf War, when Iraqi Republican Guards suppressed twin revolts by Kurds in the north and Shiite Muslims in the south. The discovery of mass graves began soon after the overthrow of Saddam's regime in April 2003. This page: Local civilians recover remains of Shiite Muslims from a mass grave near Al Musayyib, 100 kilometers south of Baghdad. Facing page, top: A man examines photos of people who have disappeared. The pictures were found in secret files, photocopied and displayed in Baghdad. Middle: Abbas Sabar, followed by his mother Zainab, carries the corpse of his identified brother Navar, found in the grave near Al Musayyib. Below: Hamisha Ali kisses the skull she has just identified as being of her son Hassan Habaeb. He was killed in 1991 and buried in a mass grave near Al Mahawil, 50 kilometers south of Baghdad. Following pages: An Iraqi civilian takes a photograph of bodies of Shiite Muslims executed in 1991 and buried near Al Musayyib.

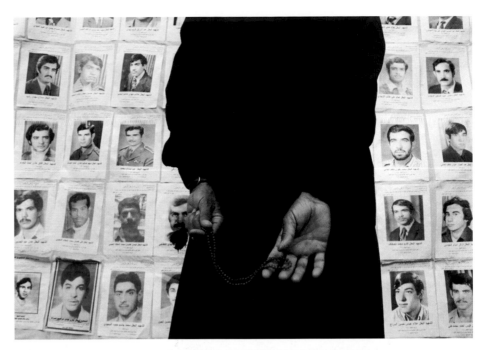

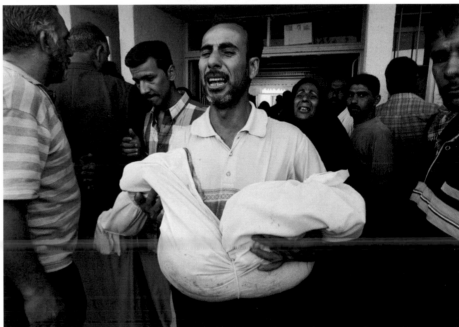

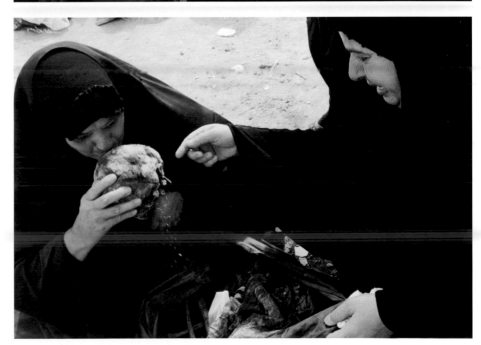

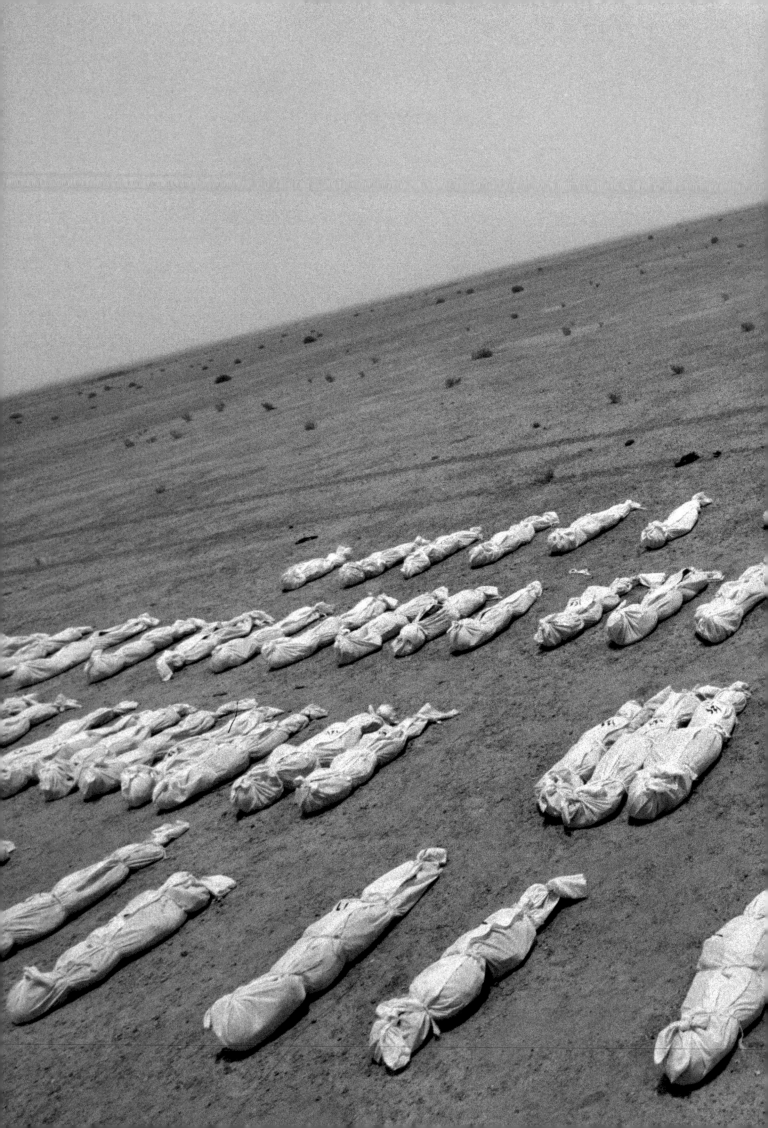

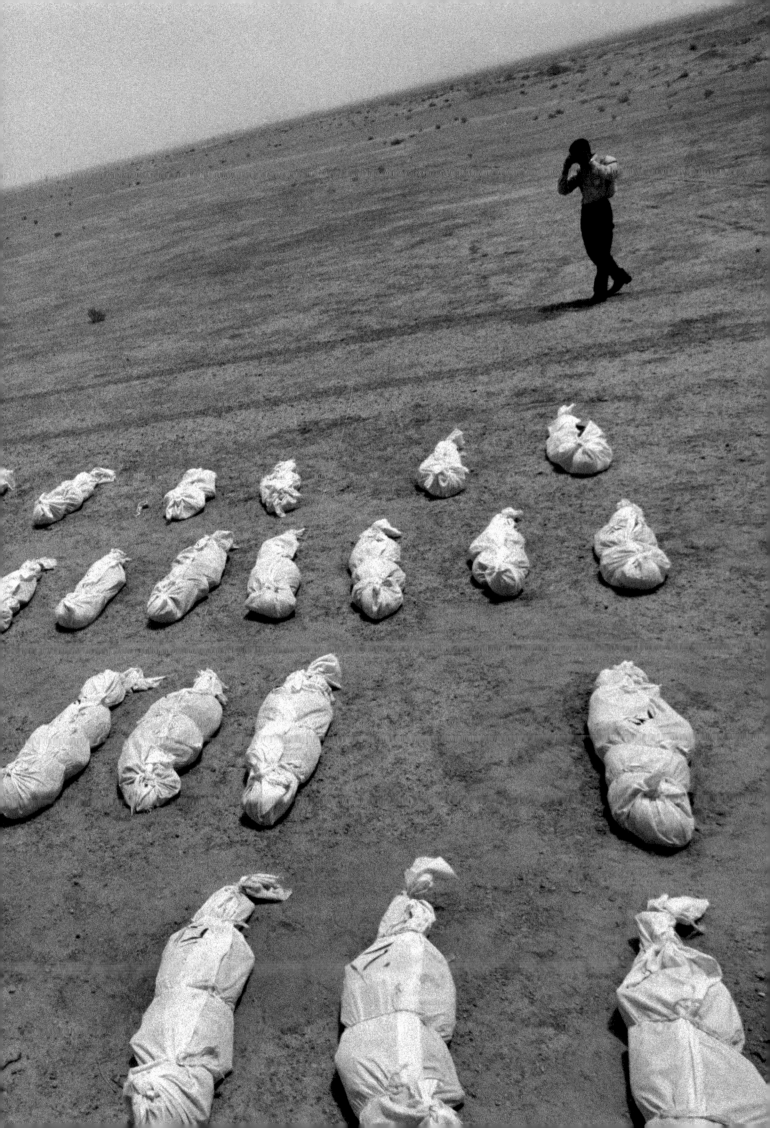

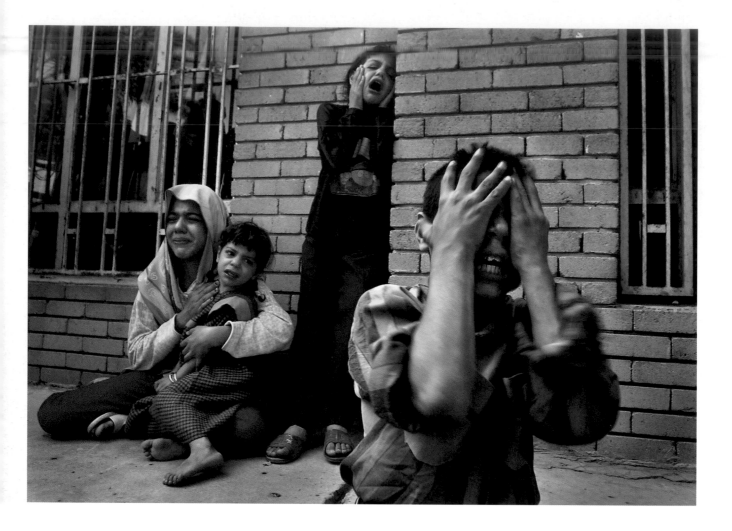

Carolyn Cole
USA, Los Angeles Times
2nd Prize Singles

An Iraqi family grieves as the bodies of three family members shot by US Marines in Baghdad on April 9 are brought home. Mohammed Khadim Hussein, his son Emad and another relative Hussein Ahmed Khadim were killed when the car Khadim Hussein was driving failed to stop upon a command given in English at a US checkpoint. The family didn't know about the shootings until a relative brought the car to the house with the bodies still inside. Soon after American entry into Baghdad, there was widespread looting in the capital and other cities. Security deteriorated and tensions rose as young soldiers at roadblocks found they had neither the language nor local awareness to deal with the situation they found themselves in.

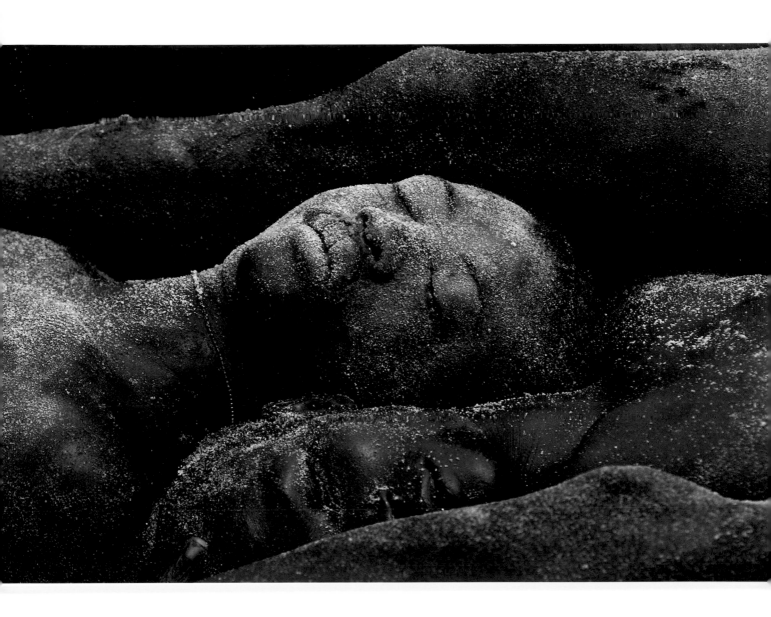

Carolyn Cole
USA, Los Angeles Times
3rd Prize Singles

Bodies are placed in a mass grave in Liberia at the beginning of August, on the day that peacekeeping forces arrived. Civil conflict had wracked Liberia for more than a decade, claiming up to 250,000 lives, and leading to half a million internally displaced people and around 320,000 in exile. In August, Nigerian peacekeepers arrived, followed by US troops. President Charles Taylor left the country, and an interim administration was set up from October under Gyude Bryant. US troops later withdrew, and the UN launched a major peacekeeping mission, beginning to disarm former combatants.

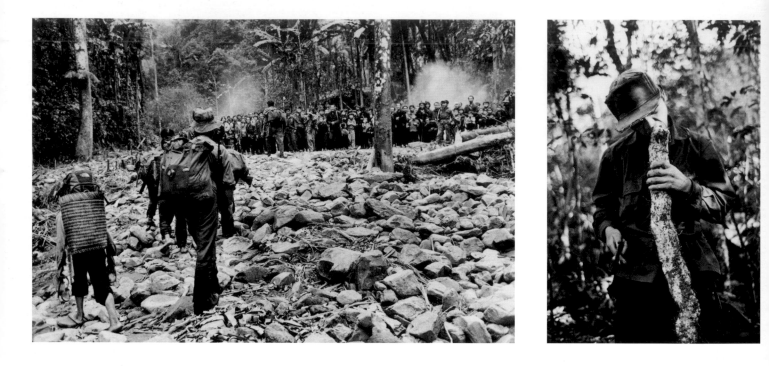

Philip Blenkinsop
Australia, Agence Vu for Time Asia
1st Prize Stories

The Hmong ethnic minority in Laos sided with the United States army during the Vietnam War, and in the follow-on conflicts in Laos and Cambodia. They became members of a CIA-backed militia that assisted downed US pilots and disrupted North Vietnamese supply routes. After the war, the US government stopped its support for the Hmong. As much as a third of the Hmong population is thought to have left the country, but those that remained suffered the consequences of their support for the Americans. Many were forced to migrate from their highland homes to areas where they were unable to carry out their traditional occupation of agriculture, and isolated pockets are reported to be fighting a low-level guerilla war against the Lao government. Top left: The population of a Hmong camp in the jungle of Xaysomboune in northern Laos gather as journalists approach the clearing in which they live. Right: A Hmong guerilla wards off hunger by chewing on a tree root, the staple diet of the village. Facing page, top: Crossing a river en route to the camp, which is in a section of jungle surrounded by Lao government troops and landmines. Below: Surrounded by government troops, Hmong rebels beseech the help of journalists who have arrived at the camp. (story continues)

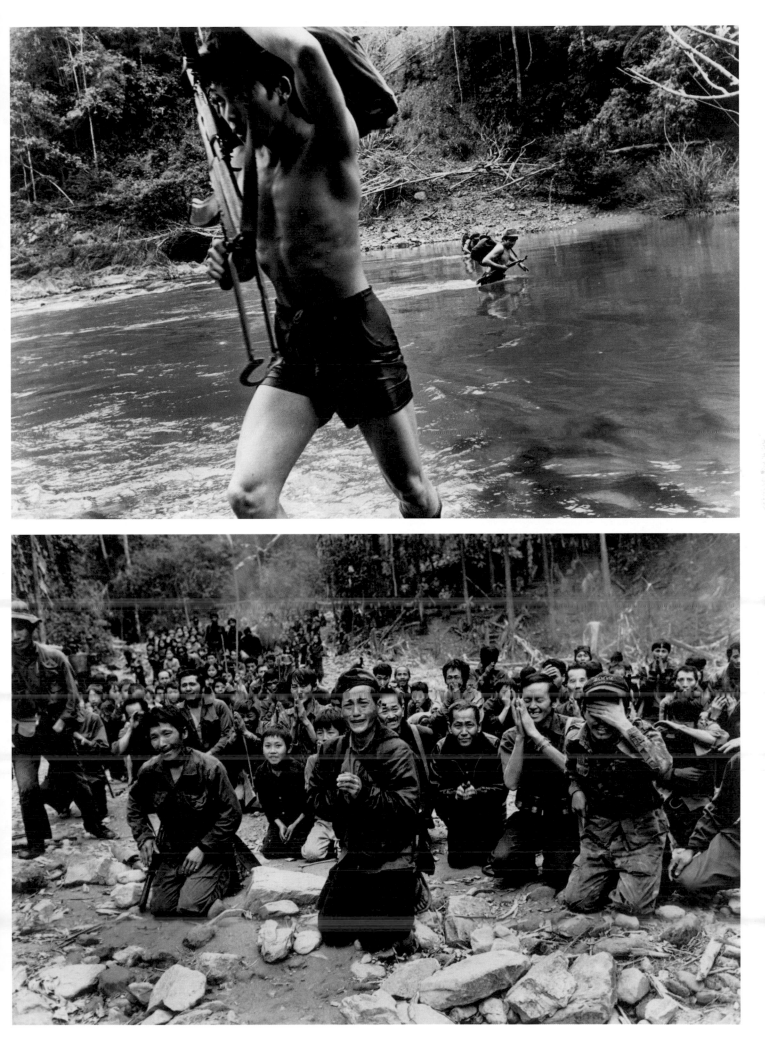

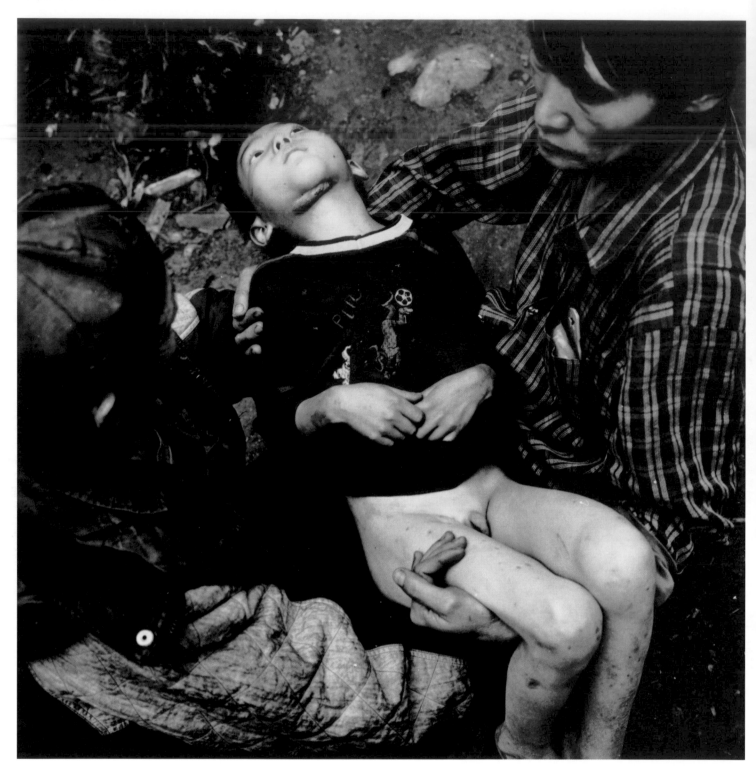

(continued) The leader of the Xaysomboune camp of Hmong, Moua Toua Ther, recorded his group as numbering 7,000 people in 1975. Today there are around 800 left. This page: Yaeng Hua is nine years old, and has not spoken since a mortar attack that killed his parents and left him with multiple shrapnel injuries and a broken jaw. Facing page: Buhn Si was injured when a Lao army helicopter attacked with B-41 rockets in 1991. His wife and children were killed in 2002.

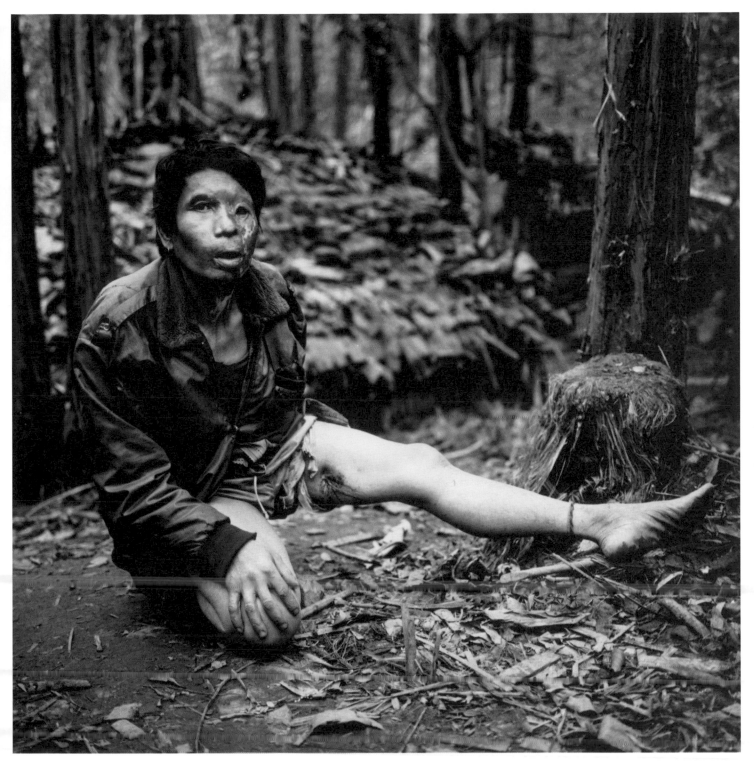

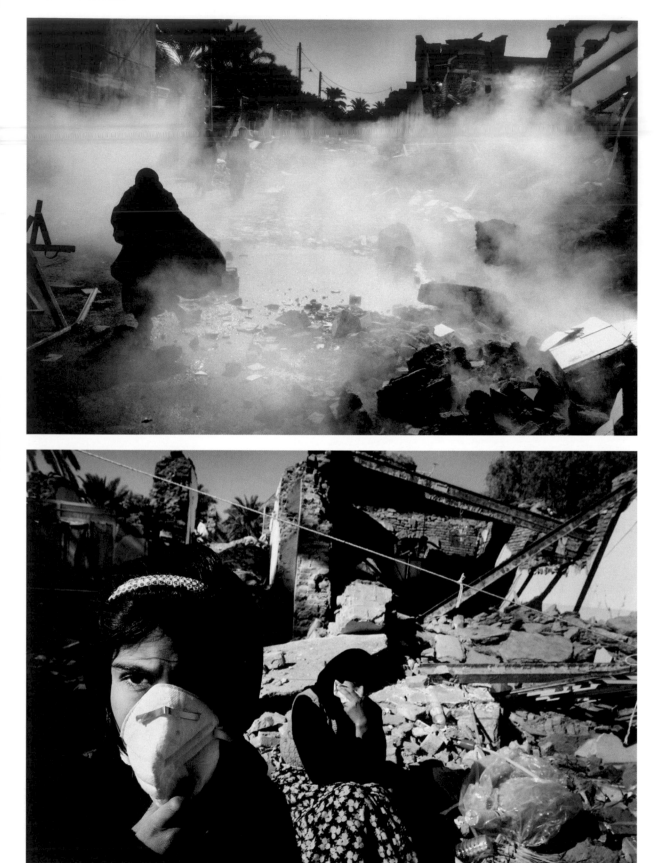

Jan Grarup
Denmark, Politiken/Rapho
2nd Prize Stories

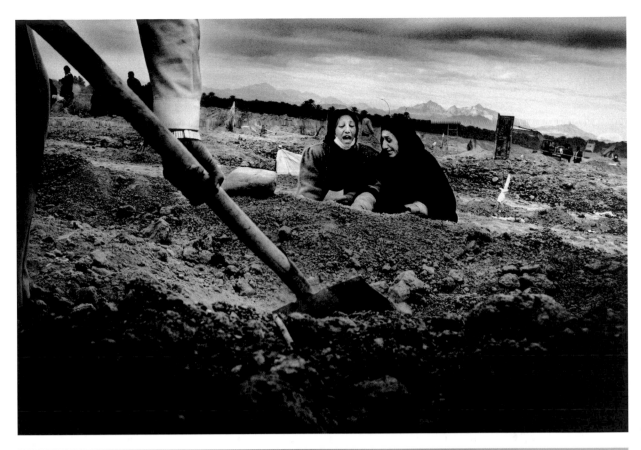

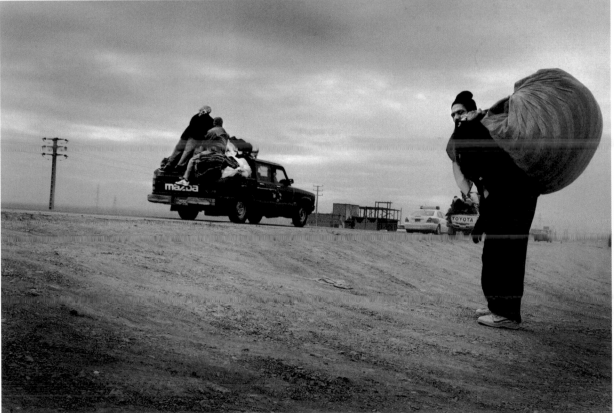

On December 26, the ancient fortress city of Bam in southeastern Iran was struck by an earthquake measuring 6.5 on the Richter scale, with the loss of tens of thousands of lives. Around 85 per cent of the town's buildings were destroyed, leaving nearly the entire population homeless. Many spent freezing nights in tents provided by aid agencies, as rescue operations got underway. The UN and Red Cross appealed for a total of US$ 73 million to help the victims. Facing page, top: Aftershocks and rescue operations left the streets of Bam in a fog of dust. Below: A girl and her mother sit in the ruins of their home. They survived the quake because they stayed in the bedroom as the rest of the house collapsed. This page, top: Two young women bury seven other family members. The two were not at home when the tremor struck. Below: Survivors leave the devastated city.

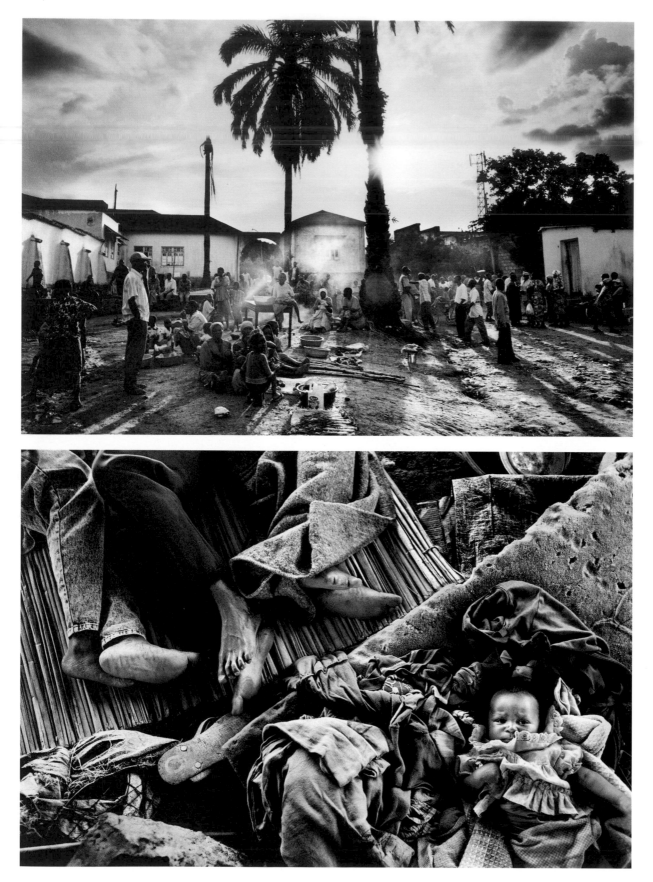

Erik Refner
Denmark, Berlingske Tidende/Rapho
3rd Prize Stories

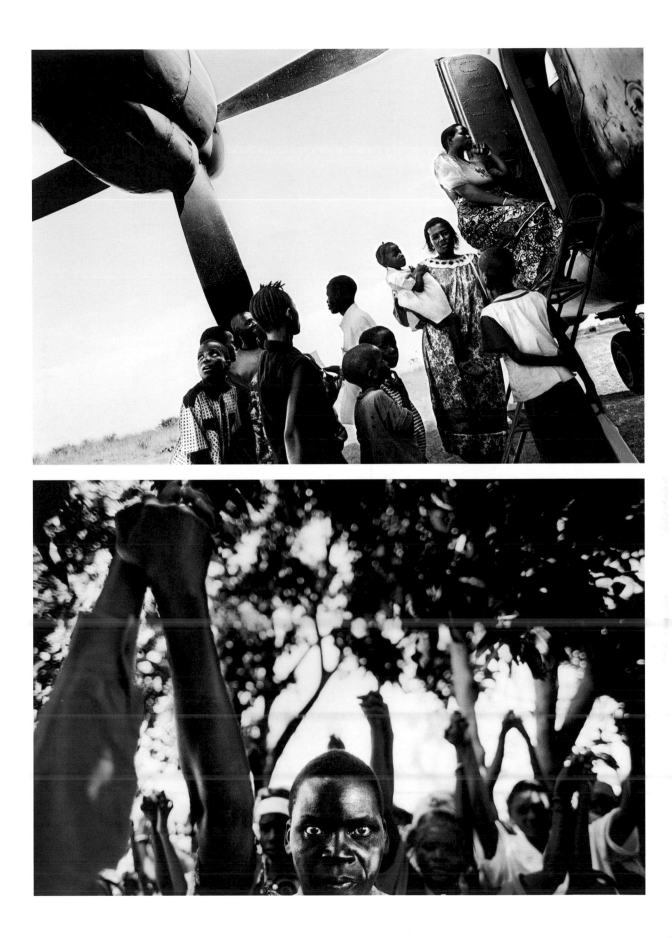

In May, a new wave of ethnic violence between Hema and Lendu militias hit the town of Bunia in the northeast of the Democratic Republic of Congo. The city, which once had 300,000 citizens, has experienced some of the most horrific atrocities of a conflict that has lasted nearly five years. An estimated 50,000 people from the region have been killed in the fighting and the rest have fled, leaving around just 10,000 survivors, mostly in and about UN buildings in the town. Facing page, top: Refugees gather for safety at the UN camp in Bunia. Below: A child lies beside other refugees at a camp near Bunia airport. This page, top: Refugees board a plane at Bunia airport. Some, especially those with money or contacts, were able to flee to Uganda. Below: People attend a religious gathering close to the refugee camp in Bunia.

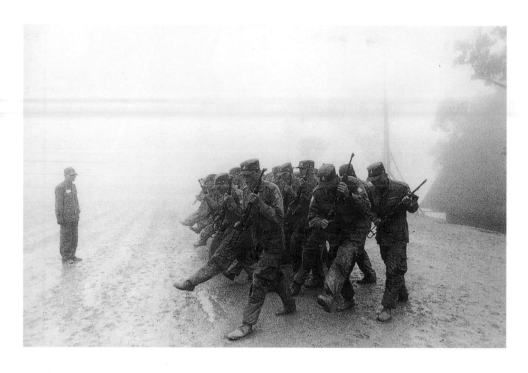

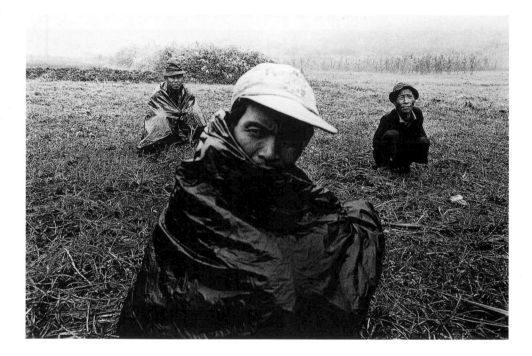

Olivier Pin-Fat
UK, Agence Vu for VSD/Time Asia/
The Independent on Sunday Review
Honorable Mention Stories

The Shan people are the dominant ethnic group of an isolated and densely forested mountain region in northeast Burma. Running through the area is part of the Golden Triangle, where much of the world's opium and heroin is produced. Human rights groups have said that the Shan, along with other minorities, have been subject to forced labor and torture at the hands of the Burmese military. The Shan State Army (SSA) is waging armed insurrection against the Burmese military junta in the hope of Shan self-determination. This page, top: Members of the SSA drill in the mist. Below: Shan villagers sit in a field that they will clear to grow opium poppies. The farmers themselves make a pittance from the trade, much of which appears to be under the control of local warlords and militias. Facing page, clockwise from top left: The SSA's headquarters at Loi Dai Leng on the Thai border. SSA recruits in Loi Dai Leng. A SSA guerilla rests among elephant grass in an area where the Burmese army is active. Two SSA guerillas stand guard in the rain.

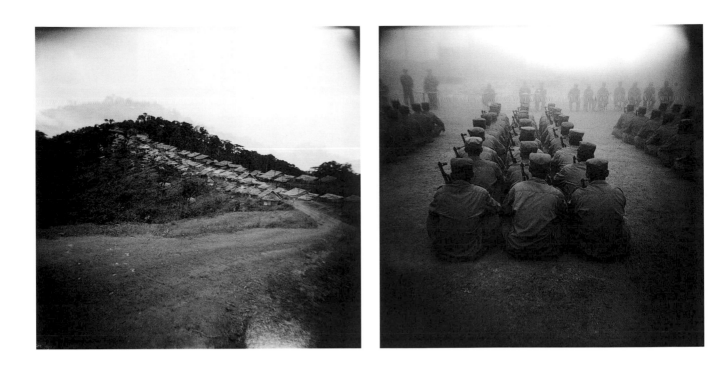

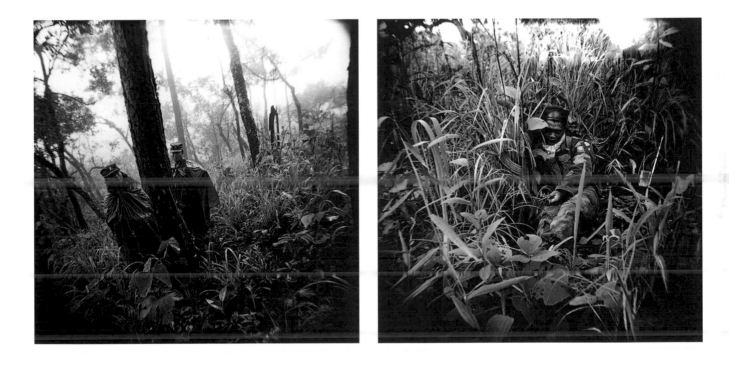

Prizewinners 2004

World Press Photo of the Year 2003
Jean-Marc Bouju, France, The Associated Press
Iraqi man comforts his son at a holding center for POWs, An Najaf, Iraq

Page 4

The World Press Photo of the Year 2003 Award honors the photographer whose photograph, selected from all entries, represents an event, situation or issue of great journalistic importance in that year, and demonstrates an outstanding level of visual perception and creativity.

Contemporary issues Singles
1 Stephanie Sinclair, USA, Corbis for Marie Claire
Self-immolation by women in Afghanistan

Page 10

2 Jacob Ehrbahn, Denmark, Politiken/Jyllands-Posten
Mongolian street boy

Page 12

3 Felicia Webb, UK, Independent Photographers Group
Jonathan - Generation XL, USA

Page 13

Contemporary issues Stories
1 Lu Guang, People's Republic of China, Gamma
Aids village, Henan Province, China

Page 14

2 Walter Schels, Germany, for Der Spiegel
Terminally Ill

Page 18

3 Tippi Thole, USA
Pamela's Story

Page 20

Honorable mention Lorena Ros, Spain, Fotopress La Caixa for Elle
Traffic in Nigerian women

Page 24

Spot News Singles
1 Ahmed Jadallah, Palestinian Territories, Reuters News Pictures
Raid on Jabalya

Page 26

2 Atta Kenare, Islamic Republic of Iran, Agence France-Presse
Bam earthquake

Page 27

3 Kuni Takahashi, Japan, Boston Herald/Reflex News
Militiaman, Liberia

Page 28

Honorable mention Tarmizy Harva, Indonesia, Reuters News Pictures
Woman mourns, Aceh, Indonesia

Page 31

Honorable mention Chris Hondros, USA, Getty Images
Militia fighter, Liberia

Page 30

Arts and
Entertainment
Stories
1 Mary Ellen Mark,
USA

Page 56

2 Stephan
Zaubitzer, France
Outdoor cinema in
Ouagadougou,
Burkina Faso

Page 60

3 Raúl Belinchón
Hueso, Spain
Underground cities

Page 62

Nature Singles
1 Mark Zaleski
USA, The Press-
Enterprise
Helicopter fights
forest fire,
California

Page 64

2 Gérard Julien,
France, Agence
France-Presse
River Herault
floods, France

Page 66

3 Jon Lowenstein,
USA, Aurora Photos
Lake Michigan
view of Chicago

Page 67

Nature Stories
1 Paul Nicklen,
Canada, for
National
Geographic
Magazine
Atlantic salmon

Page 68

2 Olivier
Grunewald, France,
for Figaro
Magazine/Grands
Reportages,
Kamchatka

Page 72

3 Tanya Lake,
Australia
Sydney waterways

Page 74

Sports Action
Singles
1 Tim Clayton,
Australia, The
Sydney Morning
Herald
Yannick Bru in th
scrum at Rugby
World Cup, Sydne

Page 76

2 Al Bello, USA,
Getty Images
Dominick Guinn
knocks out Micha
Grant

Page 78

3 Alexander
Hassenstein,
Germany, Bongar
Sportfoto
Thomas
Morgenstern at
World Cup
Skijumping,
Kuusamo, Finland

Page 79

**Portraits
Stories**
1 Jan Banning, The
Netherlands, Laif
Photos for M
Magazine/NRC
Handelsblad
Indian bureaucrats

Page 104

2 Lene Esthave,
Denmark
Powerlifters at
World
Championships

Page 108

3 Seamus Murphy,
Ireland, Redux
Pictures for
Algemeen Dagblad
Child evangelist
preacher Nezareth
Castillo

Page 110

**General News
Singles**
1 Jerry Lampen, The
Netherlands,
Reuters News
Pictures
Woman mourns
her husband, Gaza

Page 112

2 Moises Saman,
Spain, New York
Newsday
Injured Iraqi man
in hospital,
Baghdad

Page 114

3 Stefan Zaklin,
USA, for EPA
Detained Iraqi man
sits in his yard,
Tikrit

Page 115

**General News
Stories**
1 Yuri Kozyrev,
Russia, Time
Magazine
Iraq

Page 116

2 Kai Wiedenhöfer,
Germany, Lookat
Photos for NZZ/
Newsweek/Green-
peace magazine
The Wall, Israeli-
occupied territories

Page 120

3 Dario Mitidieri,
Italy, Katz Pictures
The mass graves of
Iraq

Page 122

**People in the
News Singles**
1 Jean-Marc Bouj
France, The
Associated Press
Iraqi man comfo
his son at a hold
center for POWs,
Najaf, Iraq

Page 4

2 Carolyn Cole,
USA, Los Angeles
Times
Iraqi family griev
for their dead
relatives, Baghda

Page 126

3 Carolyn Cole,
USA, Los Angeles
Times
Mass grave, Libe

Page 127

Participants 2004 Contest

In 2004, 4,176 photographers from 124 countries submitted 63,093 entries. The participants are listed here according to nationality as stated on the contest entry form. In unclear cases the photographers are listed under the country of postal address.

AFGHANISTAN
Zalmaï Ahad

ALBANIA
Bevis Fusha
Petrit Kotepano
Marketin Pici
Valdrin Xhemaj

ALGERIA
Adjeneg Ahmed
Zohra Fatma Bensemra
Hamid Seghilani

ARGENTINA
Rodrigo Miguel Abd
Martin C.E. Acosta
Humberto Lucas Alascio
Fernando Esteban Arias
Martin Arias Feijoo
Carlos Barria Moraga
Marcos Brindicci
Victor R. Caivano
Sandra Mariel Cartasso
Maria Eugenia Cerutti
Gustavo Cherro
Boris Cohen
Pablo Daniel Cuarterolo
Daniel Alejandro Dapari
Benito Francisco Espindola
Diego Goldberg
Marcos Guillermo Gómez
Pablo Ariel Gómez
Renzo Mario Gostoli
Diego Levy
César De Luca
Martin Eduardo Lucesole
Marcelo Carlos Manera
Fabian Osvaldo Mauri
Miguel Angel Mendez
Maria Milagros Solis
Hernan Gustavo Ortiz
Javier Orlando Pelichotti
Christopher Pillitz
Natacha Pisarenko
Ezequiel Pontoriero
Nestor Ricardo Pristupluk
Alberto Raggio
Sergio Ramirez Rus
Héctor Alejandro Rio Hacho
Andrés Alberto Riveras
Sergio Omar (Nono) Ruiz
Andrés Emilio Salinero
Juan Jesus Maria Sandoval
Ricardo Jose Santellan de Leon
Eduardo Seval Mazzola
Jose Enrique Sternberg
Sebastian Szyd
Luciano Thieberger
Antonio Valdez
Leonardo Adrián La Valle
Enrique Javier von Wartenberg
Hernan Zenteno

ARMENIA
Stephan Alekyan
Berge Arabian
German Avagyan
Ruben Mangasaryan
Agasijanc Rustam

AUSTRALIA
Stewart Allen
Narelle Autio
Ben Baker
Mark Baker
Kelly Barnes
Paul Blackmore
Torsten Blackwood
Philip Blenkinsop
Vasil Boglev

Angela Brkic
Patrick Brown
Philip Brown
Vince Caligiuri
Glenn Campbell
Robert Carew
Steve Christo
Suzanna Clarke
Warren Clarke
Tim Clayton
Brett Costello
William Crabb
Nick Cubbin
Ian Charles Cugley
Megan Anne Cullen
Mark Jeffery Dadswell
Sean S. Davey
Howard J. Davies
Tamara Dean
Maree Janelle Dinger
Jenny Duggan
Stephen Dupont
Brenton Edwards
Mal Fairclough
Jonathan Frank
Timothy Georgeson
Ashley Gilbertson
Kirk Gilmour
Craig Steven Golding
Steve Gosch
Philip Gostelow
David Gray
Robert Griffith
Patrick Hamilton
Mathias Heng
Phil Hillyard
Ian Alfred Hitchcock
Adam Hourigan
Jessica Hromas
Glenn Hunt
Martin Jacka
Tara Johns
David Kelly
Dirk Arthur Klynsmith
Mark Ian Kolbe
Helen Kudrich
Nicholas Laham
Tanya Lake
Dean Lewins
Guy Little
Jean-Dominique Martin
Régis Alain Michel Martin
Belinda Mason-Lovering
Chris McGrath
Justin McManus
Andrew Merry
Paul David Miller
Palani Mohan
Nick Moir
Fiona Morris
Helmut Newton
Sandy Nicholson
Debrah Novak-Fisher
Renee Nowytarger
Trent Parke
David Dare Parker
Ryan Pierse
Adam William Pretty
Andrew Quilty
Paul Raffaele
Jackie Ranken
Antony Bruce Reddrop
Colin Reuben
Noel Rowsell
Dean Saffron
Dean Sewell
Andrew Shaw
Damian Shaw
Steven Siewert
Matthew Sleeth
Kylie M. Smith
Troy Snook
Ross Swanborough
Tasso Taraboulsi
Therese Truc Tran
Mick Tsikas
Grant Turner
Leigh Turner
Tamara Voninski
Ian Waldie
Peter John Wallis
Clifford White
Thomas Wielecki

Lisa Maree Williams
Gregory Wood
Andy Zakeli

AUSTRIA
Heimo Aga
Michael Appelt
Gert Rudolf Damberger
Josef Friedhuber
Rudolf Fröese
Thomas Fröhlich
Peter Granser
Franz Killmeyer
Miroslav Kuzmanovic
Lois Lammerhuber
Christian Lapp
Stefan Pleger
Helmut Ploberger
Irene Pospisil
Reiner Riedler
Jozsef Timar
Ludwig Vysocan

AZERBAIJAN
Rafig Cambarov
Ilgar Djafarov
Farhad Hashimov
Sitara Ibragimova
Chingiz Samedzadeh
Ibadov Vuqar
Farid Zeynalov

BANGLADESH
Abir Abdullah
K.M. Jahangir Alam
Mahbub Alam Khan
Monirul Alam
Shahidul Alam
Ron Arshad
Md. Jubiad Baksh
Nazrul M.N.I. Chowdhury
Bablu Chowdury
Ranajit Das
Alam Didarul
Shoeb Faruquee
Saydul Fateheen
Md. Maruf Hasan
Rofiqul Hassan
Morshed Himadri
Shafayet Hossain Apollo
Subhash Karan
Proshanta Karmakar
Moin Khurshid
Main Uddin
Abdul Malek Babul
Polash
Mohamed Rezaul Quamar Sadi
Kazi Md. Golam Quddus
Mohammad Abdur Rashid
Andrew Vernon Rozario
Swapan Kumar Saha
Kazi Ahmad Sayeed-uz-Zaman
Kajal Shafiqul Islam
Sheikh Rashedul Islam
Din Muhammad Shibly
Tapash Shome
Hashi Talukder
Akhlas Uddin
Sanjida Sharmin Zaman
A.N.M. Zia

BELARUS
Vladimir Bazan
Vasili Fiadosenka

BELGIUM
Layla Aerts
Rudi van Beek
Robert Vanden Brugge
Michael Chia
Gert Cools
Philippe Crochet
Thomas Florian Dashuber
Stijn Decorte
Raphael Demaret
Marc Deville
Tim Dirven
Wilhelminia Dodemans Mine
Kris van Exel
Nick Hannes
Wim Hendrix
Yves Herman
Yorick Albert Jansens

Roger Job
Eddy Kellens
Wim Kempenaers
Christophe Ketels
Didier Lebrun
Francois Lenoir
Peter Maenhoudt
Firmin de Maitre
Michel Marcipont
Frederic Materne
Roger Milutin
Bart van der Moeren
Philip Reynaers
Thierry Roge
Dominique Simon
Sébastien Smets
Cristophe Michel Smets
Bruno P. Stevens
Dieter Telemans
Wanda Tuerlinckx
Gaël Turine
Stephan Vanfleteren
Alex Vanhee
Louis Verbraeken
Eva Vermandel
John Vink
Peter de Voecht
Johan Voets
Geert vanden Wijngaert
Daniel Alain Willam

BHUTAN
Tshechu Dorsi Wong

BOLIVIA
Lucio Bustillo Guachalla
Patricio Crooker Muñoz
Pedro Javier Laguna Vacaflor
David Mercado Montano
David Gonzalo Ordóñez Lozano
Martha Vázquez Yutronic

BOSNIA-HERZEGOVINA
Mediha Dimartino
Zijah Gafic
Muhamed Mujkic
Damir Sagolj
Tarik Samarah
Nedzad Ugljesa
Drago Vejnovic
Almin Zrno

BRAZIL
Alan Kardec E. Alves
Euler Paixão Alves Peixoto
Paulo Amorim
Débora Amorim
Alberto César Araujo
Elisandro Aparecido Ascari
Nário Barbosa da Silva
Mônica Bento de Souza
Jamil Bittar
José Geraldo Borges
Mario Borges Junior
Paulo Cesar Bravos
Otavio José Luís Brazil
Oslaim Brito
André Camara
Rubens Cardia
M.C. Valponto de Almeida
Weimer de Carvalho Franco
Ivaldo Cavalcante Alves
André Coelho Cardoso
Jose Luis da Conceição
Julio Cesar Bello Cordeiro
Luiz Alberto Cortes Silva
Christian Cravo
Antonio José Cury
Fernando dos Santos Dantas
Bruno de Aroujo Domingos
Davi Fernandes da Silva
Orlando da Silva Filho
Marco Antonio Fontes de Sá
M. da Fontoura de Cerqueira
Marcelo Funicelli Vigneron
Ari Correia Gomes
Rogério Gomes Lorenzoni
Ivo Gonzalez Marinho
Patrick Grosner
Yone Guedes da Costa
Julio Cesar de M. Guimarães
Andréa König Graiz
Fabio Vicentini Lanes de Souza

Marcelo Leite de Oliveira
Ulisses Job Lima
Mauricio Lima
Helvio Romero Lopes
Moacyr Lopes Junior
Benito Maddalena
Paulo Martins Pinto
Leonardo Melgarejo
Sergio Ricardo Menezes
Marco Antonio R. Montello
Sergio Moraes
Jair Motta
Genna Naccache
Ronaldo de Oliveira
Adriano Orlandi Pereira
Emilio Carlos Sales Pedroso
Domingos Rodrigues Peixoto
Rodrigo Lôbo Pereira Da Costa
Claudinei Nogueira Plaza
André Porto
Marcelo Prates
Tiago Queiroz Luciano
Fernando Quevedo de Oliveira
L. de Miranda Henriques
Marcos Antonio Ramos Esteves
Marcio de Mendonca e Silva
Levy Freire Ribeiro Filho
Michela Brígida Rodrigues
Marcio Rodrigues de Oliveira
Jonne Roriz Goncalves
Luiz Carlos Sanches Varella jr.
Paulo César Santos Araújo
Anderson L.R. Santos Schneider
Roberto Scola
Carlos Alberto da Silva
Gleice Mere S.R. Silveira
Raimundo Soares Valentim
Cristiano Souto Sant'Anna
Jean Souza Lopes
Rogério Stella Santos
Ricardo Teles
Fernando Aldo Torres Martinho
Marcos Kiyoshi Umeki Honma
Otavio Andrade Valle
Leticia Valverdes
José Varella
José Cláudio Vieira de Souza
Luis Tadeu Vilani
Luciana Whitaker
Paulo Brandao Whitaker

BULGARIA
Krassimir Andonov
Mladen Antonov
Dimitar Dilkoff
Roumen Georgiev
Vasko Hadjiivanov
Hristo Hristov
Stoyan Mihailov Iliev
Slavtcho Angelov Kalinov
Krasimir Krastev
Dimitar Kyosemarliev
Aziz Syuleyman Mehmed
Nedelian Radkov Neshev
Todor Stefanov Todorov
Biser Todorov
Ivan Sabev Tzonev
Nickolaev Veselinov
Boris Voynarovitch

BURKINA
Abel Kaboré
Ouekia Tagnabou

CAMEROON
Dieudonne Abianda
Jean Ayissi
Eustache Djitouo Ngouagna
Jean Kamta
Raphaël Mbiele

CANADA
Carlo Allegri
Christopher Anderson
Serguei Bachlakov
David Samuel Bebee
Sacha Dean Bïyan
Zoran Bozicevic
Bernard Brault
Peter Bregg
Glenn Campbell
David Campion
Phil Carpenter

Ryan James Causgrove-Carter
Grace Chiu
Jack Cusano
Vincenzo D'Alto
Barbara Davidson
Brent William Davis
Hans Deryk
Carrie Devorah
Frazer Dryden
Heather Faulkner
Adrienne Dale Fox-Keesic
Ricky Friedlander
Edward Gajdel
Brian James Gavriloff
Wayne Glowacki
Susan Hammond
John Hasyn
Chris Helgren
Marianne Helm
Philip Hossack
Harry How
Emiliano Joanes
Richard Kirkland
Marko Kokic
Robert Laberge
Rita Leistner
Roger Lemoyne
Jean Levac
Rick Madonik
Peter McCabe
Mathew McCarthy
Jeff McIntosh
Gerry Meyers
Stephen Morrison
Paul Nicklen
Farah Nosh
Gary Nylander
George Omorean
Louie Palu
Edward Parsons
Goran Petkovski
Wendell Phillips
Stephanie Pommez
Duane Prentice
Marc Rochette
James Ross
Steve Russell
Derek Ruttan
Rick Rycroft
Chris Schwarz
Peter Sibbald
Dave Sidaway
Steve Simon
Clifford Skarstedt
David W. Smith
Phill Snel
André Souroujon
Gregory Southam
Lyle Ross Stafford
Nayan Sthankiya
Kevin Unger
Jeff Vinnick
Andrew Wallace
George Webber
Dana Wilson
Larry Wong
Iva Zímová

CHILE
Orlando Barria Maichil
Rodrigo Garrido Fernández
Manuel Garrido Garrido
Waldo Nilo
Pedro Rodriguez Maulen
Gonzalo Santa-Ana Bustos
Pedro Ugarte
Eduardo Verdugo
Frank Villagra

COLOMBIA
Jose Africano Rodriguez
Luis Henry Agudelo Cano
Gabriel Aponte Salcedo
Eliana Aponte Tovar
Felipe Andrés Caicedo Chacón
Cesar Augusto Carrillo Gomez
Gerardo Chaves Alonso
Milton Diaz Guillermo
Edgar Dominquez Catano
Martin Edwardo Garcia Pinto
Camilo Jose George
Jose Miguel Gomez Mogollon
Julio Cesar Herrera

144

Albeiro Lopera Hoyos
Daniel Munoz
Eduardo Munoz Alvarez
Jorge Eliecer Orozco Galvis
Jaime Otoniel Pérez Munevar
Henry Romero
Robinson Saenz Vargas
Juan Antonio Sanchez Ocampo
Roberto Schmidt
Joana Marcela Toro Mora
John Wilson Vizcaino Tobar
Donaldo Zuluaga Velilla

COSTA RICA
Carlos Arturo Borbón Castro
Allen Campos Corrales
Marvin Caravaca Murillo
Jorge Arturo Castillo Monestel
Jose Luis Diaz Serrano
Sonia Leon Leon
Carlos Alberto León León
Marco Monge Rodriguez
Kattia Patricia Vargas Araya
David Vargas-Chacón

CROATIA
Fjodor Klaric
Jovan Kliska
Vanda Kljajo
Sasa Kralj
Zvonko Kucelin
Dragan Matic
Dejan Miculinic
Josip Petric
Hrvoje Polan
Damir Rajle
Drazen Tomic
Kos Vlado

CUBA
Dennis Miguel Delgado Garcia
Josué López Lozano
Jorge López Viera
Humberto G. Mayol Vitón
Noel Miranda Perez
Alejandro Pérez Estrada
Luis Quintanal Cabriales
Emilio Valdés Espinosa

CYPRUS
Anikitos Hadjicharalampous
Petros Karadjias
Andreas Vassiliou

CZECH REPUBLIC
Tomas Bican
Vladimir David
Alena Dvorakova
Viktor Fischer
Michael Fokt
Hana Jakrlova
Boris Kolar
Antonin Kratochvil
Stanislav Krupar
Jana Kufova
Tomki Nemec
Michal Novotny
Lucie Parizkova
Michal Prokop
Slavek Ruta
Robert Sedmik
Roman Sejkot
Jan Sibik
Josef Sloup
Veronika Souralová
Steinova Stepanka
Jan Symon
Jiri Urban
Jan Zatorsky

DENMARK
Adam Amsinck
Nicolas Asfouri
Casper Balsen
Lars Bech
Brian Berg
Soren Bidstrup
Michael H. Boesen
Thomas Borberg
Marie Louise Brimberg
Finn Byrum
Jakob Carlsen
Bo Bolther Christensen

Casper Dalhoff
Jakob Dall
Miriam Dalsgaard
Jacob Ehrbahn
Bardur Eklund Johansen
Lene Esthave
Martin Foldgast
Finn Frandsen
Jan Anders Grarup
Tine Harden
Maria Hedegaard
Jörgen Hildebrandt
David Hogsholt
Ulrik Jantzen
Michael Jensen
Jeppe Michael Jensen
Adam Jeppesen
Simon Jeppesen
Nils Jorgensen
Pelle Rink Jorgensen
Lizette Kabré
Anna Kirstine Kari
Lars Krabbe
Joachim Ladefoged
Claus Bjorn Larsen
Jens Norgaard Larsen
Soren Lauridsen
Tao Lytzen
Poul Madsen
Christian Mailand
Nils Meilvang
Lars Moeller
Martin Soeby Nielsen
Mads Nissen
Miklas Njor
Peter Hove Olesen
Ulrik Pedersen
Joergen Flemming Petersen
Torben Raun
Erik Refner
Morten Rygaard
Stefan Schnoor
Thomas Sjorup
Claus Sondberg Larsen
Soren Solkaer Starbird
Torben Stroyer Andersen
Michael Svenningsen
Ernst Tobisch
Kare Viemose
Robert Wengler
Thomas Wilmann
Martin Zakora

DOMINICAN REPUBLIC
Ignacio Ramirez

ECUADOR
Betty Bastidas
Francisco Bravo Armijos
Pavel Calahorrano Betancourt
Mario Ivan Egas Metia
Martin Manuel Herrera Torres
Dolores Ochoa Rodriguez
Christian Ortega De La Rosa
Galo Armando Paguay Becerra
Diego Roberto Pallero Torres
Juan Carlos Pérez Mino
Leen Armando Prado Viteri
Edison Geovanny Riofrio
Barros
Patricio Xavier Teran Argüello
Eduardo Vinicio Teran Urresta
Eduardo Vavenzuela Garzón

EGYPT
Mohamed Abd El Rahman
Mohamed Gamal El Arabic
Amer Sawsan Mohamed Ezzat

EL SALVADOR
Filander Alas Miranda
Félix Enrique Amaya Chices
Francisco Belloso
José Alberto Cabezas Bernal
Julio César Campos Martinez
Francisco Javier Campos Sosa
Milton Flores
Gabriela Hasbun Safie
Borman Marmol
Salvador Melendez

ERITREA
Teklemariam Tekeste Debru
Ogbai Gebre Kidan Eyob
Gebremicael Abraha Girmay
Yosief Ali Idrisadem
Yohannes Bereket Iyasu
Tesfaldet Kidane
Abrehet Tekle Teklzghi
Kidane Teklemariam
Daniel Tesfai Kahsai

ESTONIA
Märten Kross

ETHIOPIA
Tikher Teferra Kidane

FINLAND
Tommi Anttonen
Jukka Gröndahl
Seppo Haavisto
Tapio Hartikainen
Hannes Heikura
Markus Jokela
Petteri Kokkonen
Kari Kuukka
Raine Lehtoranta
Elina Moriya
Juhani Niiranen
Jussi Nukari
Linda Nylind
Timo Pyykkö
Jukka Ritola
Eetu Sillanpää
Seppo Tompuri
Ilkka Uimonen
Hannu Vanhanen

FRANCE
Bruno Abile
Pascal Aimar
Guilhem Alandry
Thierry Ardouin
Patrick Artinian
Maher Attar
Patrick Aventurier
Alain Le Bacquer
Vincent Baillais
Georges Bartoli
Patrick Baz
Halim Berbar
Christophe Bertolin
Arnaud Blanchard
Romain Blanquart
Olivier Boëls
Christian-Adrien Boisseaux
Samuel Bollendorff
Guillaume Bonn
Regis Bonnerot
Muriel Bortoluzzi
Bruno Boudjelal
Youcef Boudlal
Jean-Marc Bouju
Denis Boulanger
Alexandra Boulat
Grégory Brandel
Ali Burafi
Christophe Calais
Alvaro Canovas
Serge Cantó
Thomas Caplain
Sarah Caron
Fainali Cedmic
Franck Charton
Julien Chatelin
Eric Chauvet
Pierre Ciot
Martin Clement
Thomas Coex
Guillaume Collanges
Olivier Coret
Olivier Corsan
Olivier Coulange
Gilles Coulon
Olivier Culmann
Francois Daburon
Denis Dailleux
Julien Daniel
William Daniels
Hélène David
Georges Dayan
Beatrice De Gea
Gautier Deblonde

Luc Delahaye
Jerome Delay
Magali Delporte
Francis Demange
Michel Denis-Huot
Jeromine Derigny
Lionel Derimais
Philippe Desmazes
Agnès Dherbeys
Fabrice Dimier
Tiane Doan Na Champassak
Claudine Doury
Nicolas Dubreuil
Jean-Baptiste Duchenne
Isabelle Eshraghi
Albert Facelly
Hubert Fanthomme
Franck Faugere
Eric Feferberg
Bruno Fert
Nicolas Feuillet
Laurence Fleury
Sylvie Francoise
Mélanie Frey
Raphaël Gaillarde
Matilde Gattoni
Christophe Gin
Pierre-Yves Ginet
Pierre Gleizes
Georges Gobet
Nicolas Goldberg
Julien Goldstein
Olivier Golinksi
Nicolas Gouhier
Mathieu Grandjean
Isabelle Grattard
Olivier Grunewald
Michel Gunther
Pascal Guyot
Valéry Hache
Eric Hadj
Bruno Hadjih
Philippe Haÿs
Daniel Herard
Patrick Hertzog
Gabrielle Hirigoyen
Boris Horvat
Laurent Houdayer
Olivier Jobard
Gérard Julien
Alain Kauffmann
France Keyser
Khanh Dang Tran
Pascal Kober
Patrick Kovarik
Jean Philippe Ksiazek
Fréderic Lafargue
Vincent Laforet
Nicolas Lainez
Dominique Lampla
Yves Lanceau
Jacques Langevin
Karine Laval
Miard Laver
Christophe Lepetit
Philippe Lissac
Christian Franck Lombardi
Michel Luccioni
Gaëlle Magder
Gregoire Maisonneuve
Etienne de Malglaive
Richard Manin
Alexandre Marchi
Pascal Massieu
Bertrand Meunier
Olivier Mirguel
Philippe Montigny
Bruno Morandi
Eve Morcrette
Jean Claude Moschetti
Jean Francois Muguet
Vincent Munier
Roberto Neumiller
Jose Nicolas
Jean-Michel Niester
Rém Ochlik
Tadeusz Paczula
Serge Pagano
François Paolini
Franck Paubel
Gerard Planchenault
Jean-Pierre Porcher
Philippe de Poulpiquet

Cristina Quicler
Noël Quidu
Jean Baptiste Rabovan
Hubert Raguet
Christophe Reati
Laurent Rebours
Nicolas Reynard
Patrick Robert
Xavier Rossi
Jean-Yves Ruszniewski
Marion Ruszniewski
Joël Saget
David Sauveur
Laurent Sazy
Benoit Schaeffer
Jean-Pierre Schwartz
Pascal Le Segretain
Franck Seguin
Teddy Seguin
Roland Thierry Seitre
Ahmet Sel
Jérôme Sessini
Christophe Simon
Won-Myoung Son
Fabrice Soulié
Christine Spengler
Michel Spingler
Anne van der Stegen
Laurent van der Stockt
Dominique Szczepanski
Patrick Tourneboeuf
Olivier Touron
Jean-Michel Turpin
Gerard Uferas
Eric Vandeville
Stéphane Viard
Laurent Weyl
Bernard Wis
Stephan Zaubitzer
Michael Zumstein

GAMBIA
Njie Pamodou

GEORGIA
Tamaz Bibiluri
Giorgi Bukhaidze
Konstantin Iantbelidze
Levan Kherkheulidze
Ketevan Mgebrishvili
George Tsagareli
Mikheil Tvaradze
Beselia Vakhtang

GERMANY
Valeska Achenbach
Dirk Adolphs
Ingo Arndt
David Baltzer
Christoph Bangert
Patrick Barth
Theodor Barth
Dirk Bauer
Michael Bause
Alexander Becher
Andreas Otto Becker
Siegfried Becker
Marion Beckhauser
Markus Rolf Benk
Fabrizio Bensch
Thomas Bernst
Klaus-Dieter Beth
Antje Beyen
Frieder Blickle
Sebastian Bolesch
Stefan Boness
Karsten Bootmann
Wolf Böwig
Michael Braun
Hermann Bredehorst
Frank Bredel
Florian Brenner
Ulrich Brinkhoff
Hans Jürgen Britsch
Christian Bruch
Franka Bruns
Dirk Brzoska
Sven Creutzmann
Peter Dammann
Uli Deck
Jesco Denzel
Sven Döring
Thomas Dworzak

Winfried Eberhardt
Hans Richard Edinger
Thomas Einberger
Stephan Elleringmann
Thomas Ernsting
László György Ertl
Stefan Falke
Ute Fischer
Klaus D. Francke
Jürgen Freund
Sascha Fromm
Jürgen Fromme
Federico Gambarini
Maurizio Gambarini
Dirk Gebhardt
Christoph Gerigk
Soenke Giard-Weiss
Michael Giegold
Peter Ginter
José Giribás Marambio
Bodo Goeke
Patrick Haar
Kirsten Haarmann
Gabriel Habermann
Michael Hagedorn
Matthias Hangst
Alfred Harder
Alexander Hassenstein
Michael von Haugwitz
Harald Hauswald
Thomas Hegenbart
Gerhard Heidorn
Katja Heinemann
Kai-Uwe Heinrich
Wim van der Helm
Frank Herfort
Katharina Hesse
Markus C. Hildebrand
Annegret Hilse
Ralph Hinterkeuser
Joachim Hirschfeld
Helge Holt
Milan Horacek
Eva-Maria Horstick-Schmitt
Andreas Hub
Johann Wolfgang Huppertz
Ralf Ibing
Stephan Jansen
Rainer Jensen
Gundula Joecks
Karl Johaentges
Kati Jurischka
Paul Kalkbrenner
Claus Kiefer
Thomas Kienzle
Ursula Kimmig
David Klammer
Jorg Klaus
Christian Klein
Gunter Klötzer
Gunnar Knechtel
Herbert Knosowski
Heidi & Hans-Jürgen Koch
Vincent Kohlbecher
Thomas Köhler
Uwe Gregor Kölsch
Reinhard Krause
Gert Krautbauer
Stephan Krudewig
Dirk Krüll
Guido Krzikowski
Andrea Künzig
Charly Kurz
Georg Kürzinger
Jens Küsters
Karl Lang
Martin Langer
Paul Langrock
Daniel-Marc Lathwesen
Achim Liebsch
Andreas Lindlahr
Achim Lippoth
Dorothea Loftus
Michael Löwa
Maximilian Ludwig
Martin Magunia
Aurelius Maier
Hans Karl von Manteuffel
Ralf Maro
Noël Matoff
Markus Matzel
Daniel Maurer
Dieter Menne

145

Denis Meyer
Judith Michaelis
Jan Michalko
Thorsten Milse
Sammy Minkoff
Bernd Robert Müller
Hartmut Müller
Peter Müller
Dorcas Evelyn Müller
Heinel Müller-Elsner
Mark-Oliver Multhaup
Turemis Murat
Anja Niedringhaus
Christoph Otto
Jens Palme
Ladislav Perenyi
Carsten Peter
Marc Bernd Pfeiffer
Karoly Pump
Karl-Heinz Raach
Stephan Rabold
Thomas Rabsch
Roland Rasemann
Sabine Reitmaier
Pascal Amos Rest
Jiri Rezac
Hojabr Riahi
Astrid Riecken
Julian Röder
Daniel Roland
Daniel Rosenthal
Jens Rötzsch
Norbert Rzepka
Gerard Saitner
Michael Sakuth
Ottfried Sannemann
Martin Sasse
Horst Schäfer
Susanne Veronika Schaffry
Rüdiger Schall
Peter Schatz
Walter Schels
Günter Schiffmann
Gregor Schläger
Jordis Antonia Schlösser
Steffen Schmidt
Harald Schmitt
Katrin Schneider-Sadjiroen
Harry Schnitger
Martin Schoeller
Bernd Schönberger
Marco Schrade
Kurt Franz Schrage Ahuis
Steffen Schrägle
Markus Schreiber
Horst Thomas Schreyer
Bernd Schuller
Rolf Schultes
Frank Schultze
Silke Schulze-Gattermann
Stephan Schütze-Schulte
Hartmut Sönke Schwarzbach
Oliver Alexander Sehorsch
Yvonne Seidel
Frank Siemers
Alexandre Simdes
Peter Sondermann
Ralph Sondermann
Künibert Söntgerath
Renado Spalthoff
Martin Specht
Gabriele Staebler
David Steets
Dominique Steiner
Carsten Harry Steinke
Marc Steinmetz
Volker Strohmaier
Kai Stuht
Patrick Sun
Jens Sundheim
Peter Thomann
Elena Tikhonova
Jaywant Ullal
Markus Ulmer
Friedemann Vetter
Heinrich Voelkel
Horst Wackerbarth
Frank Peter Wartenberg
Eduard Friedrich Weigert
Maurice Weiss
Wolf-Dietrich Weissbach
Philipp Wente
Sabine Wenzel

Detlef Westerkamp
Jennifer Weyland
Sebastian Widmann
Kai Wiedenhöfer
Claudia Yvonne Wiens
Ann-Christine Wöhrl
Michael Wolf
Christian Wyrwa
Christian Ziegler
Marcus Zumbansen

GHANA
Forstin Adjei Doku
Thomas Fynn
Godfred Blay Gibbah
Florence Nortey
Emanuel Quaye

GREECE
Stylianos Baklavas
Yannis Behrakis
Alexandros Beltes
Efstratios Chavalezis
Greg Chrisohoidis
Nikolaos Chrysikakis
Petros Giannakouris
Vasilis D. Gonis
Louisa Gouliamaki
Markos George Hionos
Navridis Ippouratis
Ioannis Kampouris
Georgios Katsouras
Yannis Kolesidis
Yannis Kontos
Thomas Lappas
Dimitri Messinis
Aris Messinis
Chryssa Panoussiadou
Maria Paschali
Lefteris Pitarakis
Vladimiros Rys
Thanasis Stavrakis
Sophie Tsabara
Georgios Ventouris

GUATEMALA
Moisés Castillo Aragón
Ernesto Ramírez Arriola

HAITI
Carl Juste

HONG KONG, S.A.R. CHINA
Jih Sheng Lei
David Wong Chi Kin

HUNGARY
Eva Arnold
László Balogh
Andras Bankuti
Imre Benkö
Gyula Czimbal
Bela Doka
Tivadar Domaniczky
Istuan Fazeuas
Imre Földi
Csaba Forrásy
Viktória Gálos
Balazs Gardi
András Hajdu
Szilárd Koszticsák
Terei Miklos
Zoltan Molnar
Maté Nandorfi
Németh Peter
Lajos Soós
Miklós Szabó
Sandor H. Szabo
Peter Szalmás
Bela Szandelszky
Péter Zádor
Balázs Róbert Zsolt

ICELAND
Jóhann Kristjánsson
Finnbogi Marinosson
Brynjar Gauti Sveinsson

INDIA
Piyal Adhikary
Ajay Aggarwal
Wani Aijaz Rahi
Riyas Annamanada

Bindu Arora
Ali Arshad
Anthony Azavedo
Ashish Bahl
Anand Bakshi
Ranganathan Balaji
Suman Ballav
Mohan Dattaram Bane
Tarapada Banerjee
Utpal Baruah
Jaswant Singh Bassan
Shome Basu
Shyamal Basu
Kamalendu Bhadra
Kadire Bhagya Prakash
Sandesh Bhandare
Rajesh Kumar Bhasin
Mahesh Bhat
Rama Krishna Bhat
A.K. Bijuraj
Rana Chakraborty
Kalyan Chakravorty
Suman Chatterjee
Chiang Quai Chou
Kamakhya Choudhary
Sherwin Crasto
Saurabh Das
Shantanu Das
Sucheta Das
Arko Datta
Suman Datta
Raaj Kumar Dayal
Rajib De
Pallikunnel Raghavan Deva Das
Dilipkumar
Jaganathanan Durai Raj
Subir Kumar Dutta
Dudmalkar Gajaman
Anumalla Gangadhar
Sanjib Jagannath Ganguly
Satyaki Ghosh
Subhendu Ghosh
Kumar Gopinathan
Subir Halder
Sankaran Kutty Harisankar
Abu Hashim
Deepak Hazra
Vyas Himanshu
Sunil Inframe
Mohammad Asaf Iqbal
Ramakrishna S. Iyer
Mahesh Kumar Jain
C.K. Jayakrishnan
N.P. Jayan
Samar S. Jodha
Fayaz Ahmad Kabli
Sankha Kar
Anil Kumar Karadiyil Rajappan
Harikrishna Katragadda
Kamal Kishore
Ajeeb Komachi
Jan Kristianto
Vipin Kumar
Salil Kumar Bera
Atul Loke
Anay Maan
Sham Manchekar
Johnson Mandumbal Kuriyan
B. Mathur
S.K. Mohan
K. Mohanan
Thattankandy Mohandas
Arun Mondhe
Bhaskar Mukherjee
Indranil Mukherjee
Sabuj Mukhopadhyay
James Sundar Murthy
Kunjumohammed Najeeb
Pankaj Nangia
Gorantla Venkata Narayana
Chowdavarapu Narayana Rao
Dev Nayak
Josekutty J. Panackal
Punit Paranjpe
Ganesh Parida
Shriya Patil
Rajeev Prasad
Syed Altaf Ammad Qadri
M.K. Abdul Rahman
Chellapan Rajendron
S.S. Ram
Ramanathan Nileshwaram Pai
Kannekanti Ramesh Babu

Lalit Kumar Rana
Shailesh Raval
K. Ravikumar
Guggempudi Ravinder Reddy
Mallula Ravindranath
Nilanjan Ray
Abdul Razack
Ruby Sarkar
Kayyur Sasi
Anthikkal Satheesh
Pankaj Sekhsaria
Bijoy Sengupta
Hemendra A. Shah
Russell Shahul
Roshan Lal Sharma
Jayanta Shaw
V.S. Shine
Ajoy Sil
Prakash Singh
Virendra Singh
Rajib Singha
Thomas Solomon
Chetan Soni
Shekhar Soni
Arun Sreedhar
R.R. Srinivasan
Tamma Srinivasareddy
Anantha Subramanyamik
P.V. Sujith
Pradeep Tewari
Harish Tyagi
Malayil Kuriakose Varghese
Regi Varghese
Ch. V.B. Venkata Satya Rao
Keshava Vitla
Zakir Ali "Marhoom"

INDONESIA
Imal Afriadi Hikmal
Timur Angin
Arief Arianto
Abdul Kadir Audah
Bagong Zelphi
Bagus Kurniawan
Tantyo Bangun
Berto Basilissa Wedhatama
Bayu Ismoyo
Adek Berry
Wibudiwan Tirta Brata
Ali Budiman
Bernard Chaniago
Ade Dani Setiawan
Aryono Huboyo Djati
Dwi Prasetyo Budi Santosa
Bambang Fadjar
Muhammad Said Hararap
Hariyanto
Tarmizy Harva
Fernandez Hutagalung
Iim Ibrahim
Andi Kurniawan Lubis
Aris Liem
Ali Lutfi
Mahardhika
Mak Pak Kim
Yusuf Achmad Muhammad
Pang Hway Sheng
Ivan Nardi Patmadiwiria
Hadi Pramono
Edy Purnomo
Didi R. Rahardjo
Fadjar Roosdianto
Roy Rubianto
Ahmad Salman
Zakir Salmun
Pujianto Johan Leo Santo Leo
Ferdy Siregar
Poriaman Sitanggang
Sugede S. Sudarto
Tarko Sudiarno
Cholif Sudjatmiko
Arief Suhardiman Sutardjo
Jurnasyanto Sukarno
Sun Yoto
Toto Sungsang Suprapto
Rama Surya
Agus Susanto
Winarno Tjitra
Nuraini Tjitra Widya
Aris Wahyudi
Wasis Wibowo
Umar Widodo

IRAQ
Koutaiba Al-Janabi
Ahmad Al-Rubaye
Faleh Kheiber
Ibrahim S. Nadir

IRELAND
Julien Behal
Alan Betson
Marcus Bleasdale
Desmond Boylan
Deirdre Brennan
David Conachy
Seamus Conlan
Kieran Francis Doherty
Colman Doyle
Denis Doyle
Michael Dunlea
Matt Kavanagh
Dara Mac Dónaill
Josephine McGuire
John D. McHugh
Ian McIlgorm
Denis Minihane
Seamus Murphy
Jeremy Nicholl
Jacques Julien Nutan
Bryan O'Brien
Paul O'Driscoll
Kenneth O'Halloran
James O'Kelly
Joe O'Shaughnessy
Paul Stewart
Dermot Tatlow
Paul Treacy
Eamon Ward
Clive Wasson

ISLAMIC REPUBLIC OF IRAN
Masoud Ahmed Zadeh
Arash Akhtari Rad
Ali Ali
Davood Amiri
Aslon Arfa
Alireza Attariani
Mahmood Badrfar
Kaveh Baghdadchi
Ebrahim Bahrami
Maryam Bakhshi
Moharram-Ali Balabarzi
Massood Basiri Tabriz
Jamshid Bayrami
Mohammad Ali Berno
Noushin Najafi Birgani
Amirreza Boriry
Nahal Chizari
Leyla Dallalnejad
Esmaeil Davari
Mehdi Dorkhah
Mehdi Doroodian
Majid Dozdabi Movahed
Javad Erfanian Aalimanesh
Saeed Faraji
Mohammad Farnood
Mahdi Fathi
Seyyed Mohammad Fazaeli
Caren Firouz
Vaghari Shurcheh Ghadir
Ali Ghalamsiah
Mehdi Ghasemi
Amir Hoshyar Ghassemnejad
Babak Ghoorchyan
Mohammad Golchin Kohi
Reza Golchin Kohi
Farzin Golpad
Mehrak Habibi
Mansooreh Hajihosseini
Seid Reza Hashemi
Maral Hassani
Mohammad Hossein Heydari
Raheb Homavandi
Seyedi Jalil Hosseini Zahraei
Siamak Imanpoor
Hashem Javad Zadeh
Ali Karimi Rastegar
Matin Kashani Farid
Atta Kenare
Majid Khamseh Nia
Mohammad Khodadadash
Soleyman Mahmoodi
Karim Malak Madani
Katayoun Massoudi Naraghi
Hadi Mehdizadeh

Behrouz Mehri
Ashraf Jahani Mir Zahed
Yalda Moayeri
Banafsheh Modaressi
Ahmad Moeeni Jam
Morteza Mousavi
Hamid Mozaffari
Sara Ahmadi Najaf Abadi
Ahad Nazarzadeh
Hossein Neshat Mobini Tehrani
Morteza Nikoubazl
Nazi Nivandi
Morteza Noor-Mohammadi
Salehi Kolahi Omid
Amir Masoud Oskouilar
Ali Pourmahmoud
Morteza Pournejat
Javad Poursamad
Mehdi Rame
Hafez Rohani
Payam Rouhani
Md Ali Sabaghi Gharajeh
Seyed Md Taher Sadati
Kavoos Sadeghloo
Karim Sahib
Salek Soheil
Seifollah Samadi Aydenloo
Mohsen Sanei Yarandi
Hasan Sarbakhshian
Babak Sedighi
Seyed Ali Seyedi
Shahin Shahablou
Mehdi Sharifzadeh
Shahpari Sohaie
Pooyan Tabatabaei
Ataollah Taher Kenareh
Mohammad Taran
Newsha Tavakolian
Behzad Torki Zadeh
Alireza Varzam
Hasan Vasheghani Farahani
Younes Zakeri
Shahrnaz Zarkesh
Hamideh Zolfaghari Monfared

ISRAEL
Ammar Jamil Awad
Oded Balilty
Rina Castelnuovo
Gil Cohen Magen
Natan Dvir
Nir Elias
Kevin Frayer
Gil Hadani
Israel Hadari
Nir Kafri
Menahem Kahana
Ziv Koren
Benedicte Kurzen
Yoav Lemmer
Shay Mehalel
Chen Mika
Ilan Mizrahi
Lior Yoav Mizrahi
Eyal Ofer
Baz Ratner
Inbal Rose
Ruth Rubenstein
Dany Salomon
Ariel Schalit
Sebastian Scheiner
Roni Schützer
Shaul Schwarz
Ahikam Seri
Amit Shabi
Ariel Tagar
Pierre Terdjman
Gali Tibbon
Eyal Warshavsky
Pavel Wolberg
Ronen Zvulun

ITALY
Francesco Acerbis
Mauro D'Agati
Gregory Anthony Acs
Salvatore Alagna
Aurora Alfio
Alfredo D'Amato
Marco Anelli
Giovanni Attalmi
Neri Bagnai
Antonio Baiano

Luca Baldassini
Luigi Baldelli
Danilo Balducci
Isabella Balena
Alessandra Benedetti
Giuseppe Bizzarri
Mario Boccia
Paolo Bona
Tommaso Bonaventura
Marcello Bonfanti
Alberto Bortoluzzi
Enrico Bossan
Mauro Bottaro
Luca Bracali
Roberto Brancolini
Leonardo Brogioni
Roberto Caccuri
Jean Marc Caimi
Alberto Cambone
Maristella Campolunghi
Stefano Cardone
Stefano Carofei
Marco Casale
Luciano del Castillo
Lorenzo Castore
Alfonso Catalano
Riccardo Cavallari
Carlo Cerchioli
Daniela Cestarollo
Giuseppe Chiucchiú
Lorenzo Cicconi Massi
Elio Ciol
Francesco Cito
Pier Paolo Cito
Francesco Cocco
Paolo Cocco
Elio Colavolpe
Gianluca Colla
Antonino Condorelli
Giovanni Conte
Marzia Cosenza
Alessandro Cosmelli
Lidia Costantini
Claudio Cricca
Marco Cristofori
Pietro Cuccia
Massimo Cutrupi
Fabio Cuttica
Enrico Dagnino
Daniele Dainelli
Giovanni Diffidenti
Alessandro Digaetano
Dario de Dominicis
Giuseppe Fassino
Franco Felce
Paola Fiore
Peef Fiorillo
Massimiliano Fornari
Ermanno Foroni
Gianfranco Forza
Adolfo Franzò
Claudio Gallone
Luigi Gariglio
William Gemetti
Enrico Genovesi
Vince Paolo Gerace
Fausto Giaccone
Pietro Di Giambattista
Helen Giovanello
Nicola Giuliato
Roberto Giussani
Alessandro Grassani
Paola de Grenet
Gianluigi Guercia
Guido Harari
Mattia Insolera
Roberto Isotti
Riccardo Kriscjak
Francesco Paolo Lannino
Sabatino Laddanna
Marco Di Lauro
Antonino Lombardo
Elio Lombardo
Marco Longari
Armando Di Loreto
Valentina Love
Fabio Lovino
Enrico De Luigi
Stefano de Luigi
Alex Majoli
Ettore Malanca
Guido Ezequiel Manuilo
Claudio Marcozzi

Luca Marinelli
Carlo Marras
Domenico Marziali
Enrico Mascheroni
Roberto Masi
Massimo Mastrorillo
Andrea Matone
Daniele Mattioli
Daniele Maurizi
Paul Melillo
Giovanni Mereghetti
Raffaele Meucci
Camilla Micheli
Dario Mitidieri
Mimì Mollica
Bruno del Monaco
Davide Monteleone
Antonella Monzoni
Silvia Morara
Alberto Moretti
Lorenzo Moscia
Emanuele Mozzetti
Gianni Muratore
Giulio Napolitano
Luigi Narici
Antonello Nusca
Piero Oliosi
Oliviero Olivieri
Bruna Orlandi
Maurizio Orlanduccio
Isabela Pacini
Franco Pagetti
Stefano Paltera
Paolo Patrizi
Samuele Pellecchia
Paolo Pellegrin
Maurizio Petrignani
Carlo Pettinelli
Alessia Pierdomenico
Mario Pietrangeli
Vincenzo Pinto
Alberto Pizzoli
Daniele Ponteri
Roberto Ponti
Franco Pontiggia
Paolo Porto
Giancarlo Pradelli
Rino Pucci
Domenico Pugliese
Raffaello Raimondi
Sergio Efrem Raimondi
Sergio Ramazzotti
Alberto Ramella
Giuseppe Rampolla
Max Ranchi
Stefano Rellandini
Alessandro Rizzi
Andrea Sabbadini
Massimo Sambucetti
Gianluca Santoni
Marco Saroldi
Giuseppe Sbarigia
Gastone Scarabello
Roberto Scarfone
Antonio Scattolon
Hannes Schick
Massimo Sciacca
Emanuel Scevolutti
Alessandro Scotti
Livio Senigalliesi
Pasqualino Paco Serinelli
Fabio Sgroi
Shobha
Paolo Siccardi
Massimo Siragusa
Mario Spada
Mauro Spanu
Riccardo Tagliabue
Luigi Tazzari
Moreno Di Trapani
Francesco Troina
Marco Vacca
Antonio Vacirca
Paolo Ventura
Riccardo Venturi
Stefano Veratti
Paolo Verzone
Fabrizio Villa
Claudio Vitale
Paolo Volponi
Daniel Dal Zennaro
Francesco Zizola

IVORY COAST
Nazaire Monde Vaha
Issouf Sanogo

JAMAICA
Norman Grindley

JAPAN
Noriyuki Aida
Kazuyoshi Ehara
Yasuto Inamiya
Itsuo Inouye
Takaaki Iwabu
Teru Iwasaki
Jiro Ose
Ryo Kameyama
Ryo Kato
Chiaki Kawajiri
Kimio Ida
Takao Kitamura
Ko Sasaki
Taro Konishi
Hitoshi Maeshiro
Yohei Maruyama
Yoshinori Matsuda
Fumiko Matsuyama
Shigeki Miyajima
Yuko Miyajima
Toru Morimoto
Takuma Nakamura
Minoru Nasu
Yasuhiro Ogawa
Hiroaki Ono
Nobuko Oyabu
Takashi Ozaki
Tamako Sado
Qujiro Sakamaki
Shuzo Shikano
Shingo Nakamura
Dai Sugano
Chitose Suzuki
Ryuzo Suzuki
Kuni Takahashi
Tadao Takako
Takanori Sekine
Mitsu Yasukawa
Jun Yasukawa
Yutaka Yonezawa
Okunishi Yoshikazu

JORDAN
Osama Dawod Abughanim
Wael Al-Hijazeen
Hanady Al-Ramahi
Ali Al-Sahouri
Mohammad Al-Tarazi
Samir Atalla
Isam Bino

KAZAKHSTAN
Viktor Gorbunov
Valery Korenchuk
Olga Korenchuk
Aziz Mamirov
Shamil Zhumatov

KENYA
Anthony Kaminju
Julius Mwelu Manyasi
Omondi Onyango
Deepak Jasmat Patel
Khamis Ramadhan
Eric Santos Kadima

LATVIA
Aigars Eglite
Andris Kozlovskis
Janis Pipars
Alnis Stakle
Vadims Straume
Zigismunds Zalmanis

LEBANON
Anwar Amro
Mustapha Elakhal
Ramzi Haidar
Teddy Moarbes
Nabil Hassan Mounzer
Marwan Naamani

LITHUANIA
Giedrius Baranauskas
Tomas Bauras
Ramunas Danisevicius
Vladimiras Ivanovas
Tomas Kanueckas
Petras Katauskis
Alius Koroliovas
Kazimieras Linkevicius
Petras Malukas
Dmitrij Matvejev
Herkus Milasevicius
Rolandas Parafinavicius
Vladas Sciavinskas
Sigitas Stasaitis
Jonas Staselis

LUXEMBOURG
Jean-Claude Ernst

MACEDONIA
Ivan Blazev

MADAGASCAR
Gisele Rakotoarivony
J.L. Ravonjiarisoa Narivololona
Etienne Razafindrakoto

MALAWI
Amos Gumulira

MALAYSIA
Jaafar Abdullah
Sawlihim Bakar
Chai Hin Goh
Jwee Hiong Kee
Lee Keng Siang
Kah Meng Lek
Liew Wei Kiat
Swee Giok Lim
Lim Beng Hui
Jeffery Lim Chee Yong
Bazuki Muhammad
Noor Azman Zainudin
Alexander Ong Wee Beng
Sang Tan
Tan Ee Long
King Huat Tang
Vincent Thian
Aswad Yahya
Yau Choon Hiam

MALI
Emmanuel Daou Bakary
Yaya Alpha Diallo

MALTA
Michael Ellul
Darrin Zammit Lupi

MAURITIUS ISLAND
Georges Michel

MEXICO
Carlos Abraham Slim
Kira Ariadna Alvarez Bueno
Hector Amezcua
Guillermo Arias Camarena
Julio César Asencio Gonzalez
Ulises Castellanos Herrera
Luis Vicente Castillo Vazquez
Julieta Cervantes Guerrero
Ray Chavez
Carlos Alberto Contreras Durán
Alejandro Cossío Borboa
Elizabeth Dalziel
Damian Dovarganes
Elizabeth Esguerra
Tonatiuh Figueroa Monterde
Allan Fis Grossman
Marco Arturo Garcia Campos
Hector Javier Garcia Ibarra
Gustavo Gatto Caceres Perez
Ramón Gonzalez Gutierrez
Claudia Guadarrama Guzman
Hector Guerrero Skinfill
Ricardo Maldonado Garduno
Patricia Méndez Obregón
Danilo Morales Contreras
David Alejandro Morales Diaz
Gonzalo de Metztli Pérez Pérez
Alberto Puente Segura
Arturo Ramos Guerrero

Rafael del Rio Chávez
Jose Rodriguez Camacho
Oscar Ruizesparza Herera
Oscar Salas Gómez
Enrique Sifuentes Ramos
Rebeca Soler Ramirez
Abel Uribe
Marco Aurelio Vargas Lopez
Jose Federico Vargas Somoza
Luis Alberto Vilchez Pella
Jose de Jesus Villaseca Chavez
Enrique Villaseñor Garcia
Antonio Zazueta Olmos

MOLDAVIA
Natalia Chiosse

MOROCCO
Abdelhak Senna

NAMIBIA
Karel Prinsloo

NEPAL
Ghale Bahadur Dongol
Mukunda Kumar Bogati
Aroj Gopal Gurubacharya
Rajesh Gurung
Chandra Shekhar Karki
Dinesh Maharjan
Chandra Man Maharjan
Kiran Kumar Panday
K.C. Rajesh
Surendra Shahi
Sagar Shrestha
Prasant Shrestha
Narendra Shrestha
Naresh Kumar Shrestha

THE NETHERLANDS
Jan Banning
Shirley Barenholz
Maurice Bastings
Amber Beckers
Marcel G.J. van den Bergh
Diana Elena Blok
Peter Blok
Chris de Bode
Jan Boeve
Morad Bouchakour
Rokus van den Bout
Henk Braam
Eric Brinkhorst
Joost van den Broek
Gitta van Buuren
René Clement
Rachel Corner
Alexis Deenen
Peter Dejong
JanJaap Dekker
Max Dereta
Kees van Dongen
Danny Ellinger
Ilse Frech
Brian George
Martijn van de Griendt
Michel de Groot
Michiel Hegener
Piet Hermans
Hans Heus
Wilfred Shamkoemar Hiralal
Ronald de Hommel
Inge Hondebrink
Pieter ten Hoopen
Hessel van Huizen
David Mark Chaim Huizing
Antoinette de Jong
Martijn de Jonge
Ama Kaag
Karijn Kakebeeke
Felix Kalkman
Hans Kemp
Geert van Kesteren
Chris Keulen
Arie Kievit
Leonardus van der Kleij
Willem Klerkx
John Klijnen
Robert Knoth
Cor de Kock
Jeroen Kramer
Cornelia J. de Kruif
John Lambrichts

Jerry Lampen
Janneke Leegstra
Gé-Jan van Leeuwen
Floris Leeuwenberg
James van Leuven
Anke Ligteringen
Jaco van Lith
Kadir van Lohuizen
Alexander de Meester
Benno Neeleman
Jeroen Nooter
Jeroen Oerlemans
John Oud
Mladen Pikulic
Ahmet Polat
Frans Poptie
Patrick Post
Bernadet de Prins
Martin Roemers
Myriam Barbara Roesink
Gerhard van Roon
Raymond Rutting
Corné Sparidaens
Paul van der Stap
Frans Stoppelman
Sven Torfinn
Anne Marie Trovato
Peter Valckx
Mark Verdoes
Sophie Verhagen
Jan Vermeer
Joël Vingerling
Dirk-Jan Visser
Teun Voeten
Richard Wareham
Klaas Jan van der Weij
Eddy van Wessel
Emily Wiessner
Vincent van de Wijngaard
Paolo Orazio Woods
Herman Wouters
Rop Zoutberg

NEW ZEALAND
Scott Barbour
Craig Baxter
Melanie Burford
Geoff S. Dale
Mark Dwyer
Alan Hayward Gibson
Andrew Gorrie
Michael Hall
David Hancock
Jimmy Joe
Megan Beatrice Lewis
Robert Marriott
Michael George Millett
Brett Phibbs
Peter James Quinn
Phil Reid
Richard Robinson
Martin de Ruyter
Craig Simcox
Serena Giovanna Stevenson
Marion van Dijk

NICARAGUA
Lourdes Rossana Lacayo
Herguedas

NIGERIA
Abayomi Ademola Akinlabi
Taofeek Babajide
Moshood Olumuyiwa Hassan
Olumuyiwa Osifuye
George Osodi
Adedeji Sunday Olufemi
Peace Ilegbenedion Udugba

NORWAY
Paul Sigve Amundsen
Odd Andersen
Jonas Bendiksen
Tore Bergsaker
Stein Jarle Bjorge
Goran Bohlin
Goril Trondsen Booth
Terje Bringedal
Per Stale Bugjerde
Pal Christensen
Tomm Wilgaard Christiansen
Kristin Ellefsen
Orjan Ellingvag

147

Andrea Gjestvang
Thomas Hammarstrom
Pal Christopher Hansen
Stig B. Hansen
Harald Henden
Pal Hermansen
Jan Johannessen
Frode Johansen
Daniel Sannum Lauten
Minrsy Moller
Otto von Münchow
Fredrik Naumann
Aleksander Nordahl
Karin Beate Nosterud
Ken Opprann
Espen Rasmussen
Haavard Saeboe
Ingar Storfjell
Odd-Steinar Toellefsen
Lars Idar Waage
Knut Egil Wang

PAKISTAN
Asghar Khan

PALESTINIAN TERRITORIES
Mahfouz Abu Turk
Jaafar Ashtiyeh
Hazem Bader
Rula Halawani
Nayef Hashlamoun
Ahmed Jadallah
Abid Katib
Abed Mohamed
Bashar Nazal
Abed Omar Qusini
Mohammed Saber
Nasser Shiyoukhi

PANAMA
Demóstenes Angel Quiroz
Arnulfo Franco
Bernardino Freire Rodriguez
Ivan Mesa Jaen
Alvaro Reyes Nunez
Alcides Rodriguez
Jihan Rodriguez
Maydee Romero Sanchez

PARAGUAY
Hugo Fernández Enciso

PEOPLE'S REPUBLIC OF CHINA
Hejie An
Bian Qiwu
Bing Han
Cao Ju Juan
Cao Zhi-gang
Chan Wai Hing
Chang Gang
Yong Chen
Yongheng Chen
Mei Chen
Chen Da Yao
Chen Jun
Chen Linhua
Chen Yang
Chen Yuan Zhong
Chen Zhiwei
Cheng Bing Hong
Cheng Gang
Cheng Gong
Chenghua Gao
Ren Chenming
Chiang Yung-Nien
Zhi Shuang Cui
Cun Yun Zhou
Dalang Shao
Deng Bo
Deng Ruyi Geng
Ding Weiguo
Ding Zhogn Nan
Duan Jimin
Fang Yingzhong
Feng Lijun
Fu Chun Wai
Wei Gao
Baoyan Gao
Gu Aiping
Gu Xiao Lin
Guo Tao
Guo Yi Jiang
Haiqi Pan

Jianrong He
He DeLiang
He Jing Chen
He Yanguang
Feng Hei
Zhang Hong Feng
Hongtao Ren
Ping Hu
Hu Jin
Hu Qing Ming
Hu Weimin
Hu Yitian
Hua Qing
Yiming Huang
Huang Jingda
Huang Yibin
Huang Yue-Hou
Ji Yue Ming
Jia Guorong
Xiaoming Jiang
Jiang Zhibin
Jiao He
Jin Liwang
Jin Si Liu
Guangcai Ju
Kang Jing
Kuan Weng Kun
Leng Bai
Zhonghua Li
Jiang Song Li
Nuling Li
Zhensheng Li
Li Cheng
Li Chun Qiang
Li Fan
Li Jiangang
Li Jie Jun
Li Jincheng
Li Jinglu
Li Qiang
Li Wending
Li Xiaoguo
Li Zhao Min
Lian Xiang Ru
Liang Da Ming
Qian Ren Liao
Stan Lim
Hong Qun Liu
Yuan Liu
Zhongyi Liu
Liu Gen Tan
Liu Liqun
Liu Mengtao
Liu Shujin
Liu Wei
Liu Wei Qiang
Liu Xiaolin
Liu Yingyi
Hai Long
Lu Guang
Lu Xu Yang
Xiao-guang Ma
Ma Hongjie
Mai Qi Xuan
Man Huiqiao
Mao Shuo
Bo Miao
Mingguo Meng
Ng Hiu Tung
Feng Ning
Ning Zhou Hao
Pan Enzhan
Pan Feng
Pang Zheng Zheng
Pei Jingde
Hui Peng
Peng Nian
Pingping Zheng
Xiaolong Qi
Qi Hao
Qi Hui
Qi Jieshuang
Houqi Qian
Qin Datang
Qin Wengang
Yan Qiu
Qiu Mim
Qiu Xiao Wei
Qungang Chen
Yujie Ran
Ren Shi Chen
Ren Xi-hai
Ren Yue

Banhui Ruan
Shao Quanhai
Xingshi Shen
Shen Zhong
Sheng Jia Peng
Shi Jianxue
Shonhai Chen
Shu Wang Hou
Dustin Wan-Yat Shum
Jong Sujun
Song Gang Ming
Song Jianhao
Song Yang
Mok Suet Chi
MingHong Sun
Sun Jun
Sun Yu Hui
Sun Zhijun
Suren Li
Jian Tang
Tang Yan Jun
Tian Fei
Tian Li
Tong Jiang
Oliver Tsang Wai Tak
Chi Pak Ducky Tse
Juncai Wang
Rui Lin Wang
Chang Qing Wang
Huisheng Wang
Lei Wang
Jing Wang
Peiquan Wang
Jiang Wang
Bingyu Wang
Wang Chen
Wang Da Bin
Wang Jian
Wang Jianying
Wang Jie
Wang Jun
Wang Ri Xin
Tong Wang Tong
Wang Wenlan
Wang Xiwei
Wang Yao
Wei Xiao Ming
Wen Hao Yu
Wen Xiaohan
Alex Wong
Yunsheng Wu
Wu Chuanming
Wu Fang
Wu Wan Sheng
Wu Zhonglin
Tiewei Wung
Wuniao
Xiao Huai Yuan
Xiao Yun Zheng
Rende Xie
Xie Fucheng
Xie Guanghui
Xie Minggang
Xin Li
Xishan Chen
Wu Xu
Jian Rong Xu
Xu Bao Shan
Xu Cheng Ai
Xu Jing Xing
Xu Xian Xing
Bailiang Yan
Yan Zhixiong
Fu-sheng Yang
Yi Yang
Xuejie Yang
Yang Shen
Yang Xiaogang
Yang Youchun
Yin Gang
Yitian Hu
Fu Yongjun
Vincent Yu
Jiang-tao Yu
Xiao Zhen Yuan
Yuan Jingzhi
Lu Yun
Zeng Nian
Deng Wei Zhang
Hong Bing Zhang
Zhang Feng
Zhang Guowei
Zhang Hongjiang

Zhang Hongwei
Zhang Liang
Zhang Wang
Zhang Wei
Zhang Weiwen
Zhang Yan
Zhang Yanhui
Zhang Zhen
Jianwei Zhao
Jingdong Zhao
Hang Zhao
Jinhua Zhao
Zhao Hui
Zhao Li Jun
Zhao Tongjie
Zhao Ya-Shen
Xiao-qun Zheng
Zheng Ting
Zheng Yongqi
Chang You Zhou
Hui Zhou
Huadong Zhou
Zhou Guoqiang
Zhou Lixin
Zhu Gang
Zhu Min Hui
Zhuang Jin
Zong Lu Fan

PERU
Renzo Fernandez-Baca
Miguel Angel Bellido Almeyda
Cris Bouroncle
Max Cabello Orcasitas
Marilú Cabellos Damián
Roberto Caceres Zevallos
F. Chuquiure Santivañez
Hector Emanuel
Luis Sergio Flores Machuca
Manuel Garcia-Miro
Luis Angel Gonzales Taipe
Silvia Izquierdo
Cecilia Larrabure Simpson
Vera Lentz
Hector Mata
Maria Ines V. Menacho Ortega
Karel Keil Navarro Pando
Lenin Nolly Araujo
Jose Quintana Collachahua
Susana Raab
Osmar Rosales Abarca
Francisco Sanseviero Koffler
Daniel Silva Yoshisato
Jaime Javier Trelles Garcia
Guillermo Venegas Cabrera
Gonzalo Villena Villar

PHILIPPINES
Claro Fausto Cortes
Revoli Cortez
Jimmy A. Domingo
Pepito Frias
Romeo Gacad
Jose V. Galvez Jr.
Oliver Y. Garcia
Hadrian Hernandez
Victor Kintanar
Marvi Sagun Lacar
David Chan Leprozo Jr.
Francis Reyes Malasig
Alfonso L. Del Mundo
Gil Nartea
Diana Noche
Flordeliza M. Odulio
Reny Waro Pampolina
Bong Cabagbag Pásion
Roger Ranada
Joaquin S. Ruste
Dennis Sabangan
Robert Timonera
Remar Zamora

POLAND
Bartlomiej Barczyk
Piotr Bernas
Krystian Bielatowiecz
Piotr Blawicki
Marta Blazejowska
Robert Boguslawski
Monika Bulaj
Grzegorz Celejewski
Katarzyna Chadzynska
Antoni Chrzastowski

Wojciech Chrzastowski
Agnieszka Czajkowska
Grzegorz Dabrowski
Jacenty Dedek
Kuba Dzbrowski
Janusz Filipczak
Tomasz Gawalkiewicz
Arkadiusz Gola
Christopher Grabowski
Tomasz Gntessgraber
Nojciech Andrej Grzedzinski
Marek Grzesiak
Tomasz Gudzowaty
Rafat Guz
Grzegorz Hawalej
Arthur Homan
Krzysztof Jablonowski
Pawel Janczaruk
Jacek Jedrzejczak
Tomasz Jodlowski
Tukasz Kabocik
Marcin Kalinski
Slawomir Kaminski
Jacek Kaminski
Tomasz Kaminski
David Kaszlikowski
Alik Keplicz
Roman Konzal
Robert Kowalewski
Miroslaw Kowalski
Andrzej Kramarz
Damian Kramski
Witold Krassowski
Violetta Kus
Jerzy Lapinski
Marek Lapis
Arvadiviz Lawrywianiec
Anna Lewanska
Gabor Lörinczy
Piotr Malecki
Franciszek Mazur
Justyna Mielnikiewicz
Rafal Milach
Andrzej Nasciszewski
Wojciech Kamil Oksztol
Leonard Olechnowicz
Eliza Oleksy
Radoslaw Pietruszka
Leszek Pilichowski
Stanislaw Jan Pindera
Jacek Piotrowski
Ryszard Poprawski
Tadeusz Rojsza
Jocher Roman
Michattukasz Rozbicki
Witold Rozbicki
Olgierd Rudak
Katarzyna Sagatowska
Maciej Skawinski
Piotr Skornicki
Lukasz Sokol
Mikolaj Suchan
Lukasz Trzcinski
Adam Warzawa
Piotr Wichlacz
Zdzislaw Wichlacz
Jerzy Wierzbicki
Rafal Witczak
Luke Wolagiewicz
Bartosz Wrzesniowski
Bartlomiej Zborowski

PORTUGAL
Alfredo Almeida Coelho Cunha
Vitor Alexandre Alves Costa
Rodrigo Antunes Cabrita
José Manuel Boavida Caria
Ana Isabel Caeiro Catalão
Antonio Manuel Carrapato
José Carlos Almeida Carvalho
João Carvalho Pina
Ricardo Castelo
Leonel De Castro
Luis Filipe Castro Catarino
Angelo Catita Marinha Lucas
Luis António Costa Rosário
Nuno Coutinho Ceitil
Paulo Cunha
Hugo Delgado Fernandes
Rui Pedro Duarte Silva
Antonio Fazendeiro
Nuno Ferreira dos Santos
Jorge Firmino

Paulo Freitas
Filipe Miguel Guerra
Miguel Lopes Barreira
Antonio Machado Isidoro
Frederico Martins Colarejo
Bruno Adelino Ferrei Neves
Anabela Esteves de Oliveira
Adáo Fransisco Pereira Moreira
Bruno Rascao
Miguel Ribeiro Fernandez
Daniel Marques Rocha
Gonçalo Rosa da Silva
Carlos dos Santos Ferreira
Paulo Manuel Sargo Escoto
A. S. Lino De Sampayo Ribeiro
Augusto Araúfo Soares
Luis M. Soares da Silva Ramos
Pauliana C. R. Valente Pimentel
Miguel F. Da Silva Veterano
Miguel Angelo C. Veterano
Raquel Wise

PUERTO RICO
Jose Jimenez Tirado
Dianeris Nieves Santiago

ROMANIA
Nora Agapi
Constantin Daniel Avram
Remus Nicolae Badea
Petrut Calinescu
Bogdan Cristel
Dorian-Manuel Delureanu
Matei Horvath-Bugnariu
Dragos Lumpan
Traian Lupu
Bogdan Maran
Darius Mitrache
Marius Nemes
Lupsa Sorin Mihai
Mihai Vasile
Tudor Stefan Vintiloiu

RUSSIA
Ravil Adiev
Doneyko Anatoly
Andrey Arkchipov
Armen Asratyan
Nikolaevich Astafiev
Dmitry Astakhov
Dmitry Azarov
Maxim Vladimirovich Babkin
Yuri Balbyshev
Vladimir Baryshev
Sergey Bondarev
Viacheslav Buharev
Valery Bushukhin
Andrey Cherepanov
Evgueni Chtcherbakov
Kirill Ciaplinskiy
Boris Dolmatovsky
Alexander Dorogan
Victor Drachev
Vladimir Dubrovskiy
Viktor Durmanov
Boris Filippovich Echin
Andrei Efimov
Evgeniy Valent Epanchintsev
Vladimir Fedorenko
Alexander Fedorenko
Sofia Fetisova
Ramil Galiev
Sergey Golovach
Grigory Evgenievich Golyshev
George Gongolevich
Natalia K. Goubernatorova
Victor Gritsyuk
Sergey Ilchenko
Victoria Ivleva-Yorke
Alexey Kaluzhskikh
Sergey Kaptilkin
Pavel Urevich Kashaev
Edward Muratovich Khakimov
Victor Alekseevich Khmelik
Arthur Kirakozov
Nickolay Kireyev
Victor Kirsanov
Mikhail W. Klimentiev
Timur Koksharov
Sergei Kompaniychenko
Yevgeni Kondakov
Alexey Kondrashkin
Vladimir Korobitsyn

Denis Kozhevnikov
Yuri Kozyrev
Igor Kubedinov
Vladimir Lamzin
Vladimir Larionov
Alexsander Lisafin
Natalia Lvola
Tatiana Makeyeva
Maxim Marmur
Dmitriy Maslennikov
Valery Matytsin
Sergey Maksimishin
Maxim Maximov
Viktoria Mazikova
Anna Melikhova
Vasili Melnichenko
Marianna Melnikova
Boris Mikhalevkin
Oleg Mochtchelkov
Serguei Molodouchkine
Rustam Muhammadzian
Alexander Nakhapetov
Alexander Natruskin
Alexander Nemenov
Oleg Nikishin
Valeri Nistratov
Alexander Oreshnikov
Victor Parkhaev
Valentina Pavlova
Arturs Pavlovs
Gueorgui Pinkhassov
Alexander Polyakov
Sergey Ponomarev
Konstantin Postnikov
Mikhail Rashkovsky
Denis Rassohin
Vladimir Rodionov
Yulia Rodionova
Dmitry Rogulin
Andrey Rudakov
Yulia Rusyayeva
Olga V. Ryabtsova
Fyodor Savintsev
Sergei Shakhidzanyan
Andrei Shapran
Alexander Shchipakin
Sergiy Shekotov
Sergej Shevirin
Vladimir Shootofedov
Nikolay Sidorov
Andrey Sladkov
Alexey Smirnov
Oleg Sourine
Oxana Starikova
Vitaly Sutulov
Vladimir Syomin
Alexander Taran
Artem G. Tchernov
Igor Utkin
Sergei Vasilyev
Vladimir Velengurin
Dmitri Vozvizhenskiy
Vladimir Vyatkin
Oleg Wastochken
Svetlana Yuferova
Svetlana Zadorina
Alexandr Zaitsev
Vladislav Zaporoshchenko
Konstantin Zavrazhin
Anatoliy Zhdanov

RWANDA
Finbarr O'Reilly

SAUDI ARABIA
Saleh Abdullah Al Takrouni
Ali Abdullah Al-Sinan
Hassan Ali Hussin Al-Habib
Baker Dawood Sindi
Ali Al-Sinan Zaki

SENEGAL
Ousmane Ndiaye Dago

SERBIA AND MONTENEGRO
Zoran Anastasijevic
Nedeljko Deretic
Aleksandar Dimitrijevic
Andrej Isakovic
Boza Ivanovic
Aleksandar Kelic
Vladimir Boogie Milivojevich
Mihály Moldvay

Milan Obradovich
Branislav Puljevic
Hazir Reka
Aleksandar Stojanovic
Goran Tomasevic

SIERRA LEONE
Patrick Bockarie Koroma

SINGAPORE
Bryan van der Beek
Chin Hon Chua
Joyce Fang Hui-Lin
Ernest Goh Liwai
How Hwee Young
Huang Zhi Ming
Kai Chung Kwong
Lau Fook Kong
Francis Lee
Lance Lee
Sor Luan Ng
Leonard Phuah Hong Guan
Tzyy Wei Seyu
Darren Soh
Terence Tan
Tay Kay Chin
Thiang Yu Ming
Wang Hui Fen
Teck Hian Wee
Woo Fook Leong
David Yeo

SLOVAKIA
Andrej Balco
Martin Bandzak
Jozef Barinka
Dusan Guzi
Vladimir Kampf
Martin Kollár
Marian Meciar
Mária Zarnayová

SLOVENIA
Dusan Jez
Natalija Juhnov
Manca Juvan
Tamino Petelinsek
Borut Peterlin

SOUTH AFRICA
Adrian Bailey
Peter Bennett
Jodi Bieber
Paul Botes
Nicholas Bothma
Thys Dullaart
Thembinkosi Dwayisa
Brenton Geach
Anton Hammerl
Rian Horn
Jon Hrusa
Nadine Kim Hutton
Andrew Ingram
Nonhlanhla Eddie Kambule
Elské Kritzinger
Halden Krog
Juhan Kuus
David Arthur Larsen
Stephen Lawrence
Angelique Maria Lazaro
Jack Leon Lestrade
Charlé Lombard
Kim Ludbrook
David Lurie
Liam Lynch
Mnguni Alpheus Mabuza
Simon Zwelibanzi Mathebula
Nanette Melville
Gideon Mendel
Eric Miller
Katherine Muick
Christine Nesbitt
Mykel Nicolaou
Neo Ntsoma
Obie Oberholzer
Hein du Plessis
Raymond Preston
Marianne Pretorius
John Robinson
Shayne Robinson
Mujahid Safodien
David Sandison
Karen Lee Sandison

Elizabeth Sejake
Sydney Seshibedi
Lefty S. Shivambu
Justin Sholk
Siphiwe Sibeko
Joao Silva
David Silverman
Noor Slamdien
Garth Stead
Brent Stirton
Ndabula Thobeka
Guy Tillim
Muntu Vilakazi
Rogan Ward
Debbie Yazbek
Dudu Zitha
Schalck Van Zuydam
Anita van Zyl
Mouton van Zyl

SOUTH KOREA
Bae Jae-Mann
Ji-Soon Baik
Hyoung Chang
Choi Jong-Ug
Choo Youn-Kong
Jean Chung
Chung Sung-Jun
Shin Dong Phil
Dong Su Kim
Je-Won Lee
Jong Chun Back
Jea Uk Kang
John J. Kim
Kim Kyung-Hoon
Kim Seong-Ryong
Kim Sunkyu
Kiwon Lee
Jin Wook Lee
Jae-Won Lee
Seung Eun Lee
Sangjib Min
Myung Chun
Noh Soon Taek
Haseon Park
Seokyong Lee
Seong Yeon Jae
Sung Nam Hun
Yang Hyun Taek

SPAIN
Luis Alcaraz Garcia
Carmenchu Aleman Alvarez
Javier Arcenillas
Pablo Balbontin Arenas
Sandra Balsells
Josep Banus Mateu
Carlos Barajas Perez
Juan Carlos Barbera Marco
Raúl Belinchón Hueso
Clemente Bernad
Pep Bonet Mulet
Santiago Burgos Mateo
F. de Asis Calero Moreno
Jose Ignacio Calonge Minguez
Luis Camacho Peral
Sergi Camara Loscos
Jordi Cami Caldes
Juan Carlos Cárdenas Plá
Dani Cardona
Alejandro Carra
Andres Carrasco Ragel
Claudio Carreras Guillen
Alfonso Carreto Ruiz
Daniel Casares Román
Blanca Castillo
C. Ramirez Cazalis Fernandez
Xavier Cervera Vallve
Daniel Codina Zapater
Andrea Comas Lagartos
Eduard Compte Verdaguer
Matias Costa
Carlos De Andres Del Palacio
Marcelo Del Pozo Perez
Jose Delgado Pascual
Miquel Dewever-Plana
Juan Diaz Castromil
Eduardo Diequez San Bernardo
Rosmi Duaso Suarez
Sergio Antonio Enríquez Nistal
Alvaro Felgueroso Lobo
Francisco Feria Villegas
Jose Ferrin Y Abal

Salvador de Sas Fojou
Fernando Angel Garcia Arevalo
Alvaro Garcia Coronado
Xavier Garcia i Marlí
Pilar Garcia Manzanares
Cristina Garcia Rodero
Ima Garmendia
Maria Gonzalez de la Vega
Pedro Gonzalez Rodriguez
Pasqual Gorriz Marcos
Jordi Gratacòs Caparrós
Julen Alonso Laborde
Emilio Lavandeira Villar
Alvaro de Leiva
Santiago López Rodriguez
José López Soto
Carlos Lujan
Hermes Luppi Maragall
Kim Manresa Mirabet
Fernando Marcos Ibanez
Enric F. Marti
Carlos Martínez de la Serna
Javier Martinez Llona
Hector Mediaville Sabaté
Juan Carlos Medina Genuario
Fernando Moleres Alava
Raúl Montanós Garcia
Alfonso Moral Rodriguez
Aitor Lara Moreno
Isabel Muñoz
Ricardo Muñoz Martín
Roberto Navarro Cataluña
Juan Ignacio Navarro Primo
Eduardo Nave Silvestre
Carlos Javier Orti Hernandez
Benito Pajares Alonso
Oscar Palomares Acenero
Pedro Gredos Pérez Almería
Jordi Play
Joan Pujol Creus
Ferran Quevedo Bergillos
David Ramos Vidal
Sergi Reboredo Manzanares
Jose Miguel Riopa Alende
Eva Maria Ripoll Mont
José Luis Roca García
Manuel Rocca
Diego Rodríguez Sánchez
Lorena Ros Sanz
Daniel Ruano Rimbau
Abel Ruiz de León Trespando
Abraham Ruiz Mena
Moises Saman
Gervasio Sanchez Fernandez
Lourdes Segade Botella
Grau Serra Espriu
Jose Miguel Sierra Arostegui
Tino Soriano
Javier Soriano
Nelson Anibal Souto Oviedo
Carlos Spottorno
Javier Teniente Lago
Juan Carlos Toro Del Rio
Maria De Torres Solanot
Raúl Urbina Alvarez
Susana Vera Pascual
Fernando Villar Sellés
Ignacio Vinaixa Ramirez

SRI LANKA
K. Dushiyanthini
Ruwan Gunarathna
Anuruddha Lokuhapuarachchi
Angelo de Mel
Yamuni Rashmika Perera
Ranawila Premalal
Wickrama Saman Mendis
Nuwan Duminda
Udalamattha Gamage
Kavisha Kombala Vithanage
Sriyantha Walpola
Anushad Sampath Wedage

SUDAN
Kamal Mohammad Aldow
Fouad Haider Hassan
Osama Mahdi Hassan

SWEDEN
Martin Adler
Torbjörn Andersson
Roland Bengtsson
Joakim Berglund

Sophie Brandstrom
Lars Dareberg
Nils Patrick Degerman
Andrey Deyneko
Stefan Per Ed
Henrik Edsenius
Joakim Bo Mattias Eneroth
Ake Ericson
Jan Lennart Michael
Fleischmann
Jacob Forsell
Jessica Gow
Johnny Gustavsson
Magnus Hallgren
Paul Hansen
Nils-Göran Krister Hansson
Tommy Holl
Ann Inger Johansson
Magnus Jahnsson
Johan Erik Niklas Johansson
Andreas Jonasson
Gerhard Jörén
Peter Kjelleras
Björn Larsson
Christian Leo
Larseric Linden
Jonas Lindkvist
Johan Lundahl
Joachim Lundgren
Chris Maluszynski
Markus Marcetic
Paul Mattsson
Jack Mikrut
Henrik Montgomery
Björn Olsson
Jan-Christer Persson
Fredrik Persson
Per-Anders Pettersson
Bo Lennart Rehnman
Kai Rehu
Anders Ryman
Torbjörn Selander
Hakan Sjöström
Stefan Söderström
Johan Solum
Maria Steen
Göran Stenberg
Per-Olof Stoltz
Mikael Strand
Magnus Sundberg
Eva Tedesjö
Ola Torkelsson
Lars Tunbjörk
Roger A. Turesson
Joachim Wall
Jan Wiridén
Henrik Witt
Karl-Göran Zahedi Fougstedt

SWITZERLAND
Fabian Biasio
Christian Bonzon
Mathias Braschler
Markus Bühler
Christoph Bürki
Raphael Delaloye
Yolanda Flubacher
Andreas Frossard
Mariclla Furrer
Yvain Genevay
Philippe Getaz
Tobias Hitsch
Robert Huber
Steeve Iuncker
Alban Kakulya
Alexander Keppler
Thomas Kern
Reza Khatir
Roger Lohrer
Marcel Malherbe
Samuel Mizrachi
Natasha Quadri
Nicolas Righetti
Daniel Rihs
Germinal Roaux
Didier Ruef
Meinrad Markus Schade
Andreas Seibert
Hansueli Trachsel
Valdemar Verissimo
Olivier Vogelsang
Andreas Walker
Michael Wildi

SYRIA
Enbea Abdou
Adel Abu Sada
Adnan Sayed Ahmed
Zukaa Al Kahhal
Mounir Al Shaar
Salam Al-Hassn
Jehad Alaidy
Lina Alhafeez
Kenan Alhakeem
Souha Alhelu
Walid Almoughrabi
Thanaa Arnaout
Chadi Batal
Nawras Batej
Mousa Bchara
Souheir Beshara
Mouhanad Dalati
Aiham Dib
Suzan Fellouh
David Habbouh
Housam Haddad
Mohammad Hajkab
Diala Halabi
Bessam Hamadeh
Nouh Ammar Hammami
Muhammed Hasan
Aiman Al Heleby
Yousef Hosein
Samir Haj Husen
Buthaina Ibraheem
Akef Kammoush
Ussef Luoga
Muostafa Magmume
Fatima Naief
Reif Sabry Rafaeel
Sawssan Rajab
Wafa Raubeh
Entessar Salem
Mahmoud Salem
Nuoha Salem
Omar Sanadiki
Rima Shahin
Mhd. Jalal Shekho
Riita Shnes
Ragda Soulymam
Hassan Xagil
Akrem Zave
Hisham Zaweet

TAIWAN ROC
Chang Tien Hsiung
Jian-Wei Chen
Chen Chau-Yin
Chen Su-Yu
Chen-Mu Wu
Richard Chung
Hsieh Chia-Chang
Kuo-chen Chen
Simon Kwong
Tsung-sheng Lin
Ma Li-Chun
Ming-Yang Lee
Peng-Chieh Huang
Chao-Liang Shew
Yuan Mao Wang
Wei-Sheng Huang
Young-sheng Yang
Yu-Ping Chu

TANZANIA
Khamis Hamad Said
Mohamed A. Mambo

THAILAND
Pisant Jaikarroon
Supat Jarupoonpol
Pornchai Kittiwongsakul
Chanchai Lumsumruang
Sarot Meksophawannakul
Jetjaras Na Ranong
Yongrit Rungroj
Supot Sillapangam
Manit Sriwanichpoom
Chittisak Treedet
Kitti Vongbaikaw

TUNISIA
Ghaya Ben Attaya
Ben Khelifa Karim

TURKEY
Aytung Akad
Muhsin Akgün
Coskun Asar
Ali Borovali
Hulki Bozkurt
Mehmet Demirci
Ibrahim Dogan
Mehmet Yasar Durukan
Murat Duzyol
Bikem Ekberzade
Sebnem Eras
Mehmet Gülbiz
Burak Kara
Cemal Köyük
Sahan Nuhoglu
Riza Ozel
Fatih Pinar
Yilmaz Polat
Saner Sen
Selahattin Sevi
Tolga Sezgin
Alp Sime
Gökhan Tan
Ahmet Tarik Tinazay
Ibrahim Usta
Kerem Uzel

UGANDA
Bruno Birakwate
Richard Mpalanyi Ssentongo
Michael Nsubuga
Willy Tamale

UKRAINE
Gleb Garanich
Sergiy Gumenyur
Vitaly Hrabar
Oleksandr Kharvat
Borys Korpusenko
Vsevolod Kovtun
Mykola Lazarenko
Gennadiy Minchenko
Oxana Nedilnichenko
Victor Odomitch Nicolavich
Sergiy Pasyuk
Arvidas Shemetas
Oleksandr Stratiychuk
Sergei Supinsky
Viktor Mishchenko Suvorov
Olexander Svitlovskyy

UNITED KINGDOM
Bruce Philip Adams
Richard Addison
Andrew Aitchison
Roger Allen
Timothy Allen
Nigel Amies
Julian Andrews
John Angerson
Simon Mark Annand
Cedric John Arnold
Marc Aspland
Helen Margaret Atkinson
Sam Bagnall
Richard Baker
Roger Bamber
Darren Banks
Steve Bardens
Christopher Paul Barene-Jones
Steve Bent
Damion Berger
Suzanne Kathryn Bernstein
Vince Bevan
Andrew Blackmore
Steve Bloom
Russell Boyce
Denise Bradley
Julian Broad
Clive Brunskill
Jonathan Buckmaster
Sisi Burn
Nicholas Butcher
Richard Butler
Andrew Buurman
Gary Calton
Justin Canning
Angela Catlin
Dean Chapman
David Charnley
Wattie Cheung
Carlo Chinca

Daniel Chung
Garry Michael Clarkson
Paul Clements
Andrew Cleverley
Nick Cobbing
Martyn Colbeck
Rogan Coles
Stuart William Conway
Philip Coomes
Caroline Cortizo
Ted Cottrell
Victoria Couchman
Michael Craig
Tom Craig
Simon Dack
Nick Danziger
James Darling
Bill Darnell
Venetia Ann Dearden
Peter Dench
Adrian Dennis
Nigel Gordon Dickinson
Ann Doherty
John Downing
Matt Dunham
Patrick Eden
Arthur Edwards
Stuart Mills Emmerson
Mark Evans
Sophia Evans
Sam Faulkner
Tristan Fewings
Simon Finlay
Elizabeth Finlayson
Fabienne Fossez
Andrew Fox
Adam Fradgley
Stuart Freedman
Wilde Fry
Kieran Galvin
George Georgiou
John Giles
Paula Glassman
Michael Goldwater
Amanda-Jane Gordon
David Graves
Charlie Gray
Johnny Green
Michael Grieve
Christian Paul Guildford
Stephen Hale
Robert Hallam
Gary Hampton
Stephanie Harland
Mark Henley
Paul Herrmann
Tim Hetherington
Jack Hill
James Hill
Stephen Hird
John Richard Hocknell
Craig John Holmes
Kate Holt
Rip Hopkins
Jason P. Howe
Jeremy Hunter
Jess Hurd
Mike Hutchings
Paul Jacobs
Tom Jenkins
Justin Jin
Christian Keenan
Ash Knotek
Nicola J. Kurtz
Colin Lane
Kalpesh Lathigra
Belinda Lawley
Stephen Lawrence
Nicky Lewin
Barry Lewis
Geraint Lewis
Ryan Li
Amanda Margaret Lockhart
Mikal Paul Ludlow
Sinead Lynch
Peter MacDiarmid
Alex MacNaughton
Toby Madden
Michelle Maddison
Gemma Marriner
Paul Marriott
Dale Martin
Leo Mason

Jenny Matthews
Paul Mattsson
Timothy McGuinness
Toby Melville
Allan Milligan
Jon Mills
Richard Mills
Jeff Mitchell
John Douglas Moody
Andrew Moore
Jeff Moore
Mike Moore
Alexander Morrisson-Atwater
Nevil Mountford
Edward Mulholland
Rebecca Naden
Pauline Neild
Zed Nelson
Peter Nicholls
Lucy Nicholson
Antony C.J. Nicoletti
Phil Noble
Simon Norfolk
Heathcliff O´Malley
Charles M. Ommanney
Philiy Page
Paul Panayiotou
Colin Pantall
Fabio De Paola
Peter Parks
Nicholas Allen Payne
John Perkins
Marcus Perkins
Robert Perry
Duncan Phillips
Paul Pickard
Tom Pilston
Olivier Pin-Fat
Gary Prior
Léonie Purchas
Steve Race
Scott Ramsey
John Reardon
Simon Paul Renilson
Carlos Reyes Manzo
Kiran Ridley
Phillip Riley
Simon John Robbins
Gary Neil Roberts
Simon Roberts
Graeme Robertson
Ian Robinson
Karen Robinson
Mark David Robinson
Peter Robinson
Stuart Robinson
Paul Rogers
David Ruffles
Ian Rutherford
Mark Seager
Andrew Sewell
Anup R. Shah
Bill Smith
Gavin Smith
Richard Smith
Guy Smallman
David Robert Stewart
Tom Stoddart
Lee Karen Stow
Christopher Stowers
Justin Sutcliffe
Sean Sutton
Jeremy Sutton-Hibbert
Mark Parren Taylor
Ian Teh
Edmond Terakopian
Alastair Thain
Siôn Touhig
Abbie Trayler-Smith
Simon de Trey-White
Dominick Tyler
Matthew Usher
Asya Verzhbinsky
Muir Vidler
Bruno Vincent
Aubrey Wade
Richard Wainwright
Michael Walter
Zak Waters
Nigel Watmough
Geoffrey Nicholas Waugh
Felicia Webb
Simon Wheatley

Andrew Wheeler
Amiran White
David White
Gavin David White
Neil Anthony White
Lewis Whyld
Kirsty Wigglesworth
Alan Williams
James Williamson
Vanessa Jane Winship
Andrew Wong
Antony Wood
Francesca Telma Yorke
Chris Young
Dave Young
Sandy Young
Tony Yu Kwok Lam

URUGUAY
Luis Ignacio Alonso Ciganda
Leo Barizzoni Martinez
Gabriel Cusmir Cúneo
Julio Etchart
Enrique Kierszenbaum
Pablo Daniel Rivara Suchanek
Nicolás A. Scafiezzo Porcelli

USA
Sharon Abbady
Daniel Acker
Kimberlee Acquaro
Lynsey Addario
Noah Addis
Tommy Agriodimas
Peter van Agtmael
Jordan van Aken
Jamal Al-Rubaie Wilson
Donna Alberico
Jim Albright
Kael Alford
William Albert Allard
Maya Alleruzzo
Suzy Allman
Monica Almeida
Kwaku Alston
Stephen L. Alvarez
Thorne Anderson
Todd Anderson
Patrick Andrade
Ryan Anson
Ronald Antonelli
Michael Appleton
Samantha Appleton
J. Scott Applewhite
Charlie Archambault
Glenn Asakawa
Kristen Ashburn
Marc Asnin
Christopher T. Assaf
Alexandra Avakian
Tony Avelar
Floyd Aynsley
Mojgan Azimi
Stephan Babuljak
Anita Baca
Brian Baer
Karen Ballard
Bill Bangham
Sheri Bankes
Jeffrey W. Barbee
Candace B. Barbot
Bridget Barrett
James Bartlett
Tim Bauer
David Bauman
Edward Baumeister
Max Becherer
Robert Beck
Robyn Beck
Natalie Behring-Chisholm
Al Behrman
Jason Bell
Al Bello
Nicole Bengiveno
Amy Beth Bennett
Harry Benson
David Bergman
Rüdiger Bergmann
David Berkwitz
Nina Berman
Steve Berman
Alan Berner
John Biever

Keith Birmingham
Gene Blevins
David Blumenfeld
Wesley Bocxe
Gary Bogdon
Sarah S. Bones
Michael Bonfigli
James Borchuck
Harry Borden
Peter Andrew Bosch
Mark Boster
Bie Bostrom
Khampha Bouaphanh
Gilbert Boucher II
Dana Bowler
Rick Bowmer
Frank Boxler
Torin Boyd
Heidi Bradner
Alex Brandon
William Bretzger
Paula Bronstein
Kate Brooks
Kenneth R. Brooks
Richard Brooks
Jennifer Brown
Matthew Brown
Michael Brown
Andrea Bruce Woodall
Brian van der Brug
Simon Bruty
Vernon Bryant
Paul Buck
Robin Buckson
Mark Bugnaski
Robert F. Bukaty
David Burnett
Adam Butler
David Butow
Renée C. Byer
Zbigniew Bzdak
John Calaman
Julia Calfee
Loren Callahan
Billy Calzada
Gary Cameron
Marc Campos
Roberto Candia
Lou Capozzola
Jennifer Cappuccio
Paul Carter
Peter Casolino
John Castillo
Joseph Anthony Cavaretta
Joe Cavaretta
Sean Cayton
Anne Chadwick Williams
Bryan Chan
Richard A. Chapman
Tia Chapman
Don Hogan Charles
Dominic Chavez
Charles Cherney
Jahi Chikwendiu
Barry Chin
Nelson Ching
Jeff Chiu
Chien-Min Chung
Daniel F. Cima
Daniel Le Clair
Matthias Clamer
John Clark
Robert Clark
Tim Clary
Jay Clendenin
Bradley E. Clift
Chuck Close
Jodi Cobb
Victor José Cobo
Gigi Cohen
Marice Cohn Band
Carolyn Cole
Ryan Tomas Conaty
Frank Conlon
Sean Connelly
Fred Conrad
Dean Coppola
Thomas R. Cordova
Ronald Cortés
Carl Costas
John Costello
Bill Cramer
Bill Crandall

Ed Crisostomo
Manny Crisostomo
Lisa A. Croft-Elliott
Bob Croslin
Stephen Crowley
Earl Cryer
Chris Curry
Ben Curtis
Anne Cusack
Andrew Cutraro
Paul D'Amato
Jim Damaske
Meredith Davenport
Robert Davis
Patrick Davison
Suzanne DeChillo
John Decker
Tim Defrisco
James Whitlow Delano
Charles Dharapak
Stephanie Diani
Cheryl Diaz Meyer
Nuccio DiNuzzo
Steven K. Doi
Rachel Donnan
Tony Dougherty
Larry Downing
Richard Drew
Michel DuCille
Steve Dykes
Andrew Eccles
Aristide Economopoulos
Scott Eells
Debbie Egan-Chin
Davin R.M. Ellicson
Nancy Ellison
Don Emmert
Douglas Harrison Engle
Joshua Estey
James Estrin
David Eulitt
Jim Evans
Sarah Evans
Gary Fabiano
Timothy Fadek
Joan Fairman Kanes
Robin Lynne Farej
Patrick Farrell
Christopher Faytok
Gina Ferazzi
Don Feria
Jose Ismael Fernandez Reyes
Gloria Ferniz
Jonathan Howe Ferrey
Stephen Ferry
Rob Finch
Jock Fistick
Lauren Fleishman
Peter Foley
Bill Frakes
James Rafe Francis
Danny Wilcox Frazier
John Freidah
Ruth Fremson
Jen Friedberg
Gary Friedman
Hector Gabino
Kathleen Galligan Wayt
Patricia Gallinek
Sean Gallup
Preston Gannaway
Alex Garcia
Micah Garen
Mark Garfinkel
Morry Gash
Sharon Gekoski-Kimmel
Dave Getzschman
David P. Gilkey
Andrea Gjestevang
Richard Brian Glickstein
Sarah Glover
Scott Goldsmith
John David Goodman
Leila Gorchev
Chet Gordon
Russell Gordon
Mark Gormus
Ronna Gradus
William Douglas Graham
Bill Greene
Stanley Greene
Lauren Greenfield
Michael Greenlar

Eric Grigorian
Lori Grinker
Norbert von der Groeben
David Gross
Jason Grow
Jack Gruber
Justin Guariglia
Dale Guldan
David Guralnick
David Guttenfelder
Carol Guzy
Dan Habib
Robert Hallinen
Michael Halsband
Chris Austin Hamilton
Khalil Hamra
Scott Hamrick
Paul Hanna
Dariyoosh Hariri
Mark Edward Harris
David Hartung
Darren Hauck
Jennifer Hayes
Scott Heckel
Raymond Heier
Sean Hemmerle
Mark Henle
Marcelo Hernandez
Michael Hettwer
Tyler Hicks
Erik Hill
Edward J. Hille
Sean Jason Hiller
Eros Hoagland
Evelyn Hockstein
Jeremy Hogan
Jim Hollander
David S. Holloway
Celeste Diane Holt-Walters
Chris Hondros
Kevin Horan
Sarah Hoskins
Rose Howerter
Jeffrey Daniel Hutchens
Ethan Hyman
Lenny Ignelzi
Andrew Innerarity
Nasser Ishtayeh
Steve Jacobs
Jeff Jacobson
Julie Jacobson
Stephen Jaffe
Terrence Antonio James
Ken James
Rebecca Sue Janes
Kenneth Jarecke
Janet Jarman
Lawrence Jenkins
Janet Jensen
Marketa Jirouskova
Linda G. Johnson
Markham Johnson
Joseph Johnston
Marvin Fredrick Joseph
Ariane Kadoch Swisa
Michael Kamber
Sylwia Kapuscinski
Ed Kashi
Carolyn Kaster
Andrew Kaufman
Scott Keeler
Reseph Keiderling
Loretta Rae Keith
Stephanie Keith
Caleb Kenna
Brenda Ann Kenneally
Everett Kennedy Brown
David Hume Kennerly
Mike Kepka
Preston Keres
Brian Kersey
Laurence Kesterson
Yunghi Kim
John Kimmich-Javien
Scott Kingsley
Edward Jed Kirschbaum
Lui Kit Wong
Paul Kitagaki, Jr
Katherine Kivlal
Heinz Kluetmeier
David E. Klutho
Richard H. Koehler
Otaki Koichiro

Larry Kolvoord
James Korpi
Brooks Kraft
Benjamin Krain
Lisa Krantz
Perry Kretz
Sara Krulwich
Amelia Kunhardt
Teru Kuwayama
Stephanie Kuykendal
Branimir Kvartuc
Sakchai Lalit
Tim Laman
Kenneth Lambert
André Lambertson
Rodney A. Lamkey, Jr.
Nicholas Fay Lammers
Kate Lapides
Jerry Lara
Brett Conrad Lau
Lisa Lauck
Michael Laughlin
Duane A. Laverty
Tony Law
Jared Lazarus
Amy Leang
Chang Lee
David Y. Lee
John Lee
Matthew John Lee
David Leeson
Mark Leong
Imelda Josie Lepe
Paula Lerner
Will Lester
Marc Lester
Catherine Leuthold
Heidi Michelle Levine
Ron Levy
Serge J-F. Levy
Scott Lewis
Steven Lewis
Andrew Lichtenstein
Brennan Linsley
Steve Liss
Scott Lituchy
Srdjan Llic
John Anthony Locher
John Lok
Mike Longo
Rick Loomis
Walter Looss Jr.
Jon Lowenstein
Benjamin Lowy
Robin Loznak
Pauline Lubens
Melissa Lyttle
Jeffrey MacMillan
Jim MacMillan
Michael Macor
Chris Maddaloni
David Maialetti
Joseph Maida
John Makely
Thomas Mangieri
Andy Manis
Jeff Mankie
Rafiq Maqbool
Melina Mara
Mary Ellen Mark
Daniel Marschka
Bob Martin
Pablo Martínez Monsiváis
Vitali Massimo
Diana Matar
Jay B. Mather
Marianne Mather
Tim Matsui
Eric Maxen
Robert Maxwell
Matt May
Robert Mayer
Virginia Mayo
Clay Patrick McBride
Darren McCollester
Cyrus McCrimmon
Robert McCullough
Steven McCurry
John W. McDonough
Denise McGill
David G. McIntyre
Joe McNally
David McNew

Rohn Meijer
Eric Mencher
Sheryl A. Mendez
Jean Baptiste Mendino
Jim Merithew
Justin Mark Merriman
Josh Merwin
Nhut Meyer
Keith C. Meyers
Jennifer Midberry
Lester J. Millman
Doug Mills
Donald Miralle
Logan Mock-Bunting
Andrea Mohin
Genaro Molina
Yola Monakhov
M. Scott Moon
John Moore
Jose M. More
Christopher Morris
Ryan K. Morris
Graham Morrison
Matthew Moyer
Diana Mulvihill
John Munson
Edward Murray
Noah K. Murray
James Nachtwey
Adam Nadel
Michael Nagle
Jon Naso
Donna E. Natale Planas
Melville Nathanson
Scott Nelson
Trent Nelson
William Nessen
Nancy Newberry
Jehad Nga
Robert Nickelsberg
Steven Ralph Nickerson
Kyle Norman Niemi
Zia Nizami
Landon Nordeman
John O'Boyle
Michael O'Neill
Lauri Olander
Dale Omori
Francine E. Orr
Max Ortiz
José M. Osorio
L.M. Otero
Kevin D. Oules
Darcy Padilla
Hayne Palmour IV
Evan E. Parker
Gerik Parmele
Judah Passow
Bryan Patrick
Peggy Peattie
Randy Pench
John Pendygraft
Thomas Matthew Pennington
R. Perales
Hilda M. Perez
Michael Perez
Stephen Perez
Drew Perine
Lucian Perkins
William Alan Perlman
Richard Perry
Brian Peterson
Mark Peterson
Steve Peterson
David J. Phillip
Jane Phillips
Terry Pierson
Chad Pilster
Sylvia Plachy
Spencer Platt
Suzanne Plunkett
Richard Pohle
Arthur Pollock
Smiley Pool
Wes Pope
Gary Porter
Alexandra Powe Allred
Carrie Pratt
Joshua Prezant
Jake Price
Jaydie Putterman
Joseph Raedle
Asim Rafiqui

Chris Ramirez
John Ranard
Anacleto Rapping
Laura Rauch
Ryan Rayburn
Patrick Raycraft
Lucian Read
Jamie Lynn Rector
Eric Reed
Mona Reeder
Barry Lee Reeger
Tom Reese
Sarah Reingewirtz
Tim Revell
Damaso Reyes
Michael Rhoades
Eugene Richards
Theo Rigby
Josh Ritchie
Kim Ritzenthaler
John Rizzo
Kit R. Roane
Frances Roberts
Michael Robinson-Chávez
John Roca
Paul Rodriguez
Librado Romero
Vivian Ronay
Bob Rosato
K. Michael Rose
Daniel Rosenbaum
Judith Joy Ross
Lance Rothstein
Raul Rubiera
Dina Rudick
Benjamin Lee Rusnak
Jeffrey B. Russell
Rex Rystedt
Margaret Salmon
Brant Sanderlin
Wally Santana
Joel Sartore
April Saul
Jim Lo Scalzo
Erich Schiegel
Ken Schles
Eric Schmadel
Kristen Schmid
Stephen Schmitt
Christopher Michael Schneider
Jake Schoellkopf
Heidi Schumann
David Scull
Eric Seals
Bob Self
Richard Sennott
William Russell Serne
Andréanna Lynn Seymore
Dirk Edgar Shadd
Ezra Owen Shaw
Andy Shaw
David Shea
Callie Shell
Saed Shiyoukhi
Brian Shumway
Jacob Louis Silberberg
Denny Simmons
Meri Simon
Taryn Simon
Stephanie Sinclair
Luis Sinco
Rajesh Kumar Singh
Wally Skalij
Adam Skoczylas
Laurie Skrivan
Elaine Skylar
Michael James Smart
Summar Smith-Zak
John Smock
Brett K. Snow
Bahram Sobhani
Armando Solares
Chuck Solomon
Lara Solt
Chip Somodevilla
Chao Song
Pete Souza
Scott Spangler
Stacia Spragg
Fred Squillante
Jamie Squire
Clayton Stalter
John Stanmeyer

Shannon Stapleton
R. Marsh Starks
Ann States
Susan Stava
George Steinmetz
Lezlie D. Sterling
Sean Stipp
Mike Stocker
Susan Joy Stocker
Heather Stone
Leslie Stone
Scott Strazzante
David Strick
Bob Strong
Bruce C. Strong
Essdras M. Suarez
Anthony Suau
Justin Sullivan
Akira Suwa
Lea Suzuki
Tanya Swann
David Robert Swanson
Joseph Sywenkyj
Shannon Taggart
Mario Tama
Patrick Tehan
Alex Tehrani
Sara Terry
Shmuel Thaler
Robert P. Thayer
Tippi Nicole Thole
Elaine Thompson
Peter Thompson
Al Tielemans
Thomas R. Tingle
Peter Tobia
Jonathan Torgovnik
Kathryn De La Torre
Kenneth Touchton
Charles Trainor Jr.
Susan Tripp Pollard
Robert Trippett
Carmen Troesser
John Hayes Trotter
Tyrone Turner
Peter Turnley
Susan Tusa
Jane Tyska
Diego Uchitel
Erik Monte Unger
Gregory M. Urquiaga
Chris Usher
Nick Ut
Angel Valentin
Victoria Ann Valerio
Nuri Vallbona
Leonard M. Vaughn-Lahman
Dixie D. Vereen
Fernando Vergara
Mark Vergari
Jose Luis Villegas
Kurt Vinion
Stephen Voss
Dino Vournas
Evan Vucci
Craig Walker
Diana Walker
Anastasia Walsh
E. Jason Wambsgans
Ting-Li Wang
Chris Warde Jones
Steve Warmowski
David M. Warren
William Warren
Ruby Washington
Lannis Waters
Guy Wathen
Ben Watts
Billy Weeks
Steven Weinberg
David H. Wells
Annie Wells
Gregory C. Whitesell
Stephen Whitesell
Dean Wiard
Jonathan Wiggs
Gerald S. Williams
Jonathan Wilson
Mark Wilson
William Wilson Lewis III
Gordon Wiltsie
Damon Winter
Steve Winter

Dan Winters
Michael S. Wirtz
Patrick Witty
Joshua Wolfe
Mandi Wright
Jessica Wynne
Dave Yoder
Stefan Zaklin
Mark J. Zaleski
Tim Zielenbach
Sarah Zimmer
Warren Zinn

UZBEKISTAN
Anvar Ilyasov
Vladimir Jirnov

VENEZUELA
Juan Barreto
Héctor José Castillo Clemente
Freddy Henriquez Salcedo
Leonardo Liberman Lifschitz
Carlos Javier Meza Gonzalez
Pedro Ruiz
Carlos Sanchez
Luis Gerardo Sánchez Saturno

VIETNAM
Bui Van Thanh
Dang Van Tran
Do Truong Son
Doan Duc Minh
Dong Minh Dong
Cac Ho Van
Hoang Quoc Tuan
Hoang Thach Van
Huynh My Thuan
Huynh Ngoc Dan
Le Tung Khanh
Luong Chinh Huu
Luong The Tuan
Ly Hoang Long
Ngo Duc Can
The Tri Nguyen
Quang Phung Nguyen
Viet Thanh Nguyen
Nguyen Anh Tuan
Nguyen Dan
Nguyen Dong Khanh
Nguyen Duc Bai
Nguyen Hong Nga
Nguyen Ngoc Hai
Nguyen Thanh Vu
Nguyen Thi Thanh Son
Nguyen Tin Trung
Pham Ba Thinh
Pham Dinh Hien
Pham Quoc Bao
Phuong Hoai Le
Son Huynh Ngoc
Thuc Nguyen Trung
Tra Thiet
Duc Tai Tran
Viet Van Tran
Tran Minh
Tran Quoc Dung
Tran Tam My
Tran The Long
Vu Quang Huy

YEMEN
Abdulrahman M. Al-Ghabery

ZAMBIA
Salim Henry
Timothy Nyirenda

ZIMBABWE
Mukwazhi Tsvangirayi

151

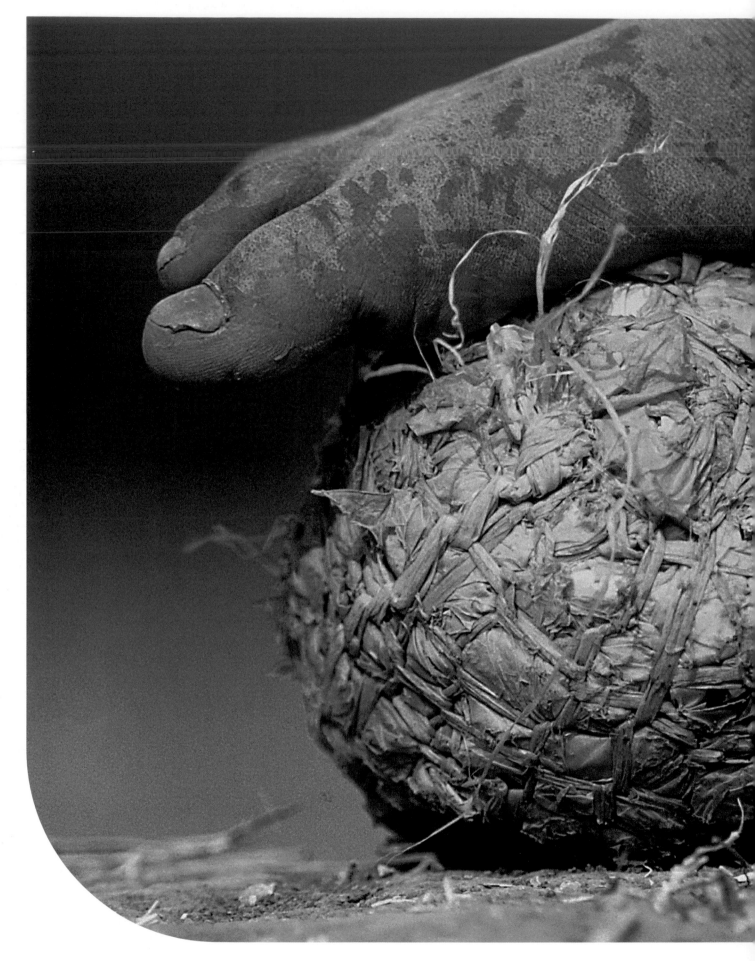

FOR THE LOVE OF FOOTBALL.
FOR THE LOVE OF PHOTOGRAPHY.

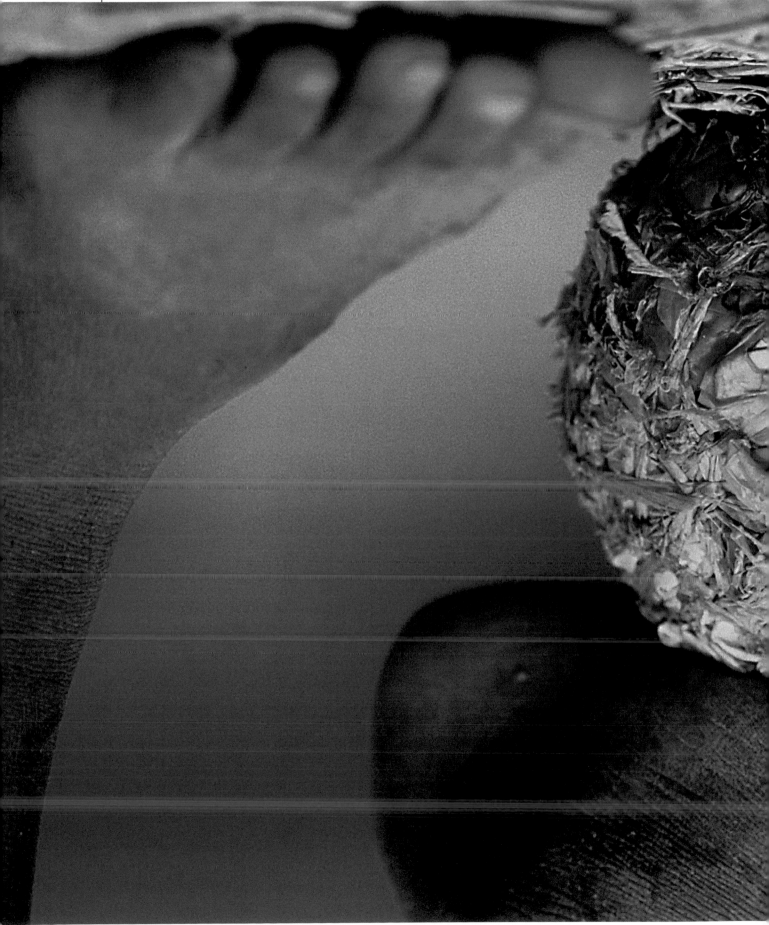

Food for Thought

In addition to feeding some 80 million people per year, World Food Programme (WFP) is the largest provider of school meals to poor children in the world. By using food to attract children to school, the agency is able to ensure they receive at least one nutricious meal a day as well as the opportunity to learn.

By becoming WFP's largest corporate sponsor, TNT is committed to making its people, skills, assets and systems available to support WFP.

Through this partnership, TNT and WFP aim to fight the slow, agonising hunger that affects millions of poor people around the world.

TNT is a global provider of mail, express and logistics solutions. World Food Programme is the United Nations' logistics arm and the world's largest humanitarian organisation.

TNT supports WFP to feed the hungry

www.tnt.com

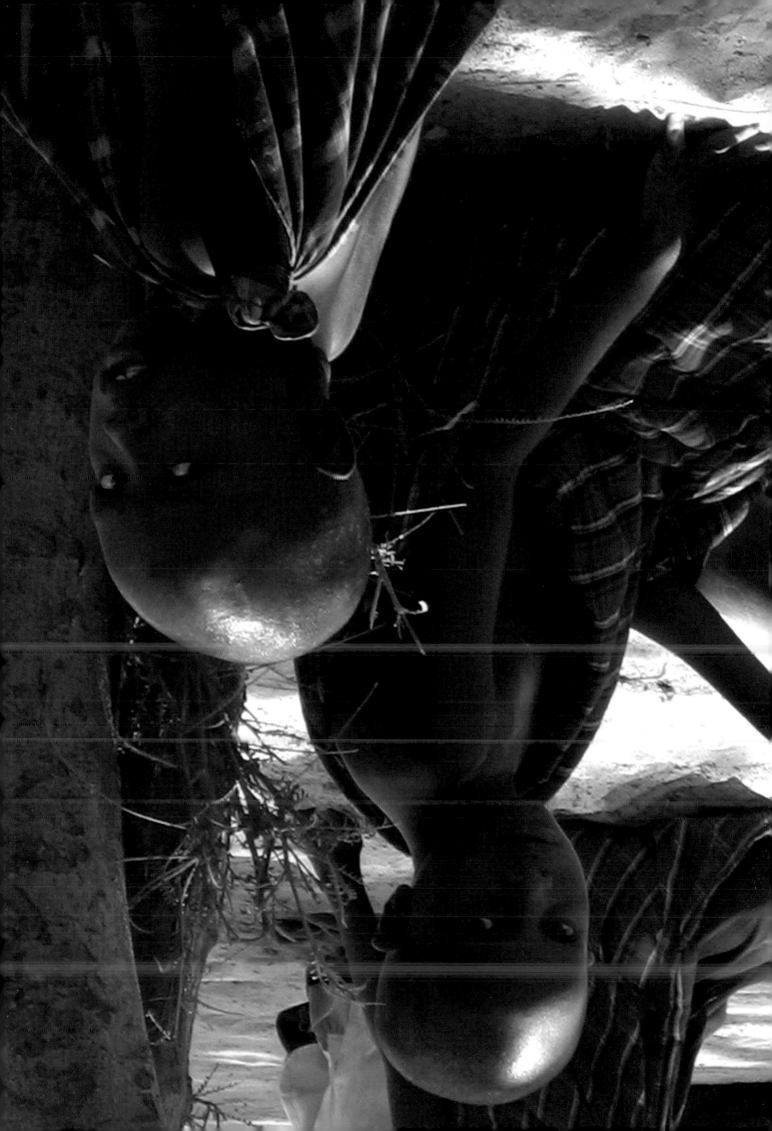

Copyright © 2004
Stichting World Press Photo, Amsterdam
Sdu Publishers, The Hague
All photography copyrights are held by the
photographers

First published in Great Britain in 2004 by
Thames & Hudson Ltd,
181A High Holborn, London WC1V 7QX
www.thamesandhudson.com

First published in the United States of
America in 2004 by
Thames & Hudson Inc., 500 Fifth Avenue,
New York, New York 10110
thamesandhudsonusa.com

Art director
Teun van der Heijden
Design
Heijdens Karwei
Picture coordinators
Petra van As
Saskia Dommisse
Elsbeth Schouten
Captions & interview
Rodney Bolt
Editorial coordinators
Bart Schoonus
Elsbeth Schouten
Editor
Kari Lundelin

Lithography
DeltaHage, The Hague
Paper
Hello Silk 135 g, quality Sappi
machine coated, groundwood-free paper
Cover
Hello Silk 300 g
Proost en Brandt, Diemen
Printing and binding
DeltaHage, The Hague
Production supervisor
Rob van Zweden
Sdu Publishers, The Hague

This book has been published under the
auspices of Stichting World Press Photo,
Amsterdam, The Netherlands.

Jury 2004
Elisabeth Biondi, Germany (chair)
visuals editor The New Yorker
Elena Ceratti, Italy
international news editor Agenzia Grazia Neri
James K. Colton, USA
photography editor Sports Illustrated
Steve Crisp, UK
editor Reuters News Pictures
Ruth Eichhorn, Germany
director of photography GEO Germany
Mark Grosset, France
photography consultant
Gary Knight, UK
photographer VII
Herbert Mabuza, South Africa
picture editor The Sunday Times
Susan Olle, Australia
freelance designer and art director
Swapan Parekh, India
photographer
Reza, Iran
photographer National Geographic
Magazine/Webistan
Dani Yako, Argentina
photographer and chief photography editor
Clarin
Aleksander Zemlianichenko, Russia
chief photographer The Associated Press
Moscow Bureau
Stephen Mayes, UK (secretary)
director Art + Commerce Anthology, New York

Office
World Press Photo
Jacob Obrechtstraat 26
1071 KM Amsterdam
The Netherlands

Telephone: +31 (20) 676 6096
Fax: +31 (20) 676 4471

office@worldpressphoto.nl
www.worldpressphoto.nl

Managing director: Michiel Munneke

Cover picture
Jean-Marc Bouju, France, The Associated
Press
Iraqi man comforts his son at a holding
center for POWs, An Najaf, Iraq